THE TREATISES OF BENVENUTO CELLINI ON GOLDSMITHING AND SCULPTURE.

THE TREATISES OF BENVENUTO CELLINI ON GOLDSMITHING AND SCULPTURE.

TRANSLATED FROM THE ITALIAN
BY C. R. ASHBEE

Dover Publications, Inc., New York

This Dover edition, first published in 1967, is an
unabridged republication of the limited edition
originally published by Edward Arnold in 1888.
The captions accompanying the illustrations were
prepared specially for this Dover edition.

International Standard Book Number: 0-486-21568-7
Library of Congress Catalog Card Number: 66-13829

Manufactured in the United States of America
Dover Publications, Inc., 180 Varick Street
New York, N.Y. 10014

TO THE METAL
WORKERS OF
THE GUILD OF
HANDICRAFT,
FOR WHOM I
HAVE SET MY
HAND TO THIS
WORK, AND TO
WHOM I LOOK
FOR THE FRUIT
IT IS TO BEAR.

TABLE OF CONTENTS.

THE TREATISE ON GOLD-SMITHING.

vi

THE TREATISE ON SCULPTURE.

A GLOSSARY OF ITALIAN TECH-NICAL TERMS FOR THE USE OF STUDENTS.

LIST OF ILLUSTRATIONS AND DIAGRAMS.

ILLUSTRATIONS.

DIAGRAMS.

AN INTRODUCTORY ACCOUNT OF THE ORIGIN AND OBJECT OF THE TREATISES & OF CELLINI'S POSITION AS CRAFTSMAN AND AUTHOR.

THIS translation is intended for the workshop; & to bring home to English craftsmen, & more particularly to my colleagues and pupils at Essex House, the methods and practice of the Goldsmith of the Renaissance. It is with this end in view that the work has been undertaken, and I am in hopes that the knowledge of this may induce my critics to give it a kindlier reading, aware as I am of its many shortcomings.

To the translator of the treatises two things are necessary, Italian scholarship and a thorough knowledge of workshop technicalities; these two qualities are difficult—perhaps impossible—to combine, and I am conscious of grave deficiencies in both, but more especially in the former. My endeavour has been to follow the lead set me by John Addington Symonds and to make this first English translation of the treatises serve, if but in some far-off measure, as a continuation volume to his masterly translation of the Autobiography. I have in many cases, therefore, adopted his manner of handling the subject, but inasmuch as the more technical and less directly personal matter with which the treatises deal, demands a somewhat different treatment, I have sought to retain what I would call the workshop vernacular, without at the same time sacrificing the archaism of the old Italian dialect.

Cellini's graphic touch, which gives their manifold brilliancy to the varying passages of that wonderful autobiography, is equally evident in the treatises. But this very vividness increases the translator's difficulty. The book is full of amusing workshop pictures and anecdotes; but it is always a workshop book. Cellini sees each process before him as he describes it, we, however, only hear the description, we do not see the process, hence it is often to the expert metal worker alone that some of the more complex technical narrations appeal, while the translator is as frequently in doubt as to whether he has realised the picture the author sought to draw. If, in my English rendering of some of these pictures, I have gone astray, I trust that my errors may be pointed out by those who are better able to follow the author's meaning.

Apology is perhaps scarcely necessary for what will often appear to be loose or ungrammatical English; this may be an offence to the stylist or the pedant, & it certainly at first sight jars in what purports to be a scientific text book. It would have been perfectly easy for me to cut out the improper stories, trim up the phrases and give precision, accuracy, and even grammar to certain of the sentences, but this would not have been Cellini. We have him not writing, but rapidly & with a delightful forgetfulness and confusion, talking his treatises to a scribe, and then omitting to revise them; it is the spirit, therefore, of the spoken word, not the careful writing, that I have sought to render.

Another difficulty hampers the translator: the absence of any living workshop tradition upon which to fall back when his subject becomes too technical. In our day of the subdivision of labour the study of the 'Eight branches of the glorious Art of Goldsmithing' as it was in Benvenuto's time is a thing of the past. Except in a few instances where workshops are conducted with the enthusiasm of the artist rather than with the itching fingers of the tradesman, there is no such thing as an all round grasp of the Art such as Cellini postulates. To the tradesman, the sculptor's ghost, the working jeweller, whether of Birmingham, Bond Street, or Clerkenwell, in the thousand and one gimcrack shops where they sell 'merrythought brooches,' & 'our latest stock of Christmas presents,' the glorious Art of Goldsmithing has no meaning, or rather is a thing not of eight branches but of a hundred subdivisions, fanned into existence by a hundred callous machines, and workshop tradition has been destroyed by 'the Trade.' For the same reason the circle of readers will be small. To those of us who in recent years have been seeking to lift the art of the goldsmith out of the slough of industrial despond, to show once more what the human hand and fancy can create, and to relegate, without repudiating it, the machine to its right place in relation to human endeavour, all this manifold production of rubbishy trinkets, useless ornaments, and things made for 'the Market,' is stupid and wasteful, and makes for the destruction not the ennobling or beautifying of life.

But though small, the circle of my readers will be an earnest one. To such as are setting the standard of modern Art and Craft, to those who are fighting the trade, and seeking to relate the creations of their hands to their reasons for existence in life, this book of the aspirations & traditions of the old Italian will have some value. Fortunately their number is increasing, not only in England, but in Europe & in the United States. In the workshops of men like Frampton, Alfred Gilbert, Simmons, Fisher, Nelson Dawson; among the artists of Glasgow & Birmingham, or among the keener creative spirits in New York, whom I have found ready to

welcome every genuine inspiration of the hand, will the real readers be found.

It is perhaps not my province as a translator to criticise the artistic merit of Cellini's work, but as my hope in placing his treatises before English craftsmen is to familiarise them with his methods, I may perhaps be allowed to give a few words of warning. We must not take Cellini at his own valuation, and we must remember that he did not draw that subtle distinction between designer and executant that we nowadays are wont to do. The fact that every aesthetic criticism is inevitably biased by the style of its period must be taken into account by the student, if such criticisms as I myself, speaking as an artist, should venture to make, are to be of value to him. To Cellini's best-known critics this applies in equal measure. Vasari, Delaborde, Milanesi, Brinckman, Symonds, have each had their point of view so to speak. To some, like Vasari, it has been coloured by what the Germans call 'die Voll-Renaissance,' of which Cellini in the art of goldsmithing was undoubtedly the central figure. To others, like Delaborde, it was influenced by the Romantic Reaction of the early Nineteenth Century, and to them his work was 'an exploded myth.' Criticised from the modern point of view—the point of view that distinguishes between goldsmith and sculptor, between craftsman & designer—we cannot rank him among the highest. There is a want of feeling for proportion in such work as we have of his, & the whole is marred by the overcrowded detail, often very exquisite in itself, of the parts; the craftsman indeed invariably overpowers the artist. Above all there is a want of spirituality in all his more important work, a want of refinement of soul, if one might so term it—a vulgarity. There is none of the 'ευηθεια of Donatello, the graciousness of Ghiberti or Duccio, the mingled strength and sweetness of Verocchio, the simple grandeur of Pisanello. Michael Angelo's manner perhaps we can trace, but of his inspiration and his self-control there is none.

If we take Cellini from the point of view he would himself have wished us to criticise him, he challenges us first as a sculptor & a designer of the figure. In this sphere, however, he falls far short of the standard he calls upon us to judge him by. Affected & uneven and imperfect in handling is his work when set beside that of earlier masters. Attenuated as we see in the nymph of Fontainebleau, thick & exaggerated as in the Perseus at Florence, leaden and stiff as in the Neptune and Cybele of the salt, there is about his figures always something *manqué*, they seem indeed to have in them the effort of a decaying school.

Much the same criticism applies to his work as a medalist. There is an

absence of reserve & the fine feeling for his limitations which puts him to my mind far beneath Sperandio, Marende, Francia, or other of the great Cinquecento medalists, and it needs no artist to point to the superiority of the Greek coins with which with redoubtable modesty he compares his own.

To estimate his position as a jeweller is all but impossible, as there is not one jewel remaining that can be authenticated as his. If, however, we may be allowed to gauge his position as an artist from such pieces as are attributed to him in the Rothschild, Vienna, Paris, & Chantilly Collections, and of which I give some specimens on pages 22 and 24, I should be inclined to place him on an equal footing with any of the great masters of the early Renaissance or the Middle Ages in any country. The reasons of this are not far to seek. Jewellery is, before all others, an art of limitations. An artist cannot but put less of himself into a gem than into a statue, he is necessarily more cabined. Further, Cellini made most of his jewellery as a young man in Florence & Rome, when the traditions of the Florentine workshop which reared Brunelleschi, Donatello, Ghiberti, were still fresh upon him, & before he had as yet attempted the impossible task of translating the *gusto grando* of Michael Angelo into minor craftsmanship. Subject to the disproving of the attributions, I give therefore to Cellini as a jeweller an equal place with the artists of Greece and Japan, with those of Spain, England and Germany in the Middle Ages & the Renaissance, whose works are known to us; but as medalist, goldsmith and sculptor, I would place him on a much lower footing. My whole criticism might be summed up briefly thus: he was a very first-rate craftsman, but a very second-rate artist.

The Autobiography and the Treatises of Cellini must be read together, they tail into one another, the former gives the life of the man, the second the methods of the craftsman; both alike bring out the writer's strong personality. A few words are needed as to their bearing upon one another, and the original of the present translation.

Both the 'Vita' & the 'Trattati' were dictated by Cellini to amanuenses; &, feeling their stylistic imperfections, he offered both, after their completion, to literary friends to polish and refine before publication. The 'Vita' he sent to the great historian Benedetto Varchi, who had the good taste and the wisdom to leave the MS. as it was, saying that he preferred it in its rough & unpolished condition; the latter was placed in less tactful hands,* & Gherardo Spini, a literateur† of the Florentine Academy,

*Plon, 117.
†See Milanesi. 'I. Trattati,' &c., novamente messi alle stampe, &c.
 xii

to whom this task has with good reason been attributed, undertook its recasting, to the no small detriment of the original. In this polished and emasculated form the 'Trattati' first appeared & for 300 years remained; the Editio Princeps* being published in Florence in the shape of a very beautiful volume in 1568, three years before Cellini's death. It was not till 1857 that Carlo Milanesi, working on the lines of Francesco Tassi, who had in the Marciana re-discovered the original MS., gave to the world the work as Cellini had originally dictated it. It is on the 'Trattati' of the Marcian Codex, therefore, & not of the first edition, that this translation is based.

Cellini is fortunate in having been handled in our own day by four eminent and scholarly men, and to the work of each of these am I indebted. Milanesi,† 1857, may be placed first, and his admirable and exhaustive edition of the 'Trattati' cannot be too highly praised. Herr Justus Brinckman‡ followed him, in 1867, with his excellent translation of the 'Trattati' into German, and his very able comparative treatment of the work of the monk Theophilus§ with that of the Cinquecento artist. In 1883 Eugène Plon‖ brought out his splendid volume on the life and works of Cellini, especially valuable for its illustrations and the critical investigation of the authentic and attributed works of the master. The work of our own John Addington Symonds is familiar to most English readers, and it is to the study of his masterly translation of the 'Vita' that I owe my first introduction to Cellini. To his memory I would wish here to express my gratefulness, and perhaps the best expression of this is in the assurance that through his introduction to Cellini has grown up the wish to familiarise the methods of the Renaissance workshop among English metal workers, & particularly among the metal workers of the Guild of Handicraft for whom this book is written.

My thanks are due to Messrs. Plon & Cie. for their kind permission to reproduce the blocks originally used in M. Eugène Plon's volume, and which illustrate in this book the various examples as Cellini describes them; and I am indebted to many friends, artists & scholars for the most

*Pub. Firenze, 1568. Valentini Panizzi e Marco Peri, 8vo.
†Milanesi. 'Due Trattati,' &c.
‡'Abhandlungen über die Goldschmiedekunst und die Sculptur v. Benvenuto Cellini.' Justus Brinckman. Leipzig, 1867.
§Theophilus lived in the early half of the 11th century. See his 'Diversarum Artium Schedula.' Hendrie's translation. Murray, 1847.
‖'Benvenuto Cellini, orfèvre, medailleur, sculpteur, &c.' Eugène Plon. Paris, 1883.

part, who have helped me with difficulties both in the text and in the workshop. To Mr. and Mrs. de Morgan and Captain Victor Ward for many hours of helpful, and, I fear, sometimes tedious revision; to Miss Constance Blount for her great assistance with the enamelling chapter, to Mr. Virtue Tebbs for his advice among the coins, to Mr. Wenlock Rollins & Mr. T. Stirling Lee in the complicated passages dealing with casting and the making of furnaces, and above all to Professor Roberts-Austen and Professor Church, not only for their invaluable help on all points dealing with metallurgy & stones, but also for their kind assistance in correcting the proofs of the whole book. I have likewise to thank for their courtesy in allowing me to refer to them in one way or another over technical & literary difficulties Mr. Heywood Sumner, Mr. M. Hewlett, Professor Giglioli of Naples, and Professor Fergusson of Glasgow.

<div align="right">C. R. ASHBEE.</div>

Essex House, Bow, E.

xiv

THE TREATISE ON GOLDSMITH-
ING.

INTRODUCTION.

WHAT first prompted me to write, was the knowledge of how fond people are of hearing anything new. Then in the second place, & this perhaps had greater weight still, I felt much troubled in mind because of all sorts of annoying things the which I purpose in the following treatise, with due modesty, to recount. That they will move my readers to great pity & no little anger in my behalf I am quite positive. Forsooth you can often attribute to difficulties of this kind the most opposite turns, to the greatest of evil the greatest of good, and had the troubles in question never come upon me, I for sure should never have set about writing down these most useful things. Thus it was that I did what no one had done before,* viz., undertook to write about those loveliest secrets and wondrous methods of the great art of goldsmithing. Things such as neither your philosopher, no, nor any other kind of man neither, if he be not of the craft, durst write about. But since they of the craft are for the most part better at work than at talk, they fall into the error of silence. This at least I determined to avoid and so set myself strenuously to the task. Perhaps never before, or at least so rarely that it has never been recorded, has a man been found who was a specialist in more than one or at most two of the eight different branches of this goodly art, but where he is, he knows, as you may imagine, how to make a good thing of them. Mind you, I don't intend to talk about those kinds of muddlers who set themselves busily dabbling in all the eight branches at once, and who many and many a time are employed by such as either couldn't or wouldn't decide whether a bit of work was good or whether it was bad. Men of that ilk methinks may be likened to the sort of small shopkeeper who hangs out in the slums or suburbs of the town and does a little now in the bakery line, now in the grocery line, now in the apothecary line and now in general retail business—in fact, a little bit of everything and nothing good in anything. These sorts of fellows I don't intend to talk about, but only of such as have come to the front in what they have done ; and only of the right workmanlike way of doing things. Well, then, I mind me to begin with, of our city of Florence and of how we there were the first to revive all those arts that are the sisters of this art of mine ; of how the earliest light dawned in the time of that first magnificent Cosimo de Medici ; of how under him flourished Donatello the great sculptor, and Pippo di Ser Brunelleschi the great architect, and of that wondrous

Cellini had of course never heard of Theophilus, the monk of the 11th century, and his great treatise ' Diversarum Artium Schedula.'

Lorenzo Ghiberti, in whose time were made the beautiful gates for what was once the ancient temple of Mars and is now the baptistry of our patron St. John.

Lorenzo Ghiberti. He was a goldsmith indeed ! Not only in the wonderfulness of his own peculiar style, but because of his unwearied power of marvellous finish, and his exceeding diligence in execution. This man, who must be counted among the most admirable of goldsmiths, applied himself to everything, but especially to the casting of smaller work. And though now and then he set about doing large pieces, yet one can see that his particular line was the production of small work, and in this branch we may well call him a master in the art of casting. Indeed he pursued this with such excellence that as is still obvious to all, no man can touch him.

Antonio Pollajuolo, or the poulterer's son, as he is always called, was likewise a goldsmith, and a draughtsman too of such skill, that not only did all the goldsmiths make use of his excellent designs, but the sculptors and painters of the first rank also, and gained honour by them, what was more ! This man did little else beside his admirable drawing, but at this he was always busy.

Maso Finiguerra pursued only the art of engraving niello, in which craft he had no rival, and he too always made use of the designs of the aforesaid Antonio.

Amerigo wrought in the art of enamel, & was by far away the first craftsman in it either before or after his time. He too, great as he was, made use of the designs of Antonio del Pollajuolo.

Michaelangelo, the goldsmith of Pinzidimonte, was a capital fellow, and worked in a variety of divers things, and especially in the setting of gems. He wrought and designed well in niello, in enamel, in hammered work, and though he come not up to the other distinguished men just named, he deserves much praise. He was the father of Baccino* whom Pope Clement made a Knight of St. John. He added the surname Bandinelli on his own account, and since he had neither family nor arms really, he took the sign of his knighthood for a coat. About this man I shall have more than enough to tell as we go along.

Bastiano del Bernardetto Cennini was a goldsmith and worked also in a number of different things. His forefathers and he for many years made the dies for the coins of Florence, until the time that Alexander de Medici, the nephew of Pope Clement, became Duke. This Bastiano in his youth did admirable large metal ware—grosserie† and hammered

* *Baccio Bandinelli, the sculptor, one of Cellini's bitterest enemies.*
† *Grosseria. Cellini uses this term for all large ware as distinguished from 'minuteria' or small ware.*

2

work,* and verily he was a first-rate craftsman. And though I said above I wasn't going to talk about bunglers who take up a number of different things indifferently, one must none the less distinguish between those who *are* bunglers & those who are good craftsmen and worthy of praise. *Piero*, *Giovanni*, and *Romolo*, were brothers, the sons of one *Goro Tavolaccino*; they were goldsmiths too, they did good work and made good designs. Amongst other things they were very good at setting jewels in pendants, rings and so forth, and this they managed so tastefully that at that time, 1518, they had no equal. They also worked in intaglio, in bas relief, and were not bad at hammered work.

Stefano Salteregli was a goldsmith too, a good man in his day, working like the others in a number of different things, but he died young.

Zanobi, son of *Meo del Lavacchio*, whose craft he followed, was a goldsmith also, had a charming way of working and designed admirably; but he died just when his beard began to bloom, at about the age of 20.

Indeed at that time there were many young fellows, whose equal and colleague I was, who promised great things to begin with; but the most of them has death snatched away, and the rest have either not stuck to the drudgery, or with undeveloped talents have got no further. As for me, I have heard myself blamed because I have talked so much about such excellent men in one profession only; but I have still to tell of work in filigree, an art though the least beautiful of many beautiful arts, still very beautiful for all that.

Piero di Nino was a goldsmith, who worked only in filigree, an art which, while it affords great charm, is not without its difficulties. He, however, knew how to work in it better than anyone else. Inasmuch as there was great riches in those days within the town, so was it likewise in the country, especially among the peasant folk of the plain, who used to get made for their wives a sort of velvet girdle with buckle and pin, about half a cubit long and covered all over with little spangles. These buckles and pins were all wrought in filigree with great delicacy and fashioned in silver of excellent setting. When later on I shall show how these things are made, I am sure the reader will find delight in them. I knew this Piero de Nino when an old man of near 90 years. He died partly from fear of dying of hunger, and partly from a shock he got one night. As for the dying of hunger it was this way: An edict had been issued in the city that no more belts should be worn either by peasants or others; and the poor old fellow, who knew no other branch of goldsmithing but this, was always grieving, and cursing from the bottom of his heart all

* *Di cesello: what we should call repoussé.*

3

those who had a hand in making this law. He lived near a draper's shop, where was a young rogue of an urchin, the son of one of them that had made the law. The boy, hearing him thus continually cursing his father, 'Oh, Piero,' said he, 'if you go on swearing like that, some fine day the devil will come and carry you off, bones and all!' Now one Saturday night, when the old chap had worked right up to midnight to finish some job he was engaged on that was to go to Bologna, the urchin took it into his head to play him a practical joke and give him a fright. So he stood on the watch for the old man on his way home. The latter, as was his wont, locked up his shop, took his lantern in his hand, and, with the lappet of his cloak thrown over his head, trudged along ever so slowly, and as lonely as a ghost, home to his house, which stood in the via Mozza. Just as he was turning the corner of the old market the urchin, who was awaiting in ambush for him, and had tricked himself out with rag-tag, sulphur lights, blue fire, and suchlike horrible devilries, suddenly jumped out upon him. The poor old thing was so terrified at the fearful monster thus suddenly coming at him, that he lost his senses; so much so that the boy, seeing he had played the fool, had to lead the old man home as well as he could, and consign him to the care of his grandsons, among whom was one called Meino, a courier, who afterwards became warden of Arezzo. Suffice it, the fright had been so great, that soon after the poor old fellow died. This is usually stated as the actual cause of Piero's death, and I have myself ofttimes heard it narrated.

Antonio di Salvi was another of our Florentine goldsmiths, a capital grosserie worker. He died at a very great age.

Salvatore Pilli likewise was a first-rate man, who also died very old; but he never worked in a shop of his own, but always in someone else's.

Solvatore Guasconti was an all round man, more especially good in small things. His work in niello and enamel is well worthy of praise.

You must know too that there were ever so many others, all of them fellow Florentines, who commenced in the goldsmith's art and took their inspiration from it for various other arts, such as sculpture, architecture, and other notable lines of work.

Donatello, for instance, the greatest sculptor that ever lived, about whom I shall have plenty to say later on, stuck to the goldsmith's art right along into manhood.

Pippo di ser Brunellesco, the first who gave new vigour to the glory of architecture, he too was a goldsmith for a long time.

Lorenzo dalla Golpaia also was a goldsmith, and always continued true to the art. As for him, he was a very prodigy of nature, for he specialised in clock making, and finding his own peculiar bent in this line, so wonderfully reproduced the secret of the heavens and the stars that

4

you really might have thought he lived up in the sky ! Amongst other things he showed his cunning in a clock he made for the magnificent Lorenzo de Medici. In this clock he put the Medici arms, making them represent the seven planets; these used to move round slowly, and revolve just like the planets in the sky do. This clock is still in its place, but it is not what it used to be because it has been so badly taken care of.

Andrea del Verocchio, the sculptor, remained a goldsmith up to the time of manhood. He was the master of Lionardo da Vinci, painter, sculptor, architect, philosopher, musician;—a veritable angel incarnate of whom I shall have heaps to tell whenever he comes to mind.

Desiderio, too, was a goldsmith in his youth, who took to sculpture later, and was a great master in the art.

I can't possibly recount all our Florentines who were adepts in the great goldsmiths' art, suffice it that I have mentioned most of those who became famous therein. But I will say a word or two about some of the foreigners who seem to me pre-eminent, and I will begin with such as wrought in niello.

*Martino** was a goldsmith from beyond the Alps, who came from some German town or other. He was a first-rate fellow in designing, & in intaglio work in the way they do it there. It was just about the time when the fame of our Maso Finiguerra spread abroad, who did those wonderful niello intaglios,—by the way, you may still see preserved in our lovely Church of St. John of Florence a silver pyx of his, with a crucifix above it, & the two malefactors, with a lot of detail of horses and other things. Antonio del Pollajuolo, whom I mentioned before, did the design, and Maso the Niello work.

Well, then, this good German Martino set to with great diligence and zeal to practise the art of niello, and turned out a number of excellent things. But because he saw that he could not produce work that should come up to our Finiguerra's for beauty and go, yet being a right-minded man, and wishing to do something that should be generally useful, he set to cutting his intaglios on copper plates with the graver (*bulino*) for so is the little steel tool called with which you engrave. In this wise he engraved a number of pretty little picture-tales, very well composed, and with great understanding of light & shade, in fact as far as one can say such a thing of a piece of German work, they were charming.

Alberto Duro also tried his hand at engraving, and with much greater success than Martino. He too was not satisfied with the results of his

Martin Schongauer.

5

work in niello, and so determined to do engravings, and this he did so well that no one can hold a candle to him. He too was a goldsmith, nor was he satisfied with niello only, he resorted in addition to his engraving, and did extraordinarily well in that line.

Andrea Mantegni, our great Italian painter, tried it too, but couldn't do it, so the less said about it the better.

Antonio Pollajuolo, the same happened with him, and because both these men could make nothing of it, I'll say naught but that Mantegni was an excellent painter, and Pollajuolo an excellent draughtsman.

*Antonio da Bologna** & *Marco da Ravenna* must also be counted among the goldsmiths. Antonio was the first who began to engrave in the manner of Alberto Duro. He studied closely the work of the great painter Raphael of Urbino. He engraved beautifully, could design in the right good Italian manner, and studied closely the style and methods of those old Greeks, who always know how to do things better than other folk. Many others pursued this branch of engraving, but because none of them came up to the great Alberto Duro, & even also a long way behind our Italian Antonio of Bologna, I'll not mention them; more especially as to do so would be to go beyond the limits of our inquiry, which is to consider the lovely art of niello and all its many difficulties.

Now you must know that when I first was a goldsmith's apprentice in the 15th year of the century, which was my 15th year too, the art of engraving in niello had quite fallen into disuse. It was only because a few old men still living did nothing else but talk of the beauty of the art and of the great masters who had wrought in it, & above all of Finiguerra, that I was seized with a mighty desire to learn it; so I set to diligently to master it, & with the examples of Finiguerra before me, made many good pieces.

My difficulty, however, was how to find out after I had engraved the intaglio how the niello that was to fill it ought to be made. So I went on trying ever so hard until I not only mastered the difficulties of making the material, but the whole art became a mere child's play to me. Here, then, is the way in which niello work is done.

**Marcantonio Raimondi.*

6

CHAPTER I. ON THE ART OF NIELLO.

TAKE an ounce of the finest silver, two ounces of copper well puri-
fied, and three ounces of lead as pure as you can possibly get it.
Then take a little goldsmiths' crucible sufficiently big to melt the
three in together. You must first take the one ounce of silver & the two
ounces of copper and put the two together in the crucible, and the cru-
cible in a goldsmiths' blast-furnace, and when the silver and the copper
are molten & well mixed together, add the lead to them. Then quickly
draw the crucible out, and with a bit of charcoal held in your tongs, stir
it round till it is well mixed. The lead, according to its wont, will make
a little scum, so with your charcoal try and take this off as much as pos-
sible, until the three metals are fully & cleanly blended. At the same time
have ready a little earthenware flask about as big as your fist, the neck
of which should, however, not be wider than might hold one of your
fingers. Fill this flask about half full with very finely ground sulphur, &
empty into this your molten mass, while quite fluid & hot. Then quickly
stuff it up with moist earth, and holding it in your hand wrapped up in
a stout bit of canvas, say for instance an old sack, shake it to & fro while
it is cooling. As soon as it is cold, break the flask and take out the stuff,
and you will see that by virtue of the sulphur it will have got the black
colour you want. But mind you take care that the sulphur is the black-
est you can get.* As for the flask, you may take one of those which are
generally used for separating gold from silver. Take then your niello,
which will now be in a number of little grains,—for you must know
that the object of all this shaking up and down whilst cooling in the
sulphur is to make it combine,—& put it anew into a crucible, then melt
it in a moderate fire, adding to it a grain of borax. When you have re-
cast it two or three times, and after each casting broken up your niello,
take it out, for you will see it will now be splendidly broken up,† and
that is as it ought to be,—and that will do.

Now I'll show you how to apply and make up your niello; but first a
word or two about the plate on which your intaglio is to be engraved,
whether in silver or in gold, for niello is used only on these metals. If
you want to get the plate on which you have cut your work nice and
smooth & without holes,‡ you must boil it in a solution of clean water

* *This is obscure, as the purest yellow sulphur would answer.*
† *Perhaps: 'have a fine fracture.'*
‡ *Bucolini. Perhaps: 'specks.'*

mixed with a deal of very clean charcoal, the best for this purpose being charred oak. When your work has cooked in the pot for about a quarter of an hour or so, transfer it to a beaker of clean fresh water, and scrub it for a long time with a clean brush till every particle of dirt be rubbed off it. Then see that you have ready a bit of iron long enough to hold the work to the fire: its length should be about three or four palms, more or less in accordance with what the nature of your work may seem to you to need. But mind you look out that the iron to which your work is fixed be neither too thick nor too thin; for it should be of such sort that when you put both to the fire they should heat equally; for if either the iron or the plate become heated first, you'll make a mess of it, so pay great attention to this. Next take your niello, & crush it on an anvil, or on a porphyry stone, & do this with a pair of pliers or a copper rod, and so that it does not spring aside. Take care, too, that it is crushed to grains and not to a powder, & these grains should be as equal as possible, and about the size of a grain of millet or sago, if not less. After this put the niello grains into some sort of vase or glass bottle, and with fresh clean water wash it out well till it be quite purified from any dust or dirt that may have got into it during the pounding. This done, take a spatula of brass or copper, and spread the niello evenly over your engraved plate to about the thickness of the back of a table-knife. Then powder over it a little well-ground borax, but mind it be not too much. Put a few pieces of wood or charcoal so that you can blow them into flame with your bellows, and this done, put your work very slowly to the wood fire & subject it to the heat very dexterously till you see the Niello beginning to melt. But look out that, when it does begin to melt, you don't get it too hot, or into a red heat, for if it gets too hot, it will lose its natural character and become soft, because, the principal component of niello being lead, this lead will begin to corrode the silver, or even the gold of which your work is made; in this way you might have all your pains for nothing. Have great heed to this, therefore, which is as important as your good engraving to begin with.

Now before we follow the work through to the end, we will pause and consider things a bit. I advise you when you are holding your work over the fire and see the niello begin to disintegrate, to have at hand a fairly stout iron rod, with a flatted end: this end hold in the fire, and when the niello begins to run, rapidly put your hot iron over it, and, treating it as if it were wax, spread it well, until it has quite filled all the graven part of your intaglio. After this, when your work has got cold, take a delicate file, and file off your niello, & after you have removed a certain quantity, not so as to graze your intaglio, but sufficient to lay it bare, take your work and put it on the hot ashes or the live charcoal.

8

When it is a little hotter than the hand can bear, or even a bit hotter still, but before it gets too hot, take your steel burnisher, well-tempered, & with a little oil burnish your niello as firmly as the work would seem to admit of, and with due discretion in every case. The only object of this burnishing, is to stop up certain bubble-holes* that sometimes come during the process. You've only got to have patience enough, and with a little practice you'll find this burnishing stops all the holes up beautifully.

After this, take your knife & touch up the intaglio. Then to finish with take some Tripoli powder and pounded charcoal, & with a reed peeled down to the pith, scrub your work till it is smooth and beautiful.

Oh thou discreetest of readers, marvel not that I have given so much time in writing about all this, but know that I have not even said half of what is needed in this same art, the which in very truth would engage a man's whole energies, and make him practise no other art at all. In my youth from my 15th to my 18th year I wrought a good deal at this art of niello, always from my own designs, and was much praised for my work.

* *Spugnuzze.*

CHAPTER II. ON FILIGREE WORK.

THOUGH I don't work much in filigree myself, I have none the less done one or two very difficult and very beautiful pieces of work in this line, and so I'll say something about it. The art is a charming one, and when well executed & well understood is as pleasing to the eye of man as anything done in goldsmithing. Those who did the best work in filigree were the men who had a good grip of drawing, especially designing from foliage & pierced spray work, for everything that you set to work upon requires first of all that you think it out as a design. And though many have practised the art without making drawings first because the material in which they worked was so easily handled and so pliable; still, those who made their drawings first did the best work. Now give ear to the way the art is pursued.

Innumerable are the purposes to which you may apply filigree. So first of all we will begin with some of the ordinary every-day things & then have a look at such other things as will make a man's mouth water. The more ordinary use to which filigree is applied, is for buckles and pins for belts, such as I told of in the introductory chapter of my book. Then is it used, too, for making crosses & earrings, small caskets, buttons, certain kinds of little charms and divers manner of necklaces; these latter are often worn with fillings of musk, as is also frequently the case with bracelets; & so an endless other variety of things. Now it is necessary that for everything that you want to execute in this line of work, you must to begin with make a gold or silver plate exactly in the way you want your work ultimately to be. After this is done, and of course, after you have made your drawing, have ready all the different kinds of wire of which you will have need, such for instance as thick and thin & middling, the usual three sizes, in due sequence, and perhaps a fourth size likewise. Then have ready some '*granaglia*'—granulated metal—for so the stuff is called; and in order to make this, you take your gold or silver, melt it, and when it is well melted, pour it into a pot of powdered charcoal. In this way every kind of granulated metal is made.* Then, too, you must have your solder prepared and ready to hand, and the right solder

* *Fine granules of gold are made by cutting gold wire into short lengths, mixing the cut pieces with charcoal, placing the mixture in a crucible and then heating the whole up to the melting point of the metal. Afterwards the charcoal is washed away, and the gold granules (which have been fused into a round form) sorted according to size by sifting.*

to use is the 'terzo' solder, so called because you make it with two ounces of silver and one of copper. Now though many are accustomed to make solder with brass, be advised that it is much better to make it with copper, and less risky. Take heed that you file your solder very fine, then put to every three parts of solder one of well ground borax, and, having well mixed them, put them in a borax crucible* such as a goldsmith uses. Then have handy some gum tragacanth,† a sort of gum which you can buy at any apothecary's. Dissolve this gum tragacanth in a little cup or vase, or whatever is convenient. When you have all these things in order, you will also need by you two pairs of stout little pliers, and also a small sharp chisel cut angularly,‡ like the wood-engravers use; but its handle ought to be short, the length & size of the handle of a graver. For its object is to cut the wires in accordance as you may wish to twist them either one way or the other, as your design requires, or your taste determines. You will also need a copper plate fairly stout, very smooth, and about the size of the palm of your hand. When you have twisted your wire into the shapes you want, you must place it bit by bit on the copper plate, and so bit by bit with a camel's-hair brush streak it over with the solution of gum tragacanth, arranging at the same time the little gold & silver beads tastily. During the time that you are piecing together your bits of leaves and other particles, the tragacanth water will hold them together sufficiently to prevent their moving. Then every time that you have composed a part of your spray-work, and before the tragacanth water has got dry, throw a little soldering powder out of your borax upon it, and put just as much as may suffice to solder your spray work, & not more. The object of putting just enough on, is that the work when soldered shall be graceful and slender, for too much solder makes it look fat.

Hereupon, when it is time for soldering, you will need in readiness a little stove, such as is used for enamelling, but since there is a great difference between the melting of enamel & the soldering of filigree, you will need to heat this furnace with a much smaller fire. Then attach your work to a little iron plate, but so that the work stands free above it, and put it little by little to the heat of the furnace, until the borax shall have fumed away, & done as is its wont. Now too much heat would move the wires you have woven out of place, so it is essential to take the greatest possible care,—really it's quite impossible to tell it properly in writing : I could explain it all right enough by word of mouth, or better still show you how it's done—still, come along—we'll try and go on as we started !

* Borraciere : perhaps a borax pan. † Dragante.
‡ Uno scarpelletto augnato.

11

When you are ready to begin soldering, and want to make your solder flow, put your work in the furnace, & place beneath it a few little pieces of well-dried wood, fanning them up a bit with your bellows. Then it is not a bad thing, too, after this to throw a few coarse cinders upon the fire, & this done at the right moment does a deal of good. But it is practice and experience, together with a man's own discretion, that are the only real ways of teaching one how to bring about good results in this or in anything. When your work is soldered, that is to say if it be silver-work, you must to begin with, cook it in tartar* mixed with some salt or other, and cook it so long till all the borax is off it. This ought to last about a quarter of an hour, by which time it will be quite clean, & free from borax. If on the other hand it be made of gold, you must put it in strong vinegar for about 24 hours, until you see a little salt forming upon it. And so, after this manner can you fashion all sorts of rosettes that may be needed in your work, such as I have not only seen, but myself made, and that give much variety to the work, when you have ordered them each in their place, and in accordance with your design.

But now I'll tell you yet something further about the cunning of this charming art; I'll tell you of a wonderful and priceless work that was shown me in France, in Paris, their most beautiful & richest city—which the French, according to their language, call 'Paris simpari,' that is to say ' sans peer,' or without equal. It was in the service of King Francis in the year 1541. This most royal and splendid of Kings retained me in Paris, and gave me of his liberality a castle, standing in the city itself, and called by the name of the ' little Nello.' Here I worked for four years, the which will be recounted all in its place when I come to tell of the great works which I made for this most worthy King. Here I will continue my talk as to the way of working in filigree, and as I promised, tell of a work most rare—a work such as may perchance never again be executed—which I saw in this city. One day—a solemn fête day—the King went at Vespers to his ' Sainte Chapelle' in Paris. He sent word to me that I was to be at Vespers too, as he had something nice to show me. When Vespers were over the King called me to him through the Constable, who sometimes represents the King himself. This gentleman came, took me by the hand, & led me before the King, who with great kindness and affability began to show me the most beautiful trinkets and jewels, and briefly asked me my opinion on them. After these he showed me a variety of ancient camei about as big as the palm of a large hand, and asked me many things about them, on which I gave him my opinion. They had stood me in the middle of all of them;—

* ' *Gomma di botte,*' i.e., *tartrate of potash.*

12

there was the King, and the King of Navarre his brother-in-law, and the Queen of Navarre, and all the first flower of the nobility, & of those that came nearest to the crown ; & before all of them his Majesty showed me many beautiful & priceless things, about which we talked for a long time to his great delight. Thereupon he showed me a drinking bowl without a foot & of a middling size, wrought in filigree with the choicest spray-work, upon which much other ornamental detail was admirably applied. Now list to my description of it ! In among the spray-work and interstices of filigree were settings of the most beautiful enamel of various colours ; and when you held it to the light these enamel fillings almost looked as if they were transparent—indeed it seemed impossible that such a piece of work should ever have been made. Thus at least thought the King, & asked me very pleasantly, since I had thus highly praised the bowl, could I possibly imagine how the work was done. I thereupon answered his question thus : 'Sacred Majesty,' quoth I, 'I can tell you exactly how it is done, even so much so that you, being the man of rare ability that you are, shall know how just as well as the master himself that made it, knew, but the explanation of the methods that underlie its making will take rather a long time.' At these words of mine all the noble assembly that waited on his Majesty thronged around me, the King declared he had never seen work of so wondrous a kind, and since it was so easy of explanation, bade me tell as I had promised. Then spake I : 'If you want to make a bowl like this, you must begin by making one of thin sheet iron, about the thickness of a knife back larger than the one you want ultimately to produce in filigree. Then with a brush you paint it inside with a solution of fine clay, cloth shearings & Tripoli clay* finely ground ; then you take finely drawn gold wire of such a thickness as your wise-minded master may wish that of his bowl to be. This thread should be so thick that if you beat it out flat with a hammer on your clean little cup, it bends more readily in the width than otherwise, in such a way that it may then be flattened out to a ribbon shape, two knife-blades broad, & as thin as a sheet of paper. You must be careful to stretch your thread out very evenly, & have it tempered soft, because it will then be easier to twist with your pliers. Then with your fine design before you, you commence to compose your stretched thread inside the iron bowl, first the principal members, according to their way of arrangement, piece by piece painting them over with solution of gum tragacanth, so that they adhere to the clay-solution with which you pasted the inside. Then when your craftsman has set all his principal members and larger outlines, he must put in the spray work, each piece in its place, just as the design guides him, setting it spray by spray, bit by bit in the

* *Tripolo.*

13

way I have told you. And then when all this is in proper order, he must have ready his enamels of all colours, well ground and well washed. It is true you might do the soldering first before you put in the enamel, & you would do it in the way that I explained above when I considered the soldering of filigree work, but it's as good one way as the other, soldered or not soldered. And when all the preliminary work is carefully done, and all the interstices nicely filled with the coloured enamels, you put the whole thing in the furnace, in order to make the enamel flow. To begin with you must only subject it to a slight heat, after which, when you have filled up any little openings with a second coat of enamel you may put it in again under a rather bigger fire, & if it appear after this that there are still crannies to be filled up, you put it to as strong a fire as the craft allows and as your enamels will bear. When all this is done you remove it from the iron bowl, which will be easy by reason of the paste of clay to which the actual work and the enamels are attached. Then with a particular kind of stones called "*frasinelle*," and with fresh water you begin the process of smoothing it down, and you must go on with this so long till the enamel is polished down to an equal thickness throughout and as may seem good to you. And when you have got as far as the "*frasinelle*" can take you, you may continue your polishing with still finer stones, and lastly with a piece of reed and tripoli clay (as I explained it in niello work), then the surface of your enamel will be very smooth and beautiful.' When the admirable King Francis heard all this description of mine, he declared that they who knew so well how to explain, doubtless knew still better how to perform, & that I had so well pointed out to him the whole process of a work that he had erst thought impossible, that now, owing to my description, he really thought he could do it himself. And therewith he heaped great favours upon me, such as you can't possibly imagine.

CHAPTER III. CONCERNING THE ART OF ENAMELLING.

NOW let us have a talk about the beautiful art of enamelling, and therewith consider those excellent craftsmen who wrought best therein ; and with the knowledge of their lovely creations before us see what is beautiful and what is difficult in this art, and get to understand the difference between what is really good and what is indifferent. As I said in the first chapter of my book, this art was well practised in Florence, and I think too that in all those countries where they used it, and pre-eminently the French and the Flemings, and certainly those who practised it in the proper manner, got it originally from us Florentines. And because they knew how difficult the real way was, & that they would never be able to get to it, they set about devising another way that was less difficult. In this they made such progress, that they soon got according to popular opinion the name of good enamellers. It is certainly true that if a man only works at a thing long enough, all his practising makes his hand very sure in his art : & that was the way with the folk who lived beyond the Alps.

As for the right and proper way about which I intend to talk, it is done in this wise. First you make a plate either of gold or silver & of the size and shape that your work is to be. Then you prepare a composition of ' *pece greca*,'* and brick ground very fine, and a little wax ; according to the season ; as for the latter you must add rather more in cold than in hot weather. This composition you put upon a board great or small in accordance with the size of your work, & on this you put your plate when you have heated it. Then you draw an outline with your compasses in depth rather less than a knife-back, and, this done, ground your plate anywhere within this outline and with the aid of a four-cornered chisel to the depth which the enamel is to be, and this you must do very carefully. After this you can grave in intaglio on your plate anything that your heart delights in, figure, animals, legend with many figures, or anything else you like to cut with your graver and your chisels, and with all the cleanness that you possibly can. A bas-relief has to be made about the depth of two ordinary sheets of paper, and this bas-relief has to be sharply cut with finely-pointed steel tools, especially in the outlines, and if your figures are clothed with drapery, know that these folds, if sharply drawn and well projecting, will well express the drapery. It is all a ques-

* *Probably powdered resin ; in Hendrie's ' Theophilus' it is given as common white pine resin from which the oil has been evaporated over hot water.*

tion of how deeply your work is engraved, and the little folds & flowerets that you figure on the larger folds may go to represent damask. The more care you put into this part of your work, the less liable your enamel will be to crack & peel off hereafter, and the more carefully you execute the intaglio the more beautiful your work will be in the end. But don't imagine that by touching up the surface of your work with punches and hammer, it will gain anything in the relief, for the enamels will either not stick at all, or the surface that you are enamelling will still appear rough. And just as when a man cuts an intaglio he often rubs it with a little charcoal, such as willow or walnut wood, which he rubs on with a little saliva or water, the same you may do here when you cut your intaglio in order to see it stand out better, because the shine made by the metal tools on the plate will make it difficult for you to see your work. But, as owing to this the work gets a bit untidy and greasy, it is necessary, when you have finished it, to boil it out in a concoction of ashes* such as was described above for niello work.

Now let us say you want to begin enamelling your work, and that it is in gold. I propose telling you first of how to enamel on gold, and then how to do it on silver. For both gold and silver the same cleanness is necessary, and in either case the same method, but there is a little difference in applying the enamel and also in the actual enamels applied, for the red enamel cannot be put on silver because the silver does not take it. The reasons of this I would explain, were it not too long a business, so I'll say nothing about it, especially as to do so would take us beyond the scope of our inquiry. Furthermore I have no intention of talking about how enamels are made, because that in itself is a great art, also practised by the ancients, & discovered by wise men, but as far as we are aware the ancients did not know of the transparent red enamel, which it is said, was discovered by an alchemist who was a goldsmith as well. But all I need tell of it is that this alchemist, while engaged in the search of how to make gold, had mixed together a certain composition, and when his work was done, there appeared among the stuff in the metal rest of his crucible a sediment of the loveliest red glass, just as we see it to this day. After much time and trouble, & by many mixings of it with other enamels the goldsmith finally discovered the process of making it. This enamel is far the most beautiful of all, and is termed in the goldsmiths' art 'smalto roggio,' red enamel, or in French 'rogia chlero' (rouge claire) that is to say, and which means in other words, red and clear or transparent. A further sort of red enamel we have also, which is not transparent and has not the splendid colour, and this is used on silver because

* Bollirlo in una cenerata.

16

that metal will not take the other. And though I have not had much practical experience of it, I have tried it often enough to be able to talk about it. As for the other, it lends itself more aptly to gold by reason of its being produced from the minerals and compositions that have been used in the search how to make gold. Now let us return to the process of enamelling.

The method of enamelling is much the same as painting, for you can have as many colours as come within human ken. And just as in painting so in enamelling you have them all ranged in order and all well ground to begin with. We have a proverb in the craft which says: *Smalto sottilé e niello grosse.*' 'Enamel should be fine, niello should be coarse,' and that's just what it is. You put your enamel in a little round mortar of well-hardened steel, and about the size of your palm, & then you pound it up with very clean water and with a little steel pestle specially made for the purpose of the necessary size. Some, to be sure, have pounded their enamels on porphyry or serpentine stone, which are very hard, & moreover have done this dry, but I now think that the steel mortar is much better because you can pound it so much cleaner. The reasons of this we may consider later, but because we want here to be as brief as possible & to avoid any unnecessary difficulties and useless confusion, all we need know is that the particular mortars in question are made in Milan. Many excellent men of this craft came from Milan and its adjacent territory, and I knew one of the best of them. His nick-name was Master Caradosso,* and he never wanted to be called by any other, and this nickname was given him once by a Spaniard who was in a great rage because he was kept waiting by the Master for a piece of work which he had promised to get finished by a particular day. When the Spaniard saw that he could not have it in time, he got so fearfully angry that he looked as if he would like to do him an injury, at which Caradosso to appease his wrath, began excusing himself as best he could, and in such a plaintive tone of voice, and such an uncouth Milanese lingo, that the irate nobleman burst out laughing, and looking him straight in the face, cried out in his high & mighty manner: '*Hai cara d'osso,*' that is to say, 'You bum face.' The sound of this appellation pleased Caradosso so much that he never would answer to any other. When later on one fine day he found out what it really meant, he would gladly have got rid of it, but he couldn't, it was too late. I knew him as an old man of 80 in Rome, where he was never called by any other name than Caradosso. He was a splendid goldsmith, especially at enamelling, and I shall have more to say of him later on.

* *His real name was Ambrogio Foppa.*

Now let us proceed with the beautiful art of enamelling. As I said above the best way of pounding the enamels is in a little steel mortar with water. I found out from personal experience that the best plan as soon as the enamels are ground is to pour off the water in which you grind them and put the powder in a little glass, pouring upon it just so much aqua fortis as may suffice to cover it; & so let it stand for about one-eighth of an hour. This done, take out your enamel and wash it well in a glass bottle with very clear, clean water until no residue of impurity be left. You must know that the object of the aqua fortis is to clean it of any fatty, just as fresh water is to clean it of any earthy impurities. When your enamels are all well washed in this way, you should put each in its little jar of glass ware or majolica, but take great care that your water is so contained that it does not dry up, because if you put fresh water to them your enamels will spoil at once. Now pay great attention to what I'm next going to tell you. If you want your enamels to come out properly you must take a nice clean piece of paper, and chew well between your teeth, that's to say if you've got any,—I couldn't do it because I've none left,—so should have to soften it and beat it up with a little hammer of iron or wood, whichever might be best; this done you must wash out your paper putty, and squeeze it till there is no water left in it, because you will have to use it as a sponge and apply it from time to time upon your enamels. The more your colours dry up during the process the better they will look afterwards. Then, too, I mustn't forget to tell you another important thing which will also affect the good or bad enamelling of your work, and this necessitates your trying a piece of experimental work first.

To this end you take a plate of gold or silver, whichever material you elect to cut your intaglio upon, and on this experimental piece,—let us suppose it is gold,—put all the different colours with which you intend to work, having made as many little hollows with your graver as there are enamels. Thus you take a little bit of each, and the only object of this is to make the necessary preliminary trial, for by this trial you find out which run easy and which run hard, because it is very necessary that they should all run alike; for if some run too slowly and others too fast they would spoil each other, and you would make a mess of your work. All those preliminaries done, you may set to work at your enamelling; lay the nice clean colours over your engraved bas-relief just as if you were painting, always keeping your colours well covered up, and take no more out of one bottle than you can conveniently use at a time. It is usual, too, to fashion an instrument called a *palettiere* (palette holder), this is made out of thin copper plate, & in imitation of fingers, it should not be bigger than your fingers, and there should be five or six of them.

18

Then you take a lump of lead in the shape of a pear, with an iron stem to it, which would correspond to the stalk of the pear, and then you put all your bits of copper which you have hollowed out somewhat, one over the other on your pear stem. And this little finger-shaped palette you stand beside your work, and you put your enamels upon it, one by one, using due care. How careful you have to be with this cannot be told in words alone—you'll have to learn that by experience!

As I said above, enamelling is similar to painting; though the mediums in the two sorts of painting in colours are oil & water, while that of painting in enamels is by dissolving them with heat. To begin with then, take your enamels with a little copper palette knife, & spread them out little by little very carefully over your bas-relief, putting on any colour you like, be it flesh colour, red, peacock blue, tawny, azure, grey or capucin colour, for that is what one of the colours is called. I don't mention yellow, white & turquoise blue, because those colours are not suitable to gold. But one colour I forgot, and that was 'Aqua Marina,' a most beautiful colour, which may be used for gold as well as for silver. Then when you have all your enamels of all colours placed in the best of orders, you have to be careful in the first coat, as it is called, to apply them very thin and neatly, and just as if you were painting in miniature you put each in its place, exactly where it is to be. This done, have your furnace in order, & well heated with charcoal. Later on I will tell you further of furnaces and point out which are the best of the many different ones in use; but now let us assume that you have in it a fire sufficient for the purpose of the work you have before you. Then having your furnace as I say, in its place, you must put your gold work on an iron plate a trifle larger than the work itself, so that it can be handled with the tongs. And you must so ply it with the tongs and hold it to the mouth of the furnace, that it gets warm gradually, then, little by little, put it into the middle of the furnace, but you must take the greatest possible care that as soon as the enamel begins to move, you do not let it run, but draw it away from the fire quickly, so, however, that you do not subject it to any sudden cooling. Then, when it is quite cool, apply, just as carefully as before, the second coat of enamel, put it in the furnace in the same way, this time to a rather stronger fire, and draw it forth in the same manner as before. After this if you see your work need further touching up with enamel in any of its corners, as is often necessary, judgment and care will show you how to do it. For this I advise you to make a stronger and clearer fire, adding fresh charcoal, and so put your work in again, subjecting it to as strong a heat as enamel and gold can stand. Then rapidly take it out, and let your 'prentice be ready, bellows in hand, to blow upon it as quickly as possible and so cool it. This you have

to do for the sake of the red enamel, the '*smalto roggio*' of which we spoke above, because in the last firing it is wont to fuse with the others, and so to make new colour effects, the red, for instance, going so yellow that you can scarce distinguish it from gold. This fusing is technically called '*aprire.*' When it has once more cooled you put it in again, but this time with a much weaker fire, until you see it little by little reddening, but take great heed that when it has got the good colour you want, you draw it rapidly from the fire & cool it with the bellows, because too much firing will give it so strong a colour as to make it almost black.

When you have duly carried out all these processes to your satisfaction, take some of your '*frassinelle*'—these were the bits of stones or sand that I described before when I told you about King Francis' filigree bowl—and with them smooth your work over until you get the proper effect. Then finish by polishing it with tripoli as I showed you above, also in the filigree bowl. This method of finishing, which is by far the best and safest, is called hand-polishing, in contradistinction to a second method by which, after you have your work smoothed with the '*frasinella*' and then well washed with fresh water so as to remove from it all dirt, you put it again on to the iron plate and into a clear fire and thus slowly heat it. In this method, by which you get the effect of polish much quicker than with the other, you leave the work in the fire till it is hot, and the enamels begin to run; but its disadvantage is that, as the enamels always shrink a bit, and shrink unequally in the firing, you cannot get so even a surface as by the hand-polishing. You have to take the same precautions, too, as you took when firing your '*roggio clero,*' or red enamel. In the event of your not employing the latter—as would be the case on silver—you must take great care to observe the same precautions in putting your work in, but do just the opposite in taking it out of the fire, that is to say draw it very gradually from the furnace, so that it cools very slowly instead of very rapidly as was the case with the red enamel. Of course you may have to enamel a lot of pieces, such for instance as little pendants, and bits of jewelry, and other such things, where you are not able to use the '*frasinella*' at all. Things of this kind, fruit, leaves, little animals, tiny masks and such like, are applied in the same way with well-ground and washed enamels, but cannot be similarly polished because of their relief.

And if by reason of the great time and labour and patience you spend upon the doing of all this your enamels begin to dry up, and thus fall off in turning your work, this you may remedy in this wise: take a few quince seeds, which you get by cutting the fruit through the middle,

choose such as are not empty, and let them soak in a vase with a little water; this you should do over night if you want to enamel the next morning, and you should be careful to do it very clean. Then when you want to apply your enamels, having put a morsel of each colour on your palette (the finger palette I described to you above fixed on to the stem of your leaden pear) you mix with every bit of enamel you lay on your work, a tiny drop of this quince-seed-water, the effect of which is to produce a kind of gum which holds the enamels together so that they don't fall, & no other gum has a like effect. For the rest, all you have to do is to carefully carry out the methods I have so far explained to you, and whether your enamel be on gold or silver, except in so far as I have told, those methods are the same.

CHAPTER IV. JEWELLERY.

NOW let us discuss jewellery, and of what pertains to precious stones. Of such there are four only, and those four are made by the four elements, the ruby is made by fire, the sapphire most obviously by the air, the emerald by the earth, and the diamond by water. In its due place I shall have something to say of the virtue of each. But what we have before us here is to talk about what pertains to the setting, in pendants, bracelets, rings, tiaras and crowns. We will leave diamonds till the last, because they are the most difficult of all stones to treat, and the reason of this is that while of other stones set in gold each one has its foil, of which more anon, the diamond of certain varieties has a tint which has to be specially prepared at the back of the stone, according to the peculiarities of each; and in their place will I tell you the loveliest things about them.

We will begin with rubies, of which there are various sorts. The first is the oriental ruby, which is found in our side of the Levant and near home; this part of the Levant, indeed, produces rarer and more beautiful jewels than any other lands. These Levant rubies have a mature colour, they are deep and very fiery. The rubies of the West on the other hand, though still red, lean towards peacock colour and are somewhat sharp and crude. Northern rubies are sharper and cruder still, while those of the South are quite different from the others, but so rare that they are very seldom to be met with, so I will mention one of their peculiarities only, they have not the same grand colour as the Levant ruby, but verge somewhat upon that of the ballas,* and though this has not the beautiful suffused colour it is none the less fiery, and so grand is it that they seem perpetually to scintillate by day, and by night throw out a gleam akin to that of a glow-worm, or other little creatures that shine in the dark. True it is that these southern rubies do not always possess this wonderful quality, but so delightful are they to the eye, that your good jeweller easily tells them from the others, the name carbuncle is, however, only applied to the very rare ones, and those that shine in the dark. As soon as we have considered, from personal experience, and from the experience of others, what are the best ways of setting jewels, we will talk of the qualities of the stones themselves. But I have a thing or two to say in order not to scandalize a certain class of men who call themselves jewellers, but may be better likened to hucksters or linen-drapers, pawnbrokers, and grocers; I have seen more than enough of wondrous sam-

*Balaschio.

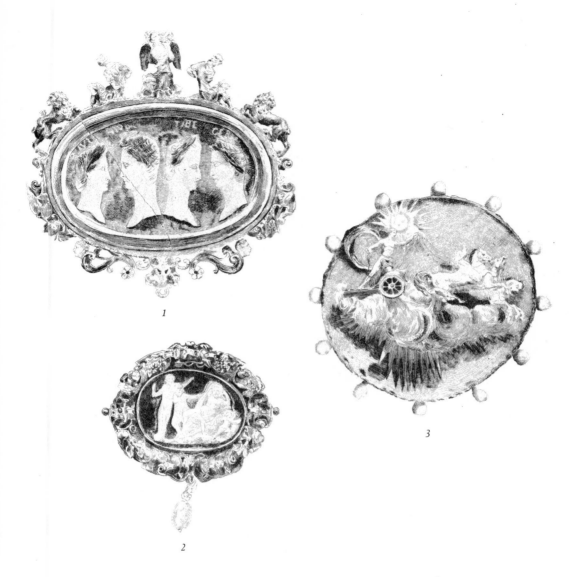

JEWELRY THAT HAS BEEN ATTRIBUTED TO CELLINI.

(1) Antique Roman cameo (sardonyx field; 35×54 mm) with busts of Julius Caesar, Augustus, Tiberius and Germanicus (names added at later period). Setting of enameled gold, attributed to Cellini, features bas-relief trophies and lions and—modeled in the round—Fame between two chained captives; these three figures seem to have been executed in the manner described by Cellini when discussing his medals of Atlas and Hercules (see p. 48). In the Cabinet de France.

(2) Antique Roman onyx cameo mounted on crystal; represents Bacchus (supported by Silenus) discovering Ariadne. Setting of enameled gold, with pendent pear-shaped pearl. Not readily attributable. In Florence.

(3) Apollo in his chariot drawn by four horses, modeled in the round above a gold cloud that is covered with reddish enamel. Apollo and horses enameled in white, with gold reserved for god's hair and horses' manes. Chariot and wheels in blue enamel with gold rim. Field bright blue enamel, bordered with pearls. Very possibly by Cellini. In the collection of the Duc d'Aumale in the Château de Chantilly.

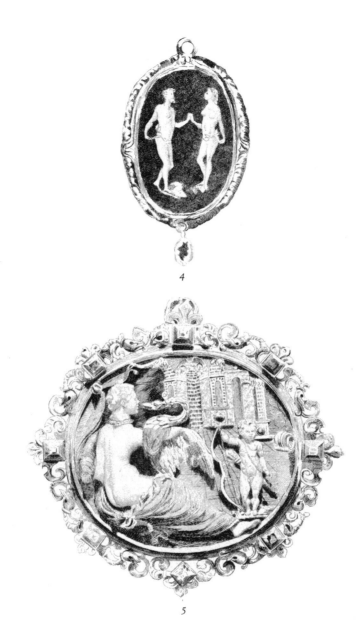

4

5

JEWELRY THAT HAS BEEN ATTRIBUTED TO CELLINI.

(4) Medallion representing Adam and Eve. Figures in enameled gold on false
emerald field. Setting of enameled gold, with pendent emerald. Attribution uncertain.
Formerly in the Collection Debruge-Dumesnil.

(5) Leda and the swan. Cameo on gold field adorned with enamels, diamonds
and rubies. In Vienna.

ples in plenty of them in Rome, and there you may still see them to this day, with a maximum of credit and a minimum of brains. So what I say is out of respect to these dunderheads lest they should be shocked at my affirming that the real stones are of four sorts only, and thus wag their arrogant tongues at me & cry, 'How about the chrysoprase or the jacynth, how about the spinell, how about the aqua marine; nay, more, how about the garnet, the vermeil, the crysolite, the plasma, the amethyst, ain't these all stones and all different?' Yes, and why the Devil won't you add pearls, too, among the jewels, ain't they fish bones? I really don't think it worth while to try and cope with veritable empty-headed ignoramuses, but I will say that there are many, very many, like them, and that your great princes are mainly to blame for encouraging them, since they quite put themselves in the hands of such men, and so not only do injury to themselves, but undervalue men that walk in the right way and do excellent work. But let us pass from this little digression & consider what is most beautiful and most rare in jewellery; a digression merely entered into because I don't want ignorant men to jeer at me for having said nothing of the ballas and the topaz. The ballas is a ruby with but little colour, as if it were a kind of feminine form of the stone, called in the West the ballas ruby, but it is of the same hardness, and so a gem of the nature of the ruby, and differing from it only as to cost. The like holds good with the topaz, in its relationship to the sapphire, it is of the same hardness as the sapphire, and though of a different colour must be classified with the sapphire, just as the ballas must be with the ruby—what better classification do you want? hasn't the air got its sun?

Of these four sorts of stones, the ruby, the sapphire, the emerald, and the diamond, you must know that the first is far the most costly. A ruby, for instance, of five grains of wheat, & of as fine a fire as you could wish, would be worth about 800 golden scudi, and an emerald of the same size and beauty would run to about 400, similarly a diamond would be worth 100, & no more, while a sapphire would fetch about 10. These few facts I thought might be worth having to all those many youths always springing up and eager to learn the beautiful art of the goldsmith. To be sure, they ought to begin learning as soon as they can toddle, & use that greatest of all opportunities which is afforded by apprenticeship to some Master of renown, whether in Rome, in Venice, or in Paris. In all of them did I sojourn for a long while, and in all of them did I see and handle many and invaluable pieces of jewellery.

CHAPTER V. HOW TO SET A RUBY.

WE will now continue our talk & consider the way of setting a ruby, and the box of gold in which it has to be fitted. This box, whether in a pendant, a ring, or what not, is always called the bezel. What you have first of all to observe in the setting of the stone in this bezel, is that the former must not be set too deep, so as to deprive it of its full value, nor too high, so as to isolate it from its surrounding detail. I mention this because I have seen mistakes made in both ways, and I am certain that practising jewellers who have a right knowledge of drawing and design would not go wrong in either the one direction or the other.

So let us place our fine ruby into its bezel. In order to what is technically called 'set'* it, we must provide ourselves with four or five ruby foils † of which some should be of so deep a glow that they seem quite dark, and others differing in intensity till they have scarce any red in them at all. With all these different specimens of foils before us, we take hold of the ruby with a piece of hard black wax well pointed, pressing the wax upon one of the projections of the stone. Then your good jeweller tries his ruby now upon this foil, now upon that, till his own good taste determines him which foil will give most value to his stone. Sometimes the jeweller will find it may help him to move the stone to and from the foil, but he has to recollect that the air between the foil & the stone will always give an effect different to that afterwards given when the stone is set in the bezel where no air passes behind. Therefore your capable man places the cut foil in the setting, at one time bringing it close, at another interposing a space. Thereupon let him set his jewel with all the care, taste & delicacy of which an able man is master.

* Legare. † Literally leaves that are of themselves red.

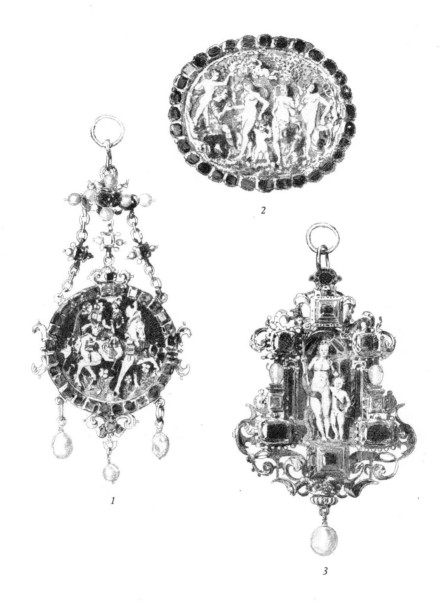

JEWELS FROM THE COLLECTION OF BARON FERDINAND DE ROTHSCHILD, LONDON,
ONCE ATTRIBUTED TO CELLINI.

*(1) Enameled gold pendant with knight (holding falcon) and lady on horseback.
Circular frame of rubies. Triple gold chain with cross of six pearls with precious stone
in center. Three pendent pearls. Country of origin uncertain.*

(2) Enameled gold brooch representing Judgment of Paris. Framed with rubies.

*(3) Enameled gold pendant, adorned with rubies and pearls, representing Venus and
Cupid. Pendent pearl. Possibly by Théodore de Bry (1528-1598), who worked at
Frankfurt am Main.*

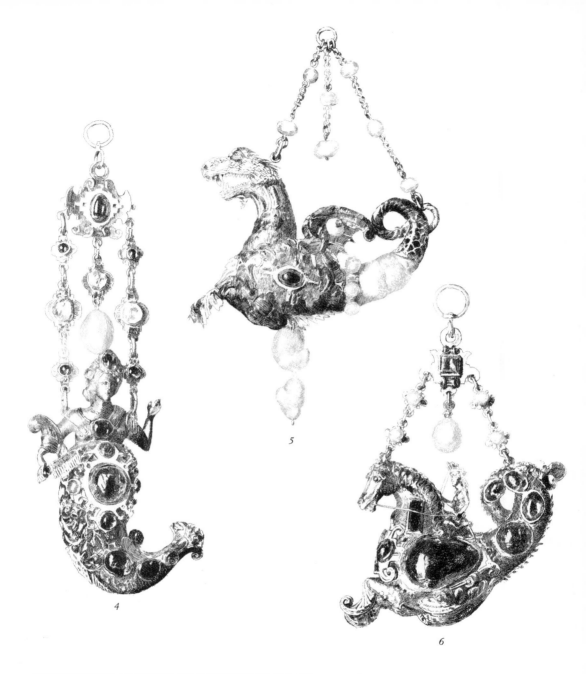

JEWELS FROM THE COLLECTION OF BARON FERDINAND DE ROTHSCHILD, LONDON,
ONCE ATTRIBUTED TO CELLINI.

(4) *Enameled gold pendant, adorned with emeralds, representing a siren. Chains set
with gems and pendent pearl. Cabochons in siren's body. Possibly Italian or Spanish
work.*

(5) *Chased gold pendant, adorned with pearls and enamels, representing a dragon.
Similar to engraved designs by Hans Collaert.*

(6) *Chased gold pendant, enameled and adorned with pearls and gems, representing
a fantastic seahorse. Thirteen emeralds* en cabochon. *Possibly Spanish work.*

CHAPTER VI. HOW TO SET AN EMERALD AND A SAPPHIRE.

NOW, as to the emerald and the sapphire, the same skill must be used with the foils adaptable to them as with those of the ruby. And because I consider that practice always has come before theory in every craft, and that the rules of theory, in which your skillful craftsman is accomplished, are always grafted on to practice afterwards, I will give you a case in point of what once happened to me when I was setting a ruby of about 3000 scudi in value. This ruby had, when it came into my hands, been very well set at different times by some of the best known jewellers of the day. So I was incited to work at it with all possible care. Seeing that I could in no way satisfy myself with the result of my efforts, I locked myself up somewhere where no one could see me; not so much because I did not wish my secret to go further, but because I did not want to be caught trying so mean an experiment upon so goodly and wonderful a gem. I took a little skein of silk stained with Kermes, and with a pair of scissors cut it carefully, having previously spread a little wax in the bezel. Then I took the tiny bit of silk and pressed * it firmly on to the wax with the point of a small punch. Then did I put my ruby upon it, and so well did it make, and such virtue did it gain, that all the jeweller folk who had seen it first, suspected me of having tinted it, a thing forbidden in jewellery except in the case of diamonds, of which more anon. But for this ruby, some of the jewellers asked me to say what kind of a foil I had put behind it, upon which I answered that I had put no foil behind it. At this reply of mine, a jeweller who was with the gentleman to whom the ruby belonged, said, 'If the ruby has no foil, you can't have done anything else but tint it in some way or other, and that you know is forbidden.' To which I replied again that I had neither given it a foil, nor done anything forbidden to it. At this the jeweller got a little nasty and used strong language, at which the gentleman who owned the ruby said, 'Benvenuto, I pray you, be so good, provided I pay you for it, to open your setting and show it to me only, I promise you I'll not tell anyone your secret.' Then said I to him that I had worked several days on the job, and that I had my living to earn, but that I would willingly do it if he paid me the price of the setting, and, moreover, do it in the presence of all of them, because I should be much honoured in thus being able to teach my teachers. When I had said this, I opened the bezel and took out the stone in their presence. They were very much obliged, we parted very good friends, and I got

* *Calcai—possibly : 'I frayed.'*

very well paid. The ruby in question was a thick one, & so limpid and luminous that all the foils you put beneath it gave it a sort of uncertain flash, like that which shimmers from the girasol opal, or the cat's-eye, two kinds of stones to which the dunderheads, of whom I told before, would also give the name of gems.

Now a word about the emerald and the sapphire, in both which gems one meets with the same peculiarities and difficulties as with the ruby, so I know of but little to say about them than that they are stones that are often falsified, which should be a warning to those who delight in gems or buy them, whether to set or to keep. There is a kind of Indian ruby with as little colour as you can possibly imagine, and I once saw a ruby of this nature falsified ever so cleverly by one of these cheats. He had done it by smearing its base with dragon's blood, which is a kind of composition made of a gum that will melt in the fire, and that you can buy at any apothecary's in Florence or Rome. Well, the cheat had smeared the base of the stone with dragon's blood, & then set it in such a way that it showed so well, you would gladly have given 100 golden scudi for it; but without this colour it wouldn't have fetched 10, and have been much more likely to come out of the setting. But the colour looked so fine, and the stone seemed so cunningly set, that no one unless very careful, would have spotted it.

It happened one day that I was with three old jewellers to whom I had expressed my doubts as to the genuineness of the stone, so they made me unset the ruby and they stood round me greedily watching, ready to pounce upon it. As soon as I had done it they all three jeered at me for my wisdom and said another time I should open my eyes better, for it was obvious that this stone was set by a good man, who wouldn't do such a thing, and who knew his business right well enough. At these words of theirs I held out my hand, and begged them to let me see and have proof of my mistake, adding that if this time my good eyes had failed me, it might be because I was less keen-sighted than they, but I promised it shouldn't happen again. When I had the ruby in my hand I soon saw with my sharp eyes what their dullness had missed, and quickly taking a little steel tool I scraped off the bottom of the stone. Then might that ruby have been likened to the crow that tricked itself out in the feathers of the peacock. I returned the stone to the jewellers and suggested to them that they would do well to provide themselves with eyes somewhat superior to those they were at present using. I couldn't resist saying this because all three of them wore great big gig-lamps on their noses, whereupon they all three gaped at each other, shrugged their shoulders, and, with God's blessing, made off. You come across similar

26

difficulties and occurrences with emeralds and sapphires which I will omit, as I have other things of more importance to tell of.

I mind me also of having seen rubies and emeralds made double, like red & green crystals, stuck together, the stone being in two pieces, and their usual name is ' doppie ' or doublets. These false stones are made in Milan, set in silver, and are much in vogue among the peasant folk ; the ingenuity of man has devised them to satisfy the wants of these poor people when they wish to make presents at weddings, ceremonies, and so forth, to their wives, who of course don't know any difference between the real and the sham stone, & whom the little deceit makes very happy. Certain avaricious men however, have taken advantage of a form of industry, made partly for a useful, and partly for a good end, & have very cunningly turned it to great evil. For instance, they have taken a thin piece of Indian ruby, and with very cunning setting have twisted and pieced together beneath it bits of glass which they then fixed in this manner in an elaborate & beautiful setting for the ring or whatever it was. And these they have subsequently sold for a good and first-class stone. And forasmuch as I don't tell you anything unless I can illustrate it by some practical example, I'll just mention that there was in my time a Milanese jeweller who had so cleverly counterfeited an emerald in this way that he sold it for a genuine stone and got 9000 golden scudi for it. And this all happened because the purchaser—who was no less a person than the King of England—put rather more faith in the jeweller than he ought to have done. The fraud was not found out till several years after.

Emeralds and sapphires are also manufactured out of single stones, and this so cleverly that they are often difficult to tell, but however wonderfully they are counterfeited in colour they are so soft, that any good jeweller with the average amount of brains, can easily spot them. I could tell you ever so much more about all this, but it must do for the present, because I have to pass on to a lot of other important and useful things.

CHAPTER VII. HOW TO MAKE FOILS FOR ALL SORTS OF TRANSPARENT JEWELS.

IN order to make good foils for jewels it is essential to have steel tools, and all of the best and of the most finished description. Then, as you may suppose, for an undertaking of such importance you need the greatest possible care and patience, together with the greatest possible neatness. Long ago, when I was a lad of fifteen and began to learn goldsmithery, I knew a master in the art whose name was Salvestro del Lavacchio. This man only did stone-setting, & specialised on the making of his own foils for all sorts of gems. Though the foils from France and Venice and other places often showed up more splendidly, experience proved that they were not as lasting as Lavacchio's, which were always thicker. For this reason the setting of the gems upon them was often more difficult than on the foreign foils, but so strong were they, and so telling to the gems, that as soon as they became a bit known, he got orders from all over the world and soon had no time for anything else but foil-making. Indeed it requires all a man's energies to do this, so I thought I would give a few facts about it for the benefit of anyone anxious to learn. The first foil is called the common foil, it is of a yellow colour and is used for many jewels and transparent stones. But first a word as to the weight of a carat, which is a weight of four grains. The foils may be stated in weights thus:—

COMMON (YELLOW) FOIL.

9 carats of fine gold.
18 ,, ,, silver.
72 ,, ,, copper.

RED FOIL.

20 carats of fine gold.
16 ,, ,, silver.
18 ,, ,, copper.

BLUE FOIL.

16 carats of fine copper.
4 ,, ,, gold.
2 ,, ,, silver.

GREEN FOIL.

10 carats of fine copper.
6 ,, ,, silver.
1 ,, ,, gold.

Melt the copper well first and then put in the two other metals; when they are well mixed cast them into a fairly long ingot mould, and don't make it too thick.* When it is cast let it cool, then file it well, after which beat it very lightly and with the broad end of a hammer, often heating it again as you go on, but putting it in water, not cooling it with the bellows. And when you have beaten it down to about the thickness of two knifebacks; flatten it with a strong rounded scraper,

*Lo gitta in uno canale un boco largo, e non fare la verga molto grosso.

and pare off the edges quite smoothly till no crack remain. Then, when you are spreading it out, see that both it and your hammer be even, smooth, and burnished, and with every possible care make it as thin as you can, as, according to its nature, the metal will rend; the size of it should be about a couple of fingers, or a little longer, and the square should be of such dimensions as your metal will afford. Also mind that the size is such as you propose to make when your work is completed. But as, in beating, it will rend and crack, see that you watch this, and cut it accordingly, and to the utmost thinness possible. And all these pieces you must blanch, clean, and polish with tartar,* salt, and water, which is the blanching liquor ordinarily used for silver. Then wash in clear water, rub with a clean rag lightly, and then scrub it on a big copper tube that must be very clean and shining.

See that you scrape it with the sharpest of all possible goldsmiths' scrapers, and do this with the greatest care in order that you do not mark it with notches. Then take it with a very clean and white cloth, and have by you a graver that shall be well sharpened on an oil stone, and clean off everything in the nature of grease or dirt. It is needful, when burnishing it, to be in a room where there is no dirt. Get a black hæmatite stone† such as the sword cutlers use for burnishing gold. When you have polished it very well give it its colour. This you do over a moderate and clean fire, keeping your piece of foil near the said fire, and take care that of the two sides, the unburnished one turns to the fire. Gradually you will see the colour come according as it takes the heat. It is necessary to vary the colour as need requires.

Pope Clement gave me the commission to make the button for his cope.‡ This morse I made about the size of an ordinary plate; but because of all its wealth of figure work I had better talk of that later when I treat of embossing and the many difficulties of that art. For the present I will consider only the jewels with which it was enriched. In the middle of the morse I set a diamond the facets of which were cut starwise to a point, for which Pope Julius II. had given 36,000 ducats of the Camera. I set the stone quite free (*à jour*) between four claws, in this manner did it seem to me to make better. I had given this setting a good deal of thought, but the stone was of such exceptional beauty that it caused me much less trouble than costly stones of similar character are wont to do. True, some jewellers were of a mind that it would be better to tint the whole base of the stone

* *Gomma.* † *Amatita nera.*
‡ *This great piece, perhaps Cellini's masterpiece, was melted down in the present century.*

and the back facets,* but with my good results I got them to see that it was much better thus. Together with the diamond, and around it, were two large ballas rubies and two big sapphires, splendid stones, and four emeralds of a goodly size. To all these stones did I apply those same careful methods of which I have spoken above, thereby satisfying not only the Pope, but also the practising artists. For, previously, at the beginning of the work, and before I set to at the diamonds and the other stones—for they were right difficult to handle—certain old fossils in the art had, part in envy, part speaking true, sought to scare† me away from the job. 'Verily,' said they, 'we know you to be sure enough in all that pertains to design & to the embossing of an excellent piece of work, but when you set to the tinting and arranging of such costly jewels, why, 'twill make the teeth chatter in your head with fright.' Now I'm not the sort of fellow who's afeard of any mortal thing, but I must say that this somewhat emphatic way of expressing their astonishment made me pause a bit. But I minded me of those gifts from God Himself, & which come to a man without any toil of his own; comeliness for instance, or strength, or handiness, and to me methought God had given surety of purpose. So much was this so, that I could afford to turn laughing away from all their silly prattle. The tale of Phœbus came to my mind, and how at the outset he had sought to fright his son Phæton from wishing to guide the chariot of the sun; but then, you see, when all was done, I was luckier than Phæton, for I did not break my neck, but came out of it with much honour and profit to myself.

*Pàdiglione: or in English, pavilions. †Spaventavano.

CHAPTER VIII. ON THE CUTTING OF THE DIAMOND.

A S we have now said enough of the three gems, ruby, emerald, and sapphire, we must perforce consider at greater length the diamond. Now, though the diamond is said to be kin to water, let no man suppose that this need imply an absence of colour, perfume, and taste such as would be the case in good water. Just as water may have both colour, perfume, and taste, even so the diamond; not that the diamond actually *has* perfume or taste, but it has colours as many as nature herself. I propose here only to mention two, and these diamonds about as splendid as it is possible to imagine. The first was a stone I came across in the reign of Pope Clement, a diamond literally flesh-coloured, most tender, most limpid, it scintillated like a star, and so delightful was it to behold that all other diamonds beside it, however pure & colourless, seemed no longer to give any pleasure and to lose their gratefulness. The second was a stone I saw in Mantua, it was green, & green such as you might see in a very pale emerald, but it shone just like any diamond, and as no emerald ever shone; indeed it seemed the most glorious of all emeralds. Though I have seen all imaginable colours in diamonds, the mention of these two may suffice.

Now for just a word about the cutting of the diamond, that is to say on the changing of the stone from its roughness into those lovely shapes so familiar to us, the Table, the Facetted, & the Point.* Diamonds you can never cut alone, you must always do two at a time on account of their exceeding hardness, no other stone can cut them; it is a case of diamond cut diamond. This you do by means of rubbing one against the other until a form is obtained such as your skilful cutter may wish to produce, and with the diamond powder that falls from them in the process, the final polish is subsequently given. For this purpose the stones are set in little cups of pewter† and held against a wheel by means of certain little pinchers prepared on purpose, and they are thus held with their dust mixed with oil. The steel wheel upon which the diamonds are cut and finished should be about the thickness of a finger, & the size of an open hand and of the finest steel excellently tempered. This wheel is fastened to a hand mill and turned round as fast as it is possible to turn it. Four to five diamonds, or even six, can be applied to the wheel at the same time, and by bringing to bear a sufficiently heavy weight you can increase the pressure of the diamonds upon the wheel and give greater grip to the dust which wears them away, and so they are finished. I

* *In tavola, a facette, e in punta.*　　　　† *Piombo e stagno.*

could tell you a deal more, and all about the ways of cutting, but because it is not in my own craft, I will not bore you with it; 'tis sufficient for me to have given a general sketch of the method in question.

To return however to the subject we have in hand, I will say something of the tinting of the diamond, of its setting in gold, and of the variation between one stone & another on account of the above-mentioned colours. However great the variety of these colours is, the wondrous hardness of the stone is similar in all cases, or at least the variation is so slight that the process of cutting is the same. With the greatest possible care will I show how I set about making tints for diamonds, and give likewise a number of instances, on various exceptional occasions, that I have come across in diamonds of great importance: it is only owing to experiences such as I have passed through that one is able satisfactorily to show the great difficulties that stand in the way of those who wish to make them fine settings. I will begin with one occasion when Pope Paul III. of the house of Farnese was given a diamond by the Emperor Charles V.,—'twas when he returned from the capture of Tunis & paid a visit to the Pope in Rome. The diamond in question was purchased in Venice by certain servants of the Emperor's for 12,000 scudi, and it was set merely in a plain and simple bezel with a little claw. *
In this fashion it was given by the Emperor to the Pope, as soon as he visited him, & I heard tell that he gave it as a sign of his goodwill and friendliness, the latter receiving it courteously with the same spirit. Now forasmuch as the Pope, for a month previously, had ordered a present to be prepared for the Emperor, worthy to pass between them, he had held much counsel on the matter with many, and so called for me, and asked me in the presence of his Council, but quite privately, to give him my opinion on the matter. I straightway said that, inasmuch as the Pope was the veritable head of the Christian religion, and the veritable vicar of Christ, the most fitting gift from the Pope to the Emperor seemed to me to be a fine Christ of gold set upon a ground of lapis lazuli, an azure stone from which they make ultramarine; the foot of this crucifix I said should be of gold & set with jewels, and of such value as should please his Holiness. And because I had, with great care, already executed three gold figures that might serve for the base of this cross, & because they symbolised Faith, Hope, and Charity, and were already completed, the suggestion pleased the Pope mightily, and he bade me set to & make a model of what I proposed, for him to see.

At this model I wrought for a day and a half, and then brought it to him completed. Pleased as he had been at my suggestion, he was simply

* *Gambo.*

32

Solid gold breviary cover (approx. 9 cm high), adorned with diamonds, rubies, emeralds and enamels. Front cover: Adoration of Magi (under arch); four Evangelists in corners; winged angel's head, bottom center. Back cover: Resurrection (under arch); four women of Gospels in corners; death's-head, bottom center. Spine: Creation; birth of Eve; original sin. Book contains 13 miniatures depicting life of Christ and autograph signatures of several European rulers. Possibly made by German craftsman in Cellini's studio. In the Museum of the Castle of Friedenstein, Gotha.

*Pure gold breviary (box-) cover (9×6 cm), with bas reliefs and heightened
with translucent champlevé enamels and opaque enamels. Rings for tying book to one's
belt. Front cover: allegorical figures, including bathers at fountain. Back cover:
Garden of Eden, with birth of Eve. Spine: décor of daisies (thus this cover was
probably done for a Princess Marguerite, either the sister or daughter of Francis I).
Book is lost. In South Kensington Museum.*

delighted when he saw the model, and determined to give me the job; we clinched the bargain in no time, I was paid the earnest money and bidden to bestir myself. I strained every nerve to bring this beautiful work to being, but so it was, I was hindered from finishing by certain beasts who had the vantage of the Pope's ear. 'Tis a thing that often happens, this, with all princes; the worst men in the whole court are often the best listened to, and these fellows believe for them what they don't even believe themselves. One of these men whispered such evil things into the Pope's ear, that he got him to believe that it would be better to make a present to the Emperor of a breviary of the Virgin in miniature that had been made for the Cardinal Hippolitus de Medici as a gift to the Lady Julia Gonzaga, that this little book should be bound in a cover of fine gold set with what variety of stones might please his Holiness, and that the Emperor would like this much better, because he could make a present of it to his wife the Empress. And so it came that the Pope got so gammoned, that he was dissuaded from the crucifix, and bade me make the little book, which I accordingly did.* When the Emperor arrived in Rome, I had not yet put the finishing touches on the book because it took some time before they made up their minds about it; none the less the cover was visible, as it had all been put together, and it looked splendid with all its gorgeous jewels set upon it. Then the Pope sent to let me know that I must have it in order as well as I possibly could within three or four days, as he wanted to show it, incomplete as it was, to the Emperor, and that he would excuse me to the latter for not having completed it, on the plea of illness. As for that I will speak of it in its place.

After this the Pope with his own hands gave me the diamond he had received from the Emperor, told me to take the measure of his forefinger and make him a ring as richly wrought as possible and as quickly as ever I could. Off I hurried to my workshop, and with the greatest dispatch and in the space of two days produced as rich a ring as was ever made. Now Pope Paul had waiting in attendance on him a number of Milanese who patronised a certain Milanese jeweller, Gaio by name. This Gaio came before the Pope, and all off his own bat, without ever having been as much as asked, 'Holy Father,' quoth he, 'your Holiness knows that by profession I am a jeweller, & that I am better skilled at my craft than any man ever born. Now your Holiness has given Benvenuto a diamond to set, and the diamond is one of the most difficult stones in the whole world to set, and this particular diamond is more difficult than any other diamond, and it is a very beautiful stone, and a very costly stone & withal

*The illustration given is probably not of the breviary in question, but it is a reasonable Cellini attribution.

33

a very delicate stone, & Benvenuto is a very young man, and though he is enthusiastic enough about his art, & apt enough at his work, the tinting of so precious a stone is rather too tough a bone for tender gums like his. In my opinion your Holiness would do well to commission two or three old and tried jewellers to go and look Benvenuto up & not let him tint the diamond without their advice. It was a jeweller called Miliano Larghetta of Venice, your Holiness, who tinted and set the stone as your Holiness has it at present. This was an old man, and never did any one better know how to fix foils and tint stones.'

Weary of this plaguey babbler, the Pope told him he might go and do what he liked & thought best. So off the fellow went to look for Raphaello del Moro the Florentine, and Guasparri Romanesco, both of them men of great cunning in the matter of jewels; with these two he came to my shop on behalf of the Pope. Then did he begin to babble so tiresomely that I could scarce contain myself. The other two talked sense & were decently civil, so I turned to them in my politest manner, explained to them my views and begged them to let me have a couple of days to prepare a few tints to try this lovely stone, for this could only do good. In the first place by trying a few rare tints for the diamond, I might be able not only to teach myself, but lure on others who were following the art, & in the next place the stone might so gain at my cost, that it might delight them, do the Pope a service, and bring much credit to me. All the time I was giving them my reasons, that insolent beast of a Gaio kept fidgeting about with his feet and his head and his hands, ever and anon interjecting the most irritating words, so that I very nearly lost my temper altogether. But the others, men of sense they, managed it so that I got the time I asked for. As soon as they were gone, I set to like anything to make my tints, and this is how I did it.

CHAPTER IX. HOW YOU TINT A DIAMOND.

TAKE a very clean lamp with its cotton wick as white as possible, its oil, too, should be old, sweet and clear, then stand it on the ground, or, if you like, between two bricks. On the top of the two bricks put a concave copper disc, its upper surface cleanly polished, and its under surface acted upon by the flame to a third part of it, but not more. Be careful that only a very little soot collects on the disc at a time, because if too much soot comes, it may catch fire and be no use to you. Then, from time to time, while the flame smokes, take a little smooth paper and brush the smoke soot off the disc into a clean vessel. You may know that the soot doesn't catch fire till it grows to a coat the thickness of two big knife backs, so you needn't fear to let it smoke itself to a thickness of one knife back at a time. Then you take mastic,* a sort of gum that every apothecary sells, not, however, too fresh; you may know the fresh gum by its being bright and pale; on the other hand it mustn't be too old, and the old gum you will know by its being yellow and dry, and of little substance. When you have chosen the right sort of mastic, neither too fresh nor too dry, you proceed to select from it the roundest and cleanest grains, because, you know, when they fall from the tree they are apt to absorb earth and other impurities. All this done, as I have told, you put a little pan of live charcoal on the bench, and heat at it some small pointed steel instrument, with which you proceed to spike one of the mastic grains, not, however, spiking it right through the middle. This you then hold nearer and nearer to the fire till it begins to get hot, when you quickly, with a little spittle on your fingers, squeeze the hot mastic grain; the result of this squeezing will be a tear-drop, as limpid and pure as you can possibly imagine. Then quickly cut it off with a pair of scissors from the dirty part of the grain, and save it in a clean place. This process you repeat till you have as many mastic tears as you need.

Then you set to and make your linseed oil, & this is how you do it. You pick out the cleanest and best grains, grains without insect holes and perfect, and place a handful at a time on a porphyry stone, or a very clean copper or iron plate. On this you spread the grains, and place over them an iron plate about one finger thick and five fingers square, this plate having been previously heated so that it would singe paper, but no hotter. To the weight of it you add the pressure of some great hammer, and then you will soon begin to see the oil oozing out of the grains, but you

* *The varnish resin, commonly called gum mastic.*

must mind that your iron is neither too hot nor too cold, for if it be too cold the oil won't ooze out, and if too hot it will be scorched up and bad, but if well-tempered the oil will be admirable. Then ever so carefully you lift up the plate and the grains, and with a clean knife scrape off the oil. You have also to note that what is first pressed from the grain is a little water, this you will tell by its running to the edges of the stone, while the genuine oil remains in the middle. Then you take the oil and put it into a clean glass vase. Next you have also to provide a little sweet almond oil; and some folk use olive oil two years old, not more, and very sweet and clean. Then you want a spoon about four times the size of an ordinary spoon, and have in readiness your pan of live charcoal. You put your tear drops of mastic into the spoon, and, with a very clean silver or copper spoon, you begin to melt them over the fire. When your mastic is melting you add a little of the grain oil to it, in proportion about one part of linseed to six of mastic, and so mix the two liquids together, then apply the third, be it oil of olive or almond. After they are fused you add a little purified turpentine, and finally the lamp-black you prepared to begin with, putting just so much & no more, as you need for your tint.

Divers sorts of diamonds require some a darker, some a lighter tint; some again need a softer, some a harder tint, and so it is necessary, whenever you are setting a diamond of great importance, to try it with the hard and the soft, or with the dark and the light in accordance with the quality of the stone and the judgment of the good jeweller. Some have put as little lampblack as possible when tinting a diamond that seemed too yellow, and have instead mixed with their tint indigo, a blue colour known to every painter. They have even let indigo entirely take the place of lampblack, & this did they do when they tinted a diamond that looked like clear topaz. In these cases was a dark tint applied with admirable effect, and for this reason, by mixing the two colours, blue and yellow, they make green, hence the yellow diamond with the blue tint made an admirable water; and, if it be well applied, it becomes one colour, neither yellow as heretofore nor blue owing to the virtue of the tint, but a variation, in truth, most gracious to the eye. Inasmuch as all stones have, then, to be treated in accordance with the ability of the master and the quality of the stone, the cunning with which you treat them will depend on the amount of your experience in the art applied to each particular stone, and each several occasion.

Now to return to that big diamond, a notable example of its kind, that I set for Pope Paul, and which I had only to tint, because the setting was already made. As I told you, I had asked Rafaello, Guasparri and Gaio to allow me some two days' space; during this time I made a set of experi-

ments in tints, and by great labour produced a composition which made a much finer effect beneath the diamond than had been made by the master, Miliano Targhetta. And when I had made sure that I had beaten so admirable a man, what did I do but set to work anew with still greater energy to see if I could not beat even myself. As I told you above, this particular diamond was a most peculiarly difficult one to manage because of its subtlety,* and the good jeweller is he who produces his effect with the tint alone without having recourse to the reflector,† about which I shall have occasion to speak in its place.

When I had quite satisfied myself I sent to fetch the three old jewellers, and when they arrived I had arranged all my tints in order for them. When the three appeared that presumptuous Gaio marched into the shop first, and seeing all my apparatus neatly ranged about for the purpose of tinting the stone in their presence, he straightaway began wagging his head, pumping about with his hands, and chattering. 'Benvenuto,' said he, 'all this is mere sillyness, mere bagatelle, you just turn up again that tint of Master Miliano's, and apply it, and don't lose any time about it, because we haven't any to waste, owing to all the important commissions we have to execute for the Pope.' At this Raphaello seeing that I was just about to fly into a most terrible passion, interposed; he was a good fellow was Raphaello, and also the oldest of them, and he began to say soothing words to me, encouraging things, and such-like, and so just calmed me in time. The other man also, Master Guasparri Romanesco, in order to put a damper on that beast of a Gaio, he too began saying things, funny things which didn't come off, because I wasn't in a mood for funny things. After a bit, perceiving that I was getting to be a source of quarrel between the three men, I turned to them and spake thus: 'God Almighty,' said I, 'has, with the gift of speech, granted to mortals four different ways of expressing themselves, and these are they: the first is called *to reason*, which means to explain the reason of things in a sensible way; the second is called *to talk*, which means to make words, words of good import that is, and which, if they don't explain the reason of things, may yet be in the way of doing so; the third is called *to chatter*, and that means to say things of little value, funny things that sometimes please, and that don't hurt you; the fourth is just to *grasshopper gabble*,‡ and nothing more, and that's what people do who hav'n't got any sense in their heads at all, and want to show it off as much as they can. So, my good friends, I will just reason with you, and expound to you my rea-

* *Sottile;* i.e., *the refinement of the water.* † *Specchietto.*
‡ *Elsewhere, in one of his minor treatises on the arts, Cellini defines this word* 'Cicalare' *as the chatter of birds, a murmur of neither concord nor discord.*

sons. Master Raphaello, of a sooth, has talked elegant words, sound words; Master Guasparri, to cheer us up, has chattered a few amiable and funny things, none of which have got anything to do with what we have in hand; Gaio, what has he done? why just drivelled in the most sickening way, but since his grasshopper gabble hasn't done me any special injury I'm not going to lose my temper over him, and shall just take no notice of him at all. So now I pray you, gentlemen, just to let me tint the diamond in your presence, & if my tint does not turn out better than Master Miliano's, I can still use his, and I shall have shown you how at least I have tried my best to improve it.'

Scarce had I finished these words of mine when that beast of a Gaio called out, 'So according to this I'm a driveller, am I?' Whereupon the good Raphaello began soothing him down with amiable words till the beast got a bit pacified; I meantime set to work with my tints upon the diamond. Raphaello and Guasparri were all agog to see me tint the diamond, and first I tinted it with my own tint, the first one, and this showed up so well that they were in doubt as to whether or not I had not surpassed that of Miliano; and they praised me abundantly. Then Raphaello turned to Gaio and said: 'You see, Gaio, that Benvenuto's tint, even if it has not surpassed Miliano's, makes a close second; and so 'tis always right to give encouragement to a young man like Benvenuto who tries to do well.' I turned to him, thanked Raphaello for his pleasant words, and said, 'Now, my good friends, we'll take out my tint, & in your presence put in Master Miliano's, and then shall we be better able to judge on which the diamond makes best.' I quickly took out mine & put in Miliano's. Raphaello and Guasparri said that the stone showed better with mine, and all three said that I should re-apply my tint as rapidly as I could before the impression was lost to their eyes. Whereupon I replaced mine quickly and handed it them. All three were agreed, and Gaio before all—his ass's face quite beaming up—and they declared most amiably that I was a clever fellow, that I had good reasons for my action, & that I had beaten Master Miliano's tint by a long way, a thing they never imagined possible. At this I made a bow, not without a little pride,* but so as not to be noticed, and said to them: 'Dear masters, since you have vouchsafed me such kind encouragement to so good an end, I am only too ready on my part to be judged by you, and since you admit that I have beaten Miliano, will you now decide whether or not I have beaten myself, only just give me a quarter of an hour's grace?'

Therewith I left them and went up to the attic of my house, where I had all in order that I wanted to do. What I did there I'll tell you now, I've

* *Baldanza: swelling, brag.*

38

not told it anyone yet, and it brought me much honour in this diamond, but it does not necessarily succeed in others, and cannot be done without much labour and experience. I took a fair sized grain of mastic, cleared it well of its skin as I told above, so that it was as pure and bright as possible, & with all imaginable delicacy, having well cleaned the diamond, spread it over the stone with the aid of a moderate fire. Then I let it cool, holding it tight with the tongs used for tinting. When dry and cool I had my black tint ready, spread the same carefully and before a gentle heat on the top of the clear coat of mastic. This method suited so well to the tenderness and peculiar water of the diamond in question, that it seemed to remove from it any internal imperfections & make of it a stone of perfect quality. Then down I ran and put it into Master Raphaello's hand. He uttered an expression of astonishment like you do when you see a miracle. The two others, Guasparri and Gaio, likewise expressed amazement, only more so, and praised me up to the skies, Gaio even so far let himself down as to begging my pardon. Then they said to me, all three of them together: '12,000 scudi was the worth of this diamond before, but, of a truth, it is worth 20,000 now.' We shook hands amicably and parted the best of friends.

CHAPTER X. HOW TO GIVE A DIAMOND ITS REFLECTOR.

IN order not to leave out any of the few things that I have mastered, we will now discuss what is termed the reflector* of the diamond. This reflector is put beneath such diamonds as are so delicate as not to be able to stand a dark tint, such as would turn them black. If it happen that their delicacy is not great, and their water is good, it is customary to give them the tint under the step facets alone, and to combine the reflector with this, and the result is admirable.

The reflector is made in this wise. You take a small piece of crystal glass, quite clean, and free from cracks or flaws. You cut it into a square of a size that shall fit into the bezel in which you propose to set your diamond; and you tint your bezel with the black tint of which we spoke above. Be careful to put the said reflector, the glass of which is tinted on the lower side only, in the bottom of the bezel, low enough to admit of the diamond standing over but not touching it, because if it does it will not reflect well.† This is how all the tenderest diamonds should be set, and beautiful they look, too. Beryls and white topazes and white sapphires, white amethysts, and citrine quartz,‡ are all set in the bezel with a reflector of this kind, if they are of a sufficiently important size. It must be borne in mind that no stones but diamonds will stand a tint at the back, because they turn black, and lose their splendour. So much for the reflector.

It is an extraordinary thing that the diamond, which is the most limpid and brilliant of all earthly stones, gains a thousand-fold in beauty when you, as it were, soil it with a black tint, while all other light stones, as soon as you touch them with a tint, lose their splendour, and turn black; forsooth this is owing to some occult power, some secret of nature in the diamond, which human imagination cannot penetrate. There are certain sapphires,

*Specchietto. † *This diagram may be taken to illustrate Cellini's description:* ‡ *Citrini.*

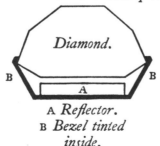

A *Reflector.*
B *Bezel tinted inside.*

40

which the ingenuity of man can turn white, by putting them in a crucible in which gold is to be melted,* and if not at the first heating, then at the second or third. Indeed your cunning gem-setter will always pick the palest sapphires, because, though they have the least colour, they are the hardest in substance. The same holds good of topazes, which are of similar hardness to sapphires, & so may be classified with them. I propose here only to touch on these two stones in so far as they have kindred qualities to the diamond. There are few, then, however great their experience, when having before them the two stones could tell which of the two was the diamond, often being unable to distinguish them at first sight. The peculiar virtue of the diamond, however, admits of the trying of a simple experiment, by which you can at once distinguish one stone from another, and it is this. You take your tint & rub both stones with it; your true diamond grows in brilliance & beauty, the other becomes deadened and splendourless. And this test suffices without trying the test of hardness too, but if you rubbed the two stones together you would soon find out the diamond. Though the sapphire is so much harder than the ruby & the emerald, it is a thousand times less so than the diamond. By the way, I need hardly mention that it would be absurd to test a polished gem by the above method. That's as much as I want to say about the diamond.

*Nel quale sia dell'oro che s'abbia a struggere.

CHAPTER XI. ABOUT WHITE RUBIES AND CARBUNCLES.

I PROMISED to tell you something about the finest sort of rubies, but before doing this, I want you to know something about another sort of ruby, called the white ruby. This stone is white by nature, not by any heating process like the other stones mentioned above, & its whiteness may be likened to the chalcedony, the twin sister of the cornelian. The latter has a sort of unpleasing livid pallor, & for this reason is not used much.

I have oft found many such in the bellies of wild fowl, so also the loveliest turquoises. I used to be very fond of going out shooting. I made my own powder, and became such a rare fine shot, that I should be ready to stand any test you like. I always shot with the simple ball, & as for the powder, well, I'll talk of that in its right place, but it was quite different from the powder commonly used. In this wise did I use to march over the Roman Campagna, at the time when the birds of passage return, and in their bellies I found stones of all sorts, turquoises, white & coloured rubies, also emeralds, & every now and again a pearl. But, as I said, these white rubies are of very little use ; only you know them for rubies because of their great hardness.

Of carbuncles : according to promise I'll tell you of these, & first of what I have seen with my own eyes. In the time of Pope Clement VII. there turned up a certain Raugeo, who was called Biagio di Bono. This man had a white carbuncle, similar to the white ruby mentioned above, but possessing so delightful a brilliance, that it shone in the dark, not so splendidly perhaps as the coloured carbuncles, but still so that when you put it into a very dark place it seemed as a glowing ember, and this did I see with my own eyes—but I must tell you in this connection an anecdote of a little old Roman gentleman—old, did I say ?—nay, very old, for his grandson was one of my shop assistants. This man came often to my place, & always had lots of pretty things to chat about. One fine day we fell a-talking about gems, and the old gentleman spake thus : 'Once when I was a young man, I happed to be in the Piazza Colonna, and I saw one Jacopo Cola, a distant kinsman of mine, coming along ; he was beaming all over, and he held out his closed fist to some friends who had been sitting on a bench hard by, and were just getting up. He spake thus to them : "What d'ye think, my friends ? I've made a good day to-day, for I've found a little stone so beautiful that it is worth many scudi, and I found it in my vineyard, and I suppose it must have belonged to our ancestors, because as you know this vineyard lies beneath the great ruins

familiar to all of you. Well, when I was coming home from work, & had gone about 200 yards, I was prompted to make water. As I was doing this and looking towards the vineyard, I fancied I saw a spark glowing at the foot of one of my vines; it seemed to me a perfect age before I could finish what I was about. When I did, I'm blessed if I could find anything, however hard I tried; so I thought I'd go back again & have another look, and keep my eyes fixed upon it, so back I went the same way, and then all of a sudden out burst the spark again. Well, I kept looking & looking at it, till, see here! I found this,"—so saying he opened his fist and showed his treasure. While he had been talking, a Venetian ambassador, who was coming along on his mule with a few servants, had stopped to listen. After a bit this gentleman came up close, as if he wanted to hear all about this wonder of a fire being transformed into a stone; then, very politely accosting my poor kinsman, "Gentlemen," said he, "If I am not presuming upon you, or appear to be taking too great a liberty, might I beg of this gentleman to allow me to look at the beautiful stone that he says he found in his vineyard." At these words Cola opened his fist, which he had kept locked up tight, & said to the ambassador: "There he is, look at him as much as you like!" The Venetian gentleman, who was a man of perfect manners, continued with the politest language: "If I am not appearing too presumptuous," he said, "I would make so bold as to ask if you, sir, are disposed to part with the stone, & if so, at what you esteem its value?" The poor Roman, whose coat was somewhat frayed & out at elbows—a fact which had given the Venetian pluck to drive his bargain—said: "Well, it isn't exactly that I've got to sweat for my daily bread, but if you're ready to pay the stone's value, I don't mind obliging you. Look at him well now, and see if you like him. I shall require ten ducats of the Camera for him." The Venetian simpered satisfaction for a bit, & then spake in the fashion of those polished gentlemen, much more polished than your Roman, who, though they are examples to the world in glory, are not up to your consummate Venetian in speech—they can't *out* with it fast enough: "One favour only I beg of you; I never carry much money in my purse, may I entreat you to send the jewel to me by some trusty servant of yours, & I will give him what you have asked." The poor Roman, who knew no trustier friend than himself, said he would go along with him personally, and winking to one of his mates, to whom he had told all his adversity, he strode off with the ambassador, who dismounted & walked beside him. Then the Venetian, in order to prevent the latter from repenting of his bargain, began chatting in the most delicious manner, in a manner such as only your Venetian can, & enough to take any Roman's breath away. The one listened, enjoying these exquisite nothings, the other prattled along as hard as he could, the journey really seeming an eternity to him. At length he reached his house, and

43

putting his hand into a purse in which he had a great pile of ducats of the Camera, he spread them out with open hand before the astonished gaze of the poor Roman; the latter, who had gone many a long year without seeing the like of such, feasted his eyes on this delicious looking gold, & then put the jewel in the ambassador's hand. One, two, three, the latter counted out the ten ducats, shouted in haste to his servants that they should saddle his good horse, & taking out two more ducats, called out to the Roman, who was just going off: "Here, I say, these two gold ducats I give you over & above our bargain, to buy a rope to hang yourself with!" The proud Roman couldn't make out why he was thus spoken to; he fired up, & wanted to make for the ambassador, but our fine gentleman quickly mounted his horse, and sped away from Rome. Later on it transpired that he had had the jewel beautifully set, and gone off with it to Constantinople, where a new prince had ascended the throne. Owing to the rarity of the stone, he asked and received for it a fabulous sum, with which he afterwards betook himself again to Venice.' That is all I ever heard of this kind of carbuncle.

CHAPTER XII. MINUTERIE WORK.

MINUTERIE work is all that class of work done with the punch, such as rings and pendents and bracelets. In my time, too, it was the custom, among other charming things, to make little medals of gold which were worn in the hat or the cap; and on these medals portraits were engraved in low or half relief, and in the round, and they looked just lovely. The greatest master in this art that I ever knew, lived in the times of the Popes Leo, Adrian, and Clement, and he was Caradosso of whom I told you above. Now will I tell you not only of the method which he adopted in his craft, but that which was employed by other masters. It was Caradosso's custom to make a little model in wax of the form he wished his work to be. When he had carefully finished the modelling of this and filled in all the undercutting, he made a cast of it in bronze of the proper thickness; then he beat out a gold leaf rather thicker, if anything, in the middle, and so as to admit of its being easily bent, and in surface some two knife-backs bigger than the surface of the model. This he proceeded to beat out into a slightly curved form, and to soften with heat, and then laid on to the bronze model, and with punches of the right sort,—wooden ones to begin with of birch or cornel,* the latter by preference—he very, very carefully followed the shape of his figure or whatever it was he was working on. Ever so much care is necessary while doing this to prevent the gold from splitting. And on you work, now with your wooden, now with your steel punches, sometimes from the back, sometimes from the front, ever most mindful to keep an equal thickness throughout, for if it become thicker in one place than in another, the work would not attain so fine a finish. It was just in this very getting of the gold so equal all over that I never knew a man to beat Caradosso. Well, then, when you've got your model worked up to the point of relief at which you want to bring it, you begin with the greatest cunning to bring the gold together over the legs and over the arms and round behind the heads of the figures & the animals, then, if, when all has been well worked together, there is still a little bit of gold loose at the edges, you carefully cut it off with a pair of scissors. And the little bits that stick out at the back of the legs and arms and heads, that is to say those in high relief, are likewise ever so carefully beaten down. By the way, I ought to have told you that your gold must be good, gold of at least twenty-two-and-a-half carats, but not quite twenty-three carat gold, for you'd find that a bit too soft to work in; and if it were less than twenty-two-and-a-half it would be too hard, and rather dangerous to solder.

*Cornus sanguinea, or dogwood.

And now for the soldering, if you've brought your work on so far. For this same hot soldering you take a little verdigris, the best you can get, from its original cake, nor must it ever have been used before, & it should be about the size of a young hazel nut without its rind, with it you put the sixth part of salts of ammonia and as much borax; when these three substances are well-pounded together you dissolve them in a glass of clear water. Then with a soft wood shaving you take the mixture, which will now have the substance of a paint, and spread wherever there are joint lines on arms, legs, heads, or on the ground of your work. After this you pepper a little more well-pounded borax upon them out of your borax castor, and then light a fresh fire of partly consumed-wood coal and put your work in the fire. See that your coals are set with their unconsumed sides away from it as they are apt to smoke. This done, erect a little grating of coal on top of your work, minding, however, that the charcoal does not touch the work itself. Be ready at hand when the charcoal is beginning to glow and your work is growing fire-coloured, to blow wind over it with your bellows very skillfully and very evenly, so that the flames may play all round it alike. If you blow too hard the fire will spring up and burst into flame, and you run the risk of melting and spoiling your work. Watching with care you will see the outer skin of gold begin to glow and then to move; as soon as you note this, quickly take a brush and sprinkle a little water on your work, which will there and then be beautifully soldered without any need of special solder being applied to it. And this one might call the first firing.

Indeed, the first soldering ought not to be called soldering at all, but rather firing in one piece, because there is so much virtue in the verdigris when combined with the salts of ammonia and the borax, that it only moves the outer skin of gold, and so fuses* it together that it all grows to one even strength After this you put your work into vinegar very strong and clean and mixed with a little salt, and in this you let it bide overnight. Next morning you find it bright and free of all borax.

After this you put a little stucco at the back of it so that you can work on it with your punches; and this stucco you make of Greek pitch resin with a little yellow beeswax, together with a little brick dust or well-ground terra cotta; and this is the real right sort of stucco on which you may lay your medals, or any other similar work you may have to chase. Then, as to your punches, you must have no end of these, from the broadest, getting smaller and smaller down to the very tiniest; and every one of these must have no sort or kind of cutting edge, because, you see, they are

*E con quello stesso lo ammarginano, a tale; che viene a essere per tutto una equal durezza.

46

only to be used for the purpose of beating in and not of taking away; and this beating in you have to do ever so delicately.

Now of a sooth shall you find that in the doing of this you will have made lots of little holes and rents, and these same have got to be soldered up. Not, mark you, in the way you did it before, but by the making of a special solder, and in this wise: You take six carats of pure and fine gold & put with it one-and-a-half carats of fine silver and of fine copper, melting the gold first, and then putting the others to it, and so you have your solder, and with it you may make good all your holes and rents. Note further, that at every fresh soldering you must introduce a fresh alloy of silver and copper* so as to prevent the solder of the time before from running together; and so on, too, in between each turn, out you take your work, press it on the stucco, & chase over it with your punches until you have wrought it to such finish as you may desire. And then you have the whole fair method of the Master Caradosso of whom I told you before.

Now I'll tell you of another fine way of working employed by other able men who ran him pretty close. After the model in wax has been made and you have decided what it is you want to create, you take a sheet of gold, as I explained above, thin at the sides and thick in the centre, and you little by little beat it from the back with your larger punches until it is bossed up much like your model; by this means you don't need to use your bronze,† and you bring your work considerably forward before even in the other method the casting is done. In the former method, too, you will have had, before each re-joining, to rub your medal down with glass paper (such stuff as the glass makers sell) in order to clean from it most carefully whatever matters the fumes from the bronze may have sullied the gold withal. But if you follow my second method you won't need to do this glass papering, because you won't be bothered by the nasty stains the bronze makes on the gold.

Whenever I can, while thus telling of my craft, I purpose giving you a practical example, which you know is always a much better way of explaining what a man means, & which will make those of my readers who

* *Or it might be rendered:* '*You must put in the ready-made solder a little of the alloy,' which is softer in the fire; each new soldered piece having to be softer than the last to avoid the running again of the earlier work: the alloy is presumably half copper and half silver, though Cellini does not say so; elsewhere he talks of one copper to two silver, so it might well be one carat of silver and the half carat of copper.*
† *Occorre adoperare il bronzo.*

are eager to learn and to practise and delight themselves in these divers methods, much more likely to believe what they read. In the manner above described I once fashioned a medal for a certain Girolano Maretta, a Sienese; and on this medal was a Hercules rending the jaws of the lion. Both Hercules and lion had I wrought in such high relief that they only just touched the background by means of the tiniest attachments. The whole work had been done in the second of the above methods, that is to say without the bronze models; now working from in front, now from the reverse, and brought to such a height of delicacy and finish of design that our mighty Michael Angelo himself came to my very workshop to see it, & when he had looked at it a minute or so, he, in order to encourage me, said: 'If this work were made in great, whether of marble or of bronze, and fashioned with as exquisite design as this, it would astonish the world; and even in its present size it seems to me so beautiful that I do not think ever a goldsmith of the ancient world fashioned aught to come up to it !' These words stiffened me up* just, and gave me the greatest longing to work, not only in the smaller things, but to try larger things also. For, thought I, words such as these, coming from so great a man, can but have the following meaning: Had the figures been tried on a large scale I should not have produced them with near such beauty as on a small; and while, on the one hand, the great man gave me so much praise, he, on the other, intimated that one who could do things in little of such merit might yet not be able to do them in great. But still, not so much because I imagined this to have been Michael Angelo's meaning, as that I had heard that he had expressed it in words to others, these words of his inspired me with longing to learn yet a thousand times more than I knew already.

This happened about a year after the sack of Rome; I was in Florence at the time. When I had made the medal, one of our Florentine gentlemen, by name Federigo Ginori, came & looked me up. He was a great lover of beautiful things, and especially fond of men of talent, to whom he was a great patron. In former days he had been many years in Naples on business, & there he had fallen in love with a great princess. On his return to Florence he bethought him of having a medal made, whereon to record this somewhat formidable attachment of his. So he came and found me out, and spake: 'Benvenuto, my well-beloved, I have seen a little medal by your hand made for Girolamo Maretta, and albeit I long to tell you that it is impossible for any medal to cap that one, yet for the love you bear me, make another for me, will you, if not more then at least as beautiful as that one ; and in this medal I should like to see an Atlas with the heavens on his back ; & I should like it all so exquisitely

* *Mi s'appicorno a dosso.*
48

done that it shall be recognised at once; & pray don't bother about any considerations of cost whatever.' I set to work and made a little model with all the diligence I could, fashioning the Atlas in question out of white wax. Then, having said to the gentleman that he might leave the working out to me, I determined to make a medal that should have a field of lapis lazuli, the heavens a ball of crystal, & engraven upon them the signs of the zodiac. So I made a plate of gold, and began, bit by bit to work my figure up in relief with all the patience you can possibly imagine. I took a small rounded stake,* and on this I wrought little by little, working up the gold from the ground with a small hammer, working right into arms and legs, & making all alike of equal thickness. In this manner, & with the greatest diligence and patience I brought the work to completion. This we call 'lavorare in tondo,' working in the round; that is without putting the figure on pitch, or such a stucco basis as I described above. It wasn't till I'd worked it up to a certain point that I then took my punches and continued it on the stucco with very great finish. Then little by little did I raise the figure off its ground,† which is a thing very difficult to explain how to do—still I'll tell you as best I can. Previously we saw how the arms & legs of the figure might be worked as one and part of the gold background, and thus make it possible for the background to be utilised as a fitting part of the design. Now, however, since the background is not needed as a part of the design, it may be used up; therefore with a small hammer on your little stake or anvil, & with the small end of the hammer you work gently on the gold, and with the action of the hand push the gold behind, using the punches as well, so that the figure comes up in high relief from the ground. In the other method where you left the figures on the ground, you didn't want them in high relief, but took care that your fine ground never got out of line; now, however, since you have no use for it, you can twist it about at will, care only being taken that sufficient gold is left for the attachments at the back, and when all the background is cut away you can proceed to fix your figure on to whatever independent background you may have devised for it. After this you give it a last coating of solder to finish up with, but without however laying your work on the stucco, for the simple reason that there are now no more open places for the stucco to go in. This is how I did the Atlas, & when I had finished him, I fixed him in those places where he was to touch the lapis lazuli background by means of fastening two little pins or stakes of gold, of sufficient strength, into holes made in the lapis, and so he was firmly set. Then I got a lovely crystal ball, of good proportion to my Atlas, engraved the zodiac thereon, and fixed it upon the nape of his neck, so that he held it high in his hands.

* *Tassetino tondo.* † *Spiccando dal suo campo.*

49

To end all I made a most sumptuous frame adorned with gold, full of foliage, fruits, and other conceits, and set the whole of my work within it. Nor ought I to forget a very pretty sentiment that had to be added in the shape of a Latin motto. My gallant, inasmuch as he was enamoured of so great a lady, and of rank so much loftier than himself, wished me to place on the medal the words '*summam tulisse juvat.*'

Some say that this gentleman died shortly after, though still quite in his youth, by reason of his love for the lady. As he had been a friend of Messer Luigi Alamanni, also a great lover of art, the latter at his death came into possession of the medal, & he, while at a later time on a visit to the King of France, made a present of the medal to the King. Then began the King to make most earnest inquiry as to whether he knew the master who had made the medal. Messer Luigi declared that he did not know him personally, albeit he was all along my very dear friend. King Francis thereupon began to have a great longing that I should come & enter his service, the which in the end I did. But of that I'll tell later on, all in its proper place, because that didn't happen till many years after.

I promised to speak in good time of a clasp that I made for Pope Clement to fasten his cope with. Now since I can't do your fine elegant manner of writing I'll tell about my craft as clearly as I can, and as well as my simple mind will permit it, and best of all, I'll give some more examples of things that happened to me—I shall be much safer if I do that. This clasp was a very big and a very hard job; for, albeit a small piece of work, there is little doubt but that these small pieces of work are often harder the smaller they are. The clasp was about the size of an open palm and circular in form. Within it was a design of God the Father giving the benediction. The head and arms of the Father were worked completely in the round, the rest was raised in good relief out of the background, and was surrounded by a number of jolly little angels, & of these some of them were peeping from out of His mantle, some were scattered about among jewels, of which I'll tell you first. These angel babies were some of them done completely in the round, others in high relief, others again in bas relief. And I so devised it that God the Father was seated on the big diamond, which had been bought it was said for 30,000 scudi. This suggests the reflection as to how much harder it is for a man to do a piece of work in which his design is limited by having to use special jewels or aught else in particular. Still for all that, you can do anything if only you set to work at it with all the love & the zeal that your noble craft demands of you, and so did I, and this is how I did it. I flattened out a sheet of gold about a finger's width wider than my work was to be, having first made a very highly finished model of it. Then I

50

began beating up the middle of the plate with my small hammers upon the stake; & now working with the narrow end on the front, now on the back, I gradually bossed up the gold, using the punches in like manner, till the figure little by little took shape; & so, little by little, first using one tool, & then another, I gradually mastered the material, till one fine day God the Father stood forth in the round, most comely to behold.

Pope Clement had got to hear that I worked in a method different from Caradosso, for certain envious men had told it to some of his suite, & by reason of their evil tongues the holy father imagined that I was an ignoramus and not up to managing so big a job. So he sent for me to come and show him the method in which I worked, and how far I had got. Straightway I went to him, bringing with me my work as far as it had got. God the Father stood out from it already & showed very well how He was going to look when finished. For my part I thought that the work in the metal excelled that in the wax, and so thought his Holiness also; and being the sensible man that he was, he turned to certain gentlemen of his suite & said: 'Great is the virtue of determination,* the more she is troubled with envy the more beautiful doth she become, & grows in despite thereof. I know but little of the technique of the work, but I am well assured that it is much more beautiful now than in the model I saw before: only I can't for the life of me see how you are going to get that crowd of angels on to this disc without spoiling what you have done already.' On this I described to the Pope the way in which I purposed to bring the angels to the fore, one by one, first those that were to be quite in the round, then those of less relief, working the gold up thick into the places where the highest relief was to be, in fact just as I had worked up God the Father, and employing hammers and punches alternately, now from in front, now from the back; and I showed him how the highest part of the relief was the hardest part of the work, and how the great art was to get the gold of as equal thickness as possible all over. Of course I know quite well that our good Master Caradosso worked in a different way, and indeed I learnt many goodly things from him; and for those who have learnt their craft, 'tis easy to put two and two together. But I'm of opinion that Caradosso's method of working on the bronze model would have been much more difficult to employ in this instance, would have taken a much longer time, would have needed ever so many botchings and solderings, & would have run all the risks of the fire into the bargain. Thus my experience was that by employing the other method you got rid of all these difficulties and had your work done much quicker.

*E gran cosa la forza che ha la virtù.

At these words of mine the good Pope, who was really an exceedingly capable man, said: 'Go, my Benvenuto, work in your own way, finish it for me quickly, and it shall be well for you; and when, from time to time, I bid you come, bring your work with you; not that I may instruct you thereon, but that I may have the joy of beholding such goodly handiwork as yours.'

The age of a good prince whose delight is in the encouragement of all beautiful things is the age for men of talent, and such a time came about in the days of the first Cosimo de Medici, who was their great patron. It was he who gave Fillippo Brunellesco, Donatello, & Lorenzo Ghiberti their opportunity. Filippo was as fine an architect as ever was; Donatello sculped in marble and in bronze, & even wrought wondrously in the difficult art of painting. Lorenzo Ghiberti made the bronze gates of S. Giovanni that have no equal in the world. Then came Lorenzo de Medici, under whom was developed Michael Angelo Buonaroti, most marvellous of men. He had scarce given proof as yet of his great powers when God willed that he should be called to Rome by Pope Julius II., who not only took pleasure in all that was beautiful, but also understood it, and so set Bramante, the architect, to work. Bramante, who, though a painter of little credit, had such a bent towards architecture in its grandest manner, that good Pope Julius, of his bountifulness, gave him lots of work and a salary of 1000 scudi a year to boot. Seeing how fond Pope Julius was of all kinds of beautiful work, and how he had a mind to have the inside of the Sistine Chapel painted, Bramante introduced Michael Angelo, who was then living in Rome almost unknown & of little account. The work was entrusted to him, & such goodly encouragement did he receive in the painting of that wonderful chapel that the grand manner of painting was as it were revived. Then came Pope Leo X., and at the same time Francis, King of France; and these twain ran it hard between them as to which should gather the greatest talent about him. Then came the luckless Pope Clement, and he helped and furthered the arts too, 'tis true, but he had so much adversity in his papacy, and there was so much trouble in the land, that he could never help as much as his kindly soul longed to do. I know well to tell of this for I served him during all his papacy, and was quite a young man at the time.

It was in connection with the work of which I have been telling you above that the Pope said he wished to see the designs and models of all those who thought themselves able to undertake the work; and this was soon after the great sack of Rome, and I had come thither from Florence, and when I heard the rumour of it, I too made me a model in white wax of the size the work was to be, & taking it with me presented myself be-

52

fore the Pope. Many artists were there showing the sketches they had prepared for this beautiful commission, & when I joined them the Pope had already seen a goodly number, and they were set before his Holiness by one Micheletto, a stone-carver, an able man enough in his own line. In all these divers designs their authors had so devised it that the big diamond was set in the middle of the breast of God the Father.* The Pope himself had suggested the motive of the design, but when he saw how everybody alike had set so great a stone into the breast of so tiny a figure he said: 'Why can't that stone be set in some other manner except always in the breast?' Whereupon some of them replied that it could not be set otherwise if right value was to be given to it in the design. The Pope, who was beginning to weary of so many designs, turned to me and asked if I had brought nothing to show; while I was still undoing my box the Pope turned to some of the older masters, and said to them: ''Tis always well to look at everybody's rendering of a thing: albeit Benvenuto is young, yet have I seen work of his that convinces me that he is in the right way.' Then when I had uncovered my model & put it before him; he had scarce seen it when he turned to me and cried out: 'You've hit it! that's how I want it done!' Then he turned to the others & said: 'See you now how this diamond can perfectly well be applied in another manner. Mark how Benvenuto has made a stool of it and seated his figure thereon; a better way of rendering it I can't conceive.' Straightway he had me paid 500 golden scudi, and with most courteous words bade me God speed to my work. And this was the beginning of such work as I—simple man as I am—have been enabled to do for the world.

You remember I promised in the beginning of my book to tell the causes that inspired me to write it, causes which will move men to great wrath & to great compassion for me. Well, I can't keep it locked up in my breast any more, I must out with it! I have just told how great princes give opportunity to men of genius, & cause to re-kindle through them the beautiful art of the past. Well, I make bold to say that Francis, King of France, was the greatest lover of genius & the most open-handed of any man that ever lived in the world. I was called to his Majesty when I was in Rome, and I joined him in the year 1540, being just forty years of age. This king gave me all sorts of goodly work to do, the which I will describe all in their place, according as their various methods demand.

During my time with his Majesty I made my first big works in sculpture and bronze, works of great size; never had I to ask him for pay or provision, but I just lived on his lordly liberality; for out of it he made me a

*See Cellini's Autobiography, Symonds' translation.

stipend of 1000 scudi annually, & gave me into the bargain a castle that is in Paris called 'Petit Nello,' wherein I served him four entire years. And forasmuch as there was great war in these parts, I begged grace of his Majesty to let me travel to Italy; which favour he accorded me, though none too willingly. In the end I left with his good will, and remained his creditor for 700 ducats of gold of my salary, & in addition all the stock and material for the great works I had been engaged on, the which amounted to about 15,000 scudi.

In my castle,* which I left under the guard of my two pupils, Pagolo Romano and Ascanio Napoletano, I left several great and small vases made of my own silver, not to mention a large vase all embossed with figures. This one I had made with the King's silver, & the others, as I have said, were made from my silver, & therefore mine. And over and above all this I left behind all the flower of the studies of my twenty years in Rome, and all the rich furniture of my house, which was such as to be worthy of hostting any noble lord or gentleman. The Bishop of Paira, who was a friend of mine, did I thus entertain, and bring away from the hostel where he was staying, during a long sojourn in Paris; & to many others too, in like manner, I gave abundant hospitality. I affirm that I came to Italy for no other purpose than to keep my six poor nephews, sons of my own sister; and I gave aid to all of them as soon as I was again among them. Before departing from Italy I went to seek out my lord the illustrious Duke Cosimo de Medici in order to pay him my respects, and ask his permission to return again to France. This amiable prince gave me as warm a greeting as could possibly be imagined, & intreated of me to make him a model for a statue of Perseus with the head of Medusa in his hand, telling me that he wished to erect the statue under one of the arches in the great loggia of the Piazza. This raised a mighty zeal for glory within me, & I said to myself: 'So is a work of yours to stand between one of Michael Angelo & one of Donatello, both of them men who surpassed the ancients in genius? What greater treasure could I desire than the honour of being set between these two mighty men?' And forasmuch as I knew that my studies in this art had by no means been slight, I promised myself that my work should hold its own beside theirs. In lightness of heart and full of energy I set me to a model of a Perseus about the height of a cubit, such as his excellency had comissioned; and when I had done it I took it to him, and he marvelled at it & said: 'Benvenuto, if you had the courage to do this thing in great as admirably as you have done it in little, I trow for a certainty that it would be the loveliest work in the Piazza.' These words moved me greatly, and in part with confidence for what I had already done, in part with great ambition for what I had still in mind to do, I said to the

*See Cellini's Autobiography, Symonds' translation.

54

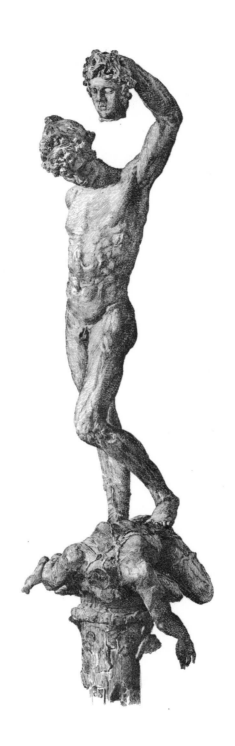

Wax model of Cellini's Perseus *(see p. 54)*. *In the Bargello, Florence.*

Duke, but with due modesty: 'Most excellent sire, consider well that in this Piazza are works by Donatello and by Michael Angelo Buonaroti, perhaps the biggest men that ever were in the world; as for my own little model, I will undertake to turn out the work at least three times more beautiful than this model you see here.'

At these words of mine the duke shook his head, & I took leave of him. Two days after he set a room at my disposal, supplied it with material and all the appliances needful for doing the work, the which by slow degrees in a few years and after great difficulties needless here to relate, I completed in the state you now see it. The noble duke said to me in winning words that I had been better than my promise, and as I had contented him so well he was minded similarly to content me in whatever way I might wish. At this so charming speech from his Excellency I asked leave first before he accorded me aught for my labours, to be allowed to go on a pilgrimage to Vallombrosa, Camaldoli, Erma and S. Francesco, in order to give thanks to God for having helped me through so many difficulties, all of which I will tell of in their place. At these words his Excellency was graciously pleased to let me go, and so I went on my way, giving thanks to God. In about six days I returned, and at once called upon my lord, who welcomed me again with the greatest favour. Two days later he seemed a bit grumpy without my having ever given him any cause for being so. When I asked him for leave of absence, he refused to grant it, and at the same time he gave me no more commissions, so that I could serve neither him nor other man. Nor was I able to find out the reason for the evil plight I was in. So in my despair I felt sure my bad luck was due to the influence of those heavenly powers who have dominance over us here below; & in this state set to work to write my whole life, my origin, and all the deeds I had done in the world, and I also described the many years in which I had served the illustrious Duke Cosimo. But on thinking the matter over I was minded how great princes often take it ill if their subjects complain & tell the truth about them; so with much heart-burning & not without tears I tore up what I had written about the part of my life spent in Duke Cosimo's service & threw it into the fire, vowing that I would never write about it again. But for the mere purpose of being of some use to the world, since I was thus left with nothing to do, and moreover prevented from doing aught, & wishing to give God some sort of thanks for having made me the man I was, I set to write what I am now writing. Well, it's off my mind now, so let us get back again to good Pope Clement, who gave me so many opportunities of doing great work, of all of which I will duly speak.

A little more about the cope clasp, then. Having thus bossed up God the

Father and wrought the whole thing in a manner different from Caradosso, I set myself afresh to fashion little by little the angels round about Him, especially those that were of higher relief than others. Everybody knows that this is one of the most difficult things to do in our craft, and likewise one of the most pleasing, for just think, I bossed up in high relief with my punches in the manner I described above, some fifteen little angels without ever having to solder the tiniest rent, and all this I was able to do because of my diligence, my knowledge, my patience, and my mastery over all the best methods of workmanship. The Pope would scarce let three days pass without sending for me, and each time would he see first one, then another angel baby peep forth, and this made him marvel greatly, and each time he asked me how on earth I managed to do it; & how I could bring so difficult a piece of work about in so short a time, and all without a single rent.

'I have seen,' said he,—and he was a man who knew a good thing when he saw it—'many works of Caradosso which were full of holes and solder long before they had got as far as this.' And thus each time he gave me good encouragement, & I pegged merrily away at my work. When I had completed all the high relief angels and joined together the gold behind their heads and arms and legs, and filled up the openings, I began with great care the soldering, doing it in the way I described above, but putting with each new soldering a fresh alloy of the baser metals (*i.e.*, the copper & the silver). Now forasmuch as I did not wish to disfigure so large a work with many solderings, and also because I wanted later on to enamel it, I put it to the fire as little as possible, managed to get all the legs and arms and heads together at one go, & finished the lot in four firings. This done, I began with great diligence to work over the soldered parts, especially those on the background, till I had it all of uniform evenness, whereupon I set it once more on the pitch (*i.e.*, the stucco), & once more wrought it over with the punches. A large number of angels in bas-relief, & many in mere outline were still to do, so them I brought out boldly with the punches; upon this I melted the pitch out again, heated the gold well, & applied it once more to the pitch, but this time with the under side of the work uppermost, so that all my figures were buried in the pitch; also this time made the pitch a bit softer because I was going to emboss from the back the figures which I had outlined in from the front; & this I did with great skill, determining which I wanted to boss up most. Then once again I emptied out the pitch, and placed the work face upwards on the harder pitch, and most cunningly finished it all over with the punches as I described above. As there were still the gems to go upon it I made a base to the work, with an eye attached, so that it might therewith be applied to the cope on the Pope's breast. This base was all worked around with

56

different little snails and masks and other pleasing trifles, and was firmly fastened with invisible screws to the boss, and looked just as if it had been soldered on. As, moreover, the work was enamelled in various places, especially round the framework, I set to to burnish it up to a fine finish on the bare & unwrought parts, and this is how I did that: I took some four or five hard pointed stones* which are sharp at the ends and thicken upwards in the manner and of the size of punches, and I used with them some well-powdered pumice stone. The object of using these stones is to take out the marks of the steel tools, the punches, chisels, files, and suchlike, & to give it a fine uniform surface; and last, but not least, a brilliancy of colour which would not be so easy if the marks of the steel tools (and the skin they make) were not obliterated. To finish the draperies also, I used a very fine steel tool exquisitely tempered and then broken off, for the broken end gives the right delicacy of texture;† and I tapped it all over the draperies with a small hammer weighing about two scudi or less, & this is what we call *camosciare*, tanning the surface.‡ A further different method yet may be employed for larger drapery, & this is called *granire*, graining, and is done by a sharp-pointed steel tool, but not broken like the other one. Then there is yet a further method by which the ground is sharply accentuated from the figures by hatching it over with a fine sharp graver§ in one direction crosswise, for it does not turn well the other way. When all the above has been carefully carried out, put your work in a clean glass vase, & get some little children to make water over it, for their urine is purer and warmer than men's. Then prepare to give it its last finishing touches by colouring. This you do with verdigris & salts of ammonia; the verdigris must be as pure as possible; and if you want it firm and richly coloured add a twentieth part of clean saltpetre, the stuff they make gunpowder with. These must all be well ground together, but mind you don't grind them upon iron or bronze, they must be pounded on stone and with stone; porphyry is the best stone of all. You then take the powder you have made from the above, put it in a glass flask, and mixing it with a strong white vinegar, make a paste of it not too moist nor too dry, and apply this paste to your work with as fine a hog sable as you can find, putting it on very evenly and to about the thickness of half a knife's back. At the same time you must have ready a wood-coal fire half-burnt out, spread the coals so that you can lay your work upon them, put it in the fire & with your pinchers take a few glowing coals and move them up and down over the paste, especially where it is thickest, so that it heats equally all over. You must be careful not to do this for too long, there's all the difference between heat-

Punte di pietre. †*Una certa grana sotilissima.*
‡ *This might be better rendered as ' matting ' or ' posting.'*
§ *Possibly what we should call a ' scorper.'*

57

ing & scorching your work, and if you did this it would get a bad colour on the one hand, & on the other be difficult to clean afterward. When you see the paste drying equally and about half-dry, put your work on to a stone, or on a wooden table; and cover it up with a clean basin till it has got cold. Then put it again into a glass jar, and if you want it to come out well, let the little ones make water over it again as before. After this clean it up with small soft hog sables. This injunction need only be observed in cases where the work is enamelled, in other cases it will do just to dip it in urine after the heating of the paste of verdigris. After this the precious gems are set firmly with screws and clamps, and last of all the base is, as I told you before, firmly screwed on.

Yet another way there is of working upon gold, particularly in cases where you want to introduce figures of about half a cubit in size. Pursuing my method of always making things clear to you by means of examples, I mind me of many of the cardinals in Rome who used to have crucifixes in their private cabinets; these crucifixes were about the height of a palm or a finger more, & were made of gold, silver and ivory. The first of these gold crucifixes was made by Master Caradosso, and most admirably designed, and I suppose he got about 100 scudi apiece for them, or more. First I'll tell you the way he made his, then I'll tell you how I made mine, which differed considerably from his method, & was much harder, but was sooner finished, and produced more beautiful results. It was in this wise: Caradosso would make a little model in wax of the size he wished his work to be, but he made the legs apart, & not as is customary with the Crucified, one crossed over the other. Then he cast his model in bronze; and cutting his gold sheet in triangular form some two or three large fingers wider all round than would cover his model, he laid it thereon and hammered it over with rather long wooden hammers till it looked like a half relief; next he proceeded very carefully to work it all over front and back with punches & hammers till the relief stood out to his liking; then, still with the same tools, he joined the ends of gold together at the figure's back until they touched on the round of the head, back, and the legs. After this he filled the figure with pitch, *i.e.*, the aforesaid stucco, and with punches and hammers brought out* all the muscles and limbs. Then he emptied the pitch out again, joined & soldered the gold together, using gold of two carats less than the gold of his figure, leaving one hole still open at the shoulder to admit of the pitch being again poured in and out; and then wrought it over once more with his punches; very carefully placed the feet crosswise, and then gave it its last coating and finish. I don't employ this bronze method because I don't think bronze & gold go well together,

Ricercando.

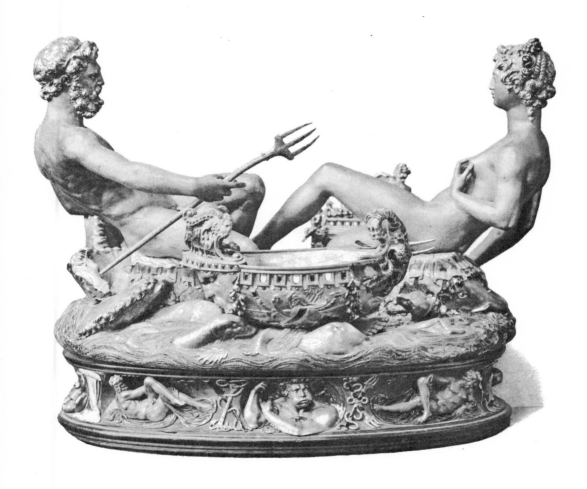

Salt cellar made for Francis I (see p. 59). In Vienna Kunsthistorisches Museum.

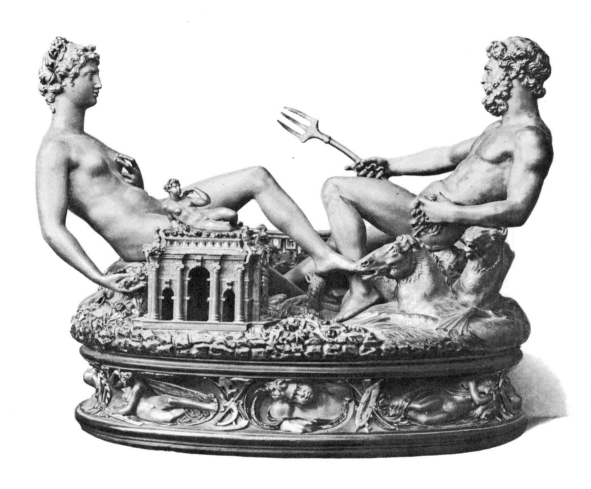

Salt cellar made for Francis I (see p. 59). In Vienna Kunsthistorisches Museum.

the bronze tending to crack the gold, and the whole thing taking a long time in the execution. Owing to my experience and my all round knowledge of the craft, I went straight to the gold with my punches and a number of small stakes called *caccianfuori*; and so, while Caradosso was still fiddling away with his bronze casting, I had got several days' work ahead of him, and was quit of the bother of the bronze firings into the bargain; and thus, though in other respects I followed all the methods of this excellent man, also in enamelling and in colouring, it came about that I did much more and obtained much better results than he.

Now my friend, in order to keep my promise with you as to the real practical things, and to show you that I'm not one who goes cribbing other people's ideas & methods but has worked them out with his own hands, I'll tell you of the salt cellar* I made for King Francis I. It was oval in shape and about two-thirds of a cubit round, and the base of it was about four man's fingers high, and very richly ornamented. And I divided it up in such pleasing wise as one's craft will allow; one part I made as ocean and the other as earth, and on the side of ocean I had put a figure of gold about half a cubit high, completely rounded & made with punches and chisels, in the manner told above. Ocean was personified by Neptune, God of the Sea, and I made him in a shell, a kind of nautical triumphal car to which were yoked four sea-horses—horses' heads and fishes' tails. In Neptune's right hand I put his trident, while his left was stretched out the whole length of his arm. Over a most richly wrought bark which was meant to hold the salt, were graven most minutely and cunningly battles of marine monsters; on the opposite side to Neptune was a female figure, of the same size as the male, and I so devised it that the legs of the male & the female were crossed most gracefully one with the other, and in each the one leg was bent and the other extended, thus typifying the mountains & the even places of the earth. By the side of the female figure I put a little Ionic temple, most richly wrought, and this was to hold the pepper; in her right hand was a very elaborate cornucopia of leaves and fruit and flowers, and on the earth where she sat I indicated a number of beautiful little beasties, just as on the other side I had fashioned a variety of exquisite little fish peeping up from the sea. Furthermore, in the oval body of the salt I had planned out eight niches, in each one of which figured Spring, Summer, Autumn & Winter, on one side, and Dawn, Day, Twilight and Night on the other. In the hollow of the salt's base was a block of ebony, of which, however, only a tiny strip showed beneath, and the which, being black, told well against the gold. This base again rested on four balls of ivory, set half way into the ebony

* *See Autobiography.*

59

and so devised that they turned on their pivots, and you could move the salt cellar about hither and thither on the table, & roll it where you liked. I must tell you some absurd things that happened to me when I presented the salt to the most Christian King. His Majesty had referred me to one of his treasurers, a Monsieur de Marmagna, a shrewd old fellow, and terribly fierce. Now you know the French & the Italians are deadly enemies; well, this old gentleman, about a month before I brought the salt-cellar to the King, had shown me a little bronze statuette a trifle bigger than my gold ones. This figure was an Antique, & represented Mercury with his caduceus in his hand. He told me that it belonged to a poor peasant who would gladly sell it, whereupon I said that if he did not care to buy it for himself, I, who knew the figure to be of very charming workmanship, would willingly give 100 golden scudi for it, and like the frank and open man I am, I praised the figure greatly, declaring I had never seen a lovelier. Whereupon that evil old man said he would do his best to get it for me, and gave me great hopes of getting it, for that I had set it at a higher value, & offered more than any other connoisseurs who had seen it. I thought no more about the matter till the day that I brought my salt-cellar to King Francis. The good King examined my work very carefully, and expressed himself most satisfied, when, just as all were expressing their delight, that wicked old fellow drew forth his statuette & said to the King: 'Sacred Majesty, this figure is an Antique, as you may readily see; and 'tis of so excellent workmanship that Benvenuto here has himself offered 100 golden scudi for it. I had it brought among my baggage from Languedoc at the time of my treasurership; but courage failed me to present it to your Majesty until I had satisfied myself that it was of sufficient excellence to merit your acceptance.'

At these words the King turned to me, and, in the old boy's presence, asked if what he had said was true. I replied: Most assuredly, and that the work appeared to me admirable. Whereupon the King said: 'Then God be praised that here in our own day there be yet men born who can turn out so much more beautiful things than the ancients.'

Therewith he smiled, and gave old M. de Marmagna back his statuette, for of course he saw that the intention had been to disparage my work beside the antique. Hundreds of most graceful & complimentary things did he continue to say about my work, so much so that I never wished for any better remuneration for it than I got that day.

CHAPTER XIII. ON CARDINALS' SEALS.

THIS sort of work is delightful. In my time in Rome, that was about 1525, there was a certain master from Perugia, called Lautizio, who practised nothing else but the making of seals for the bulls of cardinals. These seals are about the size of a ten-year-old child's hand, and they are made in the shape of an almond. The cardinal's title is engraved on them, and usually in the form of a rebus, or allegorically. Lautizio used to get at least 100 scudi for each seal he made. Now always sticking to my method of describing things from work I have done with my own hands, I'll tell you of two that I made in this branch of my art.

The first was for the Cardinal of Mantua, brother of the Duke. On it was engraved the ascension of our Lady, with the Twelve Apostles, for so ran the Cardinal's title. The other seal, much more richly figured, was for the Cardinal Ippolito of Ferrara, brother of Duke Hercules. On this one was engraved St. Ambrose on horseback, with a whip in his hand chastising the Arians. And as two stories had to be wrought upon it, for the Cardinal had a twofold title, it was divided down the middle and the legend of St. John the Baptist preaching in the desert was engraved on the other part, and both subjects were wrought with figures. For the Mantua seal I got 200 ducats, for the Ferrara one, 300.

The seals are made in the following manner. You take a smooth and polished black stone, and draw thereon the design you want to appear on the seal; and with black wax, a bit hardened, you fashion whatever relief you wish the seal ultimately to impress. When this is very delicately accomplished, you take a little volterrano gesso,* or any other gesso, provided it be very fine—boiled gesso it should be—& after having moistened your wax by painting it over very lightly with a fine paint-brush and a little clean and pure olive oil, you put the gesso on your wax. You must mind not to get too much oil on your wax, for it would then hurt the gesso and prevent it from penetrating into the finer delicacies of the wax. Before pouring on your gesso in the liquid state, you must make a little wall or embankment of fresh clean clay, about two fingers high, all round your seal. As you pour your gesso on, you guide it about very carefully into all the interstices of the wax by means of a long-haired brush.†

* *Gypsum or plaster from Volterra (the 1568 edition has 'gesso cotto Volterranno.')*
† *Un penelletto alquanto grandicello di vaio—what I think in the English workshop would be called a 'rigger.'*

After the gesso is well set, remove it from the wax. This, of course, will be easily done, as there is no undercutting, for since the work is ultimately to serve the purpose of a seal, no projections are permissible. Then you clean out the matrix with a knife, removing any scum or spoiled surface that may have been made by the gesso on the inside, and polish it all up all round.

Now there are two ways of casting in silver, both of them are good and both of them will I describe to you. 'Tis true that one is a little easier than the other, but as I say, both are good and you may adopt whichever most wins your fancy. Do not, however, fail to try both, because it is good for you to learn them, & you will find them very helpful to you in many ways in other branches of the goldsmith's art. The first method was the one employed by Lautanzio, and he, as I said, was the greatest master in this branch of work whom I ever knew. He used to take what is called earth for founding in boxes,* the same that all the bronze founders use, and from which they cast the harness of horses & mules, brass studs, and such-like trappings. And forasmuch as this clay is known all the world over, I shan't bother about describing it, but only say that it is a kind of tufa earth. By the bye, as I write I am minded of a very rare kind of this tufa which is found in the bed of the Seine in Paris. While there I used to take what I wanted from hard by the Sainte Chapelle, which stands on an island in Paris in the middle of the Seine. It is very soft, and has the property, quite different from other clays used for moulding purposes, of not needing to be dried, but when you have made from it the shape you want, you can pour into it while it is still moist, your gold, silver, brass, or any other metal. This is a very rare thing, and I have never heard of it occuring anywhere else in the world.

Before considering the other kinds of clay that may be used for this sort of work, it will be best for me to tell you carefully how to make your gesso model for casting your seal from. After it is well cleaned with the knife in the way above described, powder it with a little fine charcoal-dust, or smoke it over with the soot from your lamp or taper; either will do, and I really needn't describe this, because everybody knows how to do it. Then press the model into a caster's sand-box of sufficient size to hold it conveniently.

This done, dry well that portion of the mould where the figures come (that is to say if you are using the Italian, not the Paris clay), then have

* *Che si chiama terra da formare nelle staffe. It is not a clay, but as he says, a sand tufa ('areno di tufo') a volcanic spongey rock like pumice, and they make cement of it.*

ready a little dough* in the form of a cake similar in shape & thickness to what your silver or metal seal is finally to be, and put this over the figures formed by the gesso and which will appear in relief, having previously smoked over the mould with a little candle-smoke. This done, take the second box, fill it with the same moist earth and when dried set it upon the first. Mind in so doing that you do not disturb the part already dried where the figures are.† This second half you will easily mould. Then open the mould, and after taking out the dough-cake, make the mouths and the two vent holes, beginning at the bottom and going up as high as the mouth or ingress hole. When both parts are dry, smoke them over with a little candle-smoke and let them cool, have your silver well molten and then pour it in. Experience shows that it is better to pour the silver into cold than into hot matrices.

Now, for the second method, differing considerably from the first, but, as I have employed both, and the second not only for seals but for casting all sorts of other things too, I'll describe it to you also. When you have from your original wax cast a gesso matrix in the manner above described, take a little of the same gesso, mix with it a little pith of horn‡ well dried, a further part of tripoli,§ & finally another part of well-powdered pumice-stone, and pound these four parts well up together. Then add as much water to them as shall give them the consistency of a paste—neither too thick nor too fluid. Then with a fine brush paint the surface of your seal all round over the wax projections and into the interstices, with a little olive oil. Waiting till it is well dried in the way we Florentines call *verdemezzo*, that is to say neither too dry nor too moist,‖ make a little wall of clay about two fingers high all round it, and pour the above mixture into the work and paint it well in and around the whole of your subject. Pile the mixture up at least two fingers high and make about four fingers more of it at the upper end on account of the almond form which is the shape your seal will be, for you need there greater size for the pouring-in mouth of your silver or whatever metal you may be using. When the

* *Pasta di pane crudo.*
† *The 1568 edition gives a clearer version of this process than the original codex, which is confusing. I have translated it as literally as possible, but the following might be read as more descriptive of the process: The gesso matrix has been pressed into the sand of the first box, and has made the mould of the relief work of the seal, the dough is to make the shape of the body. It would be roughly cut away to clear the figures, and carefully placed over the part moulded. Then the second box would be put on, and the moist earth tightly packed in. After this the boxes would be separated and the dough taken out.*
‡ *Midollo di corna. See Hoepli's handbook 'Oreficeria' for the modern process.*
§ *Calcined sulphate of iron.* ‖ *Or, as we English would perhaps say, 'tacky.'*

gesso is thoroughly dried, which will not be till some four hours or so, separate the one piece of gesso from the other, taking very great care that none of your design is injured. As you may well imagine, it was much easier to separate the matrix from the wax in the first method than from the composition in the second, because in the former it had a firmer consistency. If some of the arms and heads don't appear to you to come out quite a success, and remain stuck in the matrix, you can remedy that in either of the following ways. You can either pick out the bits remaining in the mould with a small paint brush, & re-apply them with a little powdered tripoli, and since your design is in relief you will easily see the impressions made by it in the mould. Or, for the other way, you can clean out the mould entirely, paint it round again and fill it up with the composition in the same way as before; often if the first turn has not come out well, the second does.

But pay the greatest possible attention to what I am going to tell you now. Make a waxen form, almond-shaped, and of the exact size your seal is to be, hollow it out, and lay it over the surface of your gesso relief. Then make your little ramparts of earth about this wax, taking heed to make due provision for the channel of the casting, which should be of ample length; & here I ought to tell you that the longer your channel is the better chance your work has of turning out well. There are no end of little details still to be observed, but if I were to tell you all of them I might as well begin teaching you your A B C. So I assume that my readers are people who have mastered the first principles of the Art. I would remind you, too, that both the ingress mouth & the vents have to be made of wax & applied to the wax core. These vents are fixed below, & turn up around the seal towards the ingress mouth; they must not, however, come in contact with the latter, because they have to do their own work of drawing out the air.*

*This, which is the ordinary cire perdue process, is again described in Chapter XXII., where Cellini deals with a vase he is making. The accompanying diagram illustrates it in its application to seals. The mouth or ingress hole, or what will become the mouth, is rolled in wax and attached to the top, the two vents are rolled and attached in a similar way below, but so as not to touch the pattern.

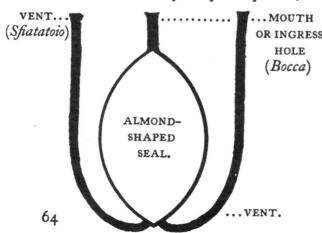

VENT...
(Sfiatatoio)

...MOUTH
OR INGRESS
HOLE
(Bocca)

ALMOND-
SHAPED
SEAL.

...VENT.

64

This done, bind up your seal with well tempered iron or copper wire, and let it bide in the sun, or some place where it can get warm & well dried. Then put it in your little furnace of tiles and iron hoops and melt out the wax with such heat as may be needful. Of course your wax must have been free from all impurities or it would never melt out properly. And when you have melted it out you make the fire stronger till your mould is regularly burnt, & the more it is baked the better your work will be. Then let it cool, and because the silver adapts* itself more readily to the cold than to the hot mould—cold, mark you, but not moist—when it is well molten pour it in. But ere you do this, in order that it may not burn,† strew a little borax over it and upon that a handful of well ground tartar, ‡ and you will find this help your work wonderfully. Then dip the mould in water in order better to separate it from the silver, and so break it open. This done clean the silver off at the points where the channel & the vent holes come, and give it a subtle finish with the file. After this, in order to give the seal its final touches, you place it on the pitch, and, with your first gesso matrix before you, work the silver with your punches, gravers and chisels, touching up and completing your subject now here, now there, figures, swags, arms, bodies, legs, all alike, accentuating§ them in the matrix with your steel tools. To see better how you are getting on, you may occasionally press in a little black wax, or whatever colour pleases you better, to gauge the projections. Now note this: my custom was to cut out the heads, hands and feet of my figures on small steel punches, and thinking the work came clearer and got a better result, I struck these punches with dexterous strokes upon the seal with a hammer into their different places. Also you should make in a similar manner an alphabet of steel punches, likewise many other conceits according as taste prompts. When I was in Rome, or elsewhere, working in this line, I ofttimes amused myself by making new alphabets, each for its occasion, for they wear out soon, and I got much credit by my inventiveness. Your letters should be well formed, & shaped as a broadly cut pen might shape them; the strokes going up or down with the action of the hand, the letters being neither too fat and stumpy, nor too long and thin, for both these are unpleasing to behold, the moderately slim ones are the nicest to look at.

I ought not to omit telling you that the cardinal's arms, or whatever they may be, have to be done on the seals; and these are always richly ornamented with figure work, and I often used to have for the handle wherewith the seal was attached, some fine beasts, or as often figures, according to the emblem of the gentleman for whom the seal was made. You should

* *Segli accosta.*
‡ *Gromma di botte: tartrate of potash.*

† *Riarda:* i.e., *oxidise.*
§ *Risserando.*

65

be careful not to omit these little complimentary touches because they redound to the honour of the master & please the patron whom he serves. I made, among others, such a handle in gold for the Duke of Mantua after I had made the one for his brother the Cardinal; and in addition to all the care I had put into the seal itself, I added a little Hercules for the handle, & he was sitting on his lion's skin, and had his club in hand. For this tiny figure I made no end of studies, & it brought me much honour with the sculptors and painters, and among these was Master Giulio Romano; some of them made use of the design, too, for other purposes, and I was well paid for it.

Some artists have gone straight to work at their seals with merely cutting directly into their silver, and without casting at all, but pluckily doing their design straight on in the reverse with genuine knowledge of their art, and using the steel dies of which I told you, and they succeeded in it, too. I also have done this, but I have found the casting method more practicable; though both are good, and can lead to excellent results.

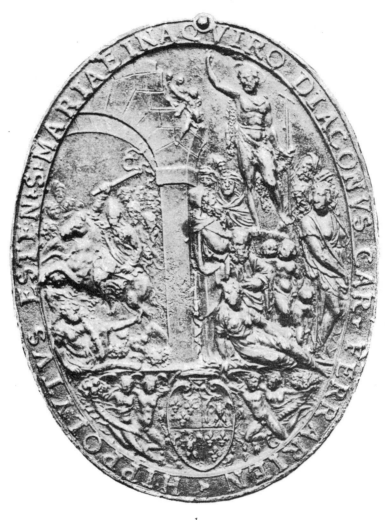

1

CARDINALS' SEALS BY CELLINI.

(1) Impress of seal of Ippolito d'Este, Cardinal of Ferrara (see p. 61). Rome, 1539.

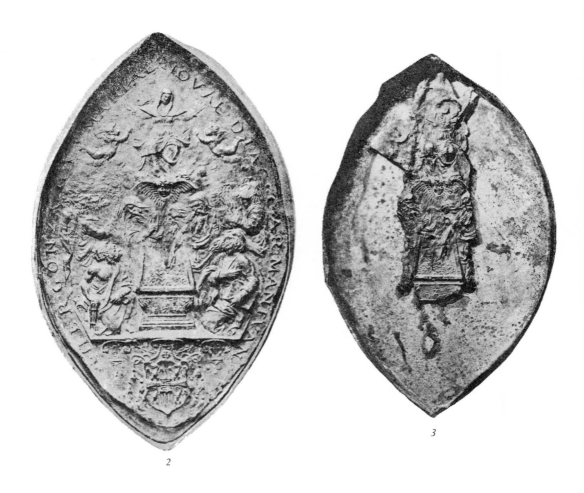

2

3

CARDINALS' SEALS BY CELLINI.

(2) Impress (1540) of seal of Ercole Gonzaga, Cardinal of Mantua (see p. 61).
Mantua, 1528.

(3) Fragmentary impress (1534) of Mantua seal.

CHAPTER XIV. HOW TO MAKE STEEL DIES FOR STAMPING COINS.

SINCE the art of the coiner can teach the elements of stamping medals in methods similar to those of the ancients, we will treat of that art first. You must bear in mind that the ancients, though they made their coins for use, undoubtedly made their medals for show; and as regards the former, we moderns may pride ourselves on being able to produce them with greater facility, and that, like the printing of books and many such-like arts, is a discovery of ours, which though it be out of my scope to speak of them here, I may have occasion to touch on elsewhere. As to the coins, I shall, according to my usual custom, speak with actual instances of the methods I have myself wrought in. The first coins I made were for Pope Clement VII. in Rome, who summoned me to come to him from Florence some eighteen months after the great sack of Rome by the Lord of Bourbon. And since the house of Medici was at that time expelled from Florence, the Pope sent for me by the hand of Master Jacopo dello Sciorina,* the same that kept the ferry across the Tiber, by the Banchi in Tresteveri not far from the palace of Messer Agostino Chigi. This Master Jacopo wrote me twice on the Pope's account; when I got the second letter, I made off as fast as I could, for of a truth those terrible radicals† in power then would have hanged me had they found it on me. Pope Clement, when I came, treated me with the most winning kindnesses, and ordered me to make the coins for his city and Mint in Rome. The first coins I made were gold pieces, worth about two ducats each, on which were stamped figures of divers sort. On the one was the form of a nude Christ, his hands bound behind him, done with all the care and study I was capable of; down the sides of the figure ran the legend '*Ecce Homo*,' and around the circumference the words '*Clemens VII., Pont. Max.*', while on the other side was stamped the head of the Pope.

A new occasion soon offered itself. Though I don't want to write a chronicle of events, & though I was not directly affected by them, I can't help touching upon them slightly. What the current talk in Rome was at the time, I don't need to dwell on; any man with a head on his shoulders may easily imagine that for himself. The second coin, a beauty, was likewise of gold, & a two-ducat piece. On one side was a pope in his pontifical robes, & an emperor also in his regalia; the two were supporting a cross which

*See the '*Vita*,' Symonds, Book I., xlii. † *Terribilissimi popolani.*

was in the act of falling to the ground. I forget if there was a legend on this side; but on the other were a St. Paul and a St. Peter in more than half relief, with this legend around them: '*Vnus spiritus, una fides erat in Eis.*' This coin brought me much honour, for I put great labour into it. As the Pope put more gold into it than its value warranted, it soon was melted down again.

A third coin of my making was in silver, of the value of two carlins, on the one side of which was the head of the Pope, and on the other side a St. Peter, just the moment after he has plunged into the sea at the call of Christ, and Christ stretches out his hand to him in most pleasing wise, and the legend to this was '*Quare dubitasti?*'

In Florence likewise did I make all the moneys for Duke Alexander the first of that name; they were 40 soldi pieces. And because the Duke was curly headed, the people called these coins the Duke's curls.* On one side was his head, and on the other St. Cosmo and St. Damian. In like manner did I make the coins called *barile* and *grossone*.

As I said above, the ancients had not the facilities for stamping coins we have, & therefore we never see any of the beautiful sort,† for coins should be made, or rather their dies, with the purpose of striking with the greatest ease. To begin with, two steel tools are needed, one called the *pila* the other the *torsello*. The *pila* is in the form of a small stake or anvil, upon which the medal you wish to press is cut in intaglio. The other tool, the *torsello*, is about five fingers high, its face being the size of your coin, and it gradually tapers off toward the end. Both *pila* & *torsello* are made of carefully chosen iron, with their heads covered in the finest steel about one finger thick. With his file the master gives them whatever shape & size his coin may need. Then he makes a concoction of earth, powdered glass, soot from the chimney, and bole of Armenia,‡ adds a little horse-dung to this, mixes it all up into a paste with a man's urine, & puts it on to the ends of the *pila* and the *torsello* to the thickness of about a finger. These he then puts into the fire, which should be strong enough to raise them to bright redness;§ keeping the fire up for, say, a good winter's night, he then lets them cool down by allowing the fire to go out.‖ The exact size of the coins is now given to the ends of the dies, barring about

*E ricci del Duca Alexandro. †Meaning in the way Cellini describes them.
‡ Terra di bolo Armenio : red earth that was and is used in gilding grounds, &c.
§ Ricuocano. ‖Cellini's method of hardening differs from that of Theophilus; the latter in describing the tempering of files, Book III, Chapter xvii., practically employs animal charcoal to case-harden his metal.

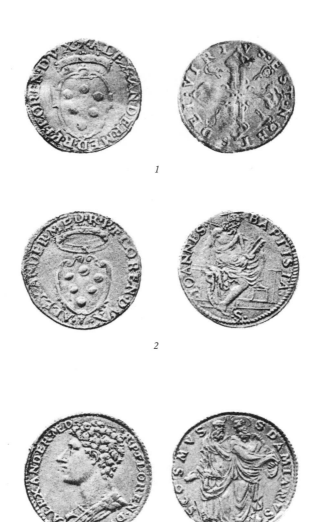

COINS AND MEDALS STRUCK FROM DIES EXECUTED BY CELLINI.

(1) Gold scudo with arms of Alexander I of Florence on obverse. Reverse has Greek cross and four heads of cherubs with legend "Virtus est nobis Dei." 26 mm diameter. Florence, 1535.

(2) Silver julio with arms of Alexander I on obverse and St. John the Baptist on reverse. 26 mm diameter. Florence, 1535.

(3) Silver 40-soldi piece with head of Alexander I on obverse and Sts. Cosmo and Damian on reverse (see p. 68). 29 mm diameter. Florence, 1535.

4

5

COINS AND MEDALS STRUCK FROM DIES EXECUTED BY CELLINI.

*(4) Medal of Pope Clement VII with two reverses. Pope's bust on obverse.
Left-hand reverse: Moses striking the rock (see p. 73). Right-hand reverse: Peace at
temple of Janus (see p. 73). 39 mm diameter. Rome, 1534.*

*(5) Silver half-julio with arms of Alexander I on obverse and bust of the boy St. John
the Baptist on reverse. 24 mm diameter. Florence, 1535.*

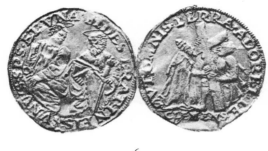

6

7

8

COINS AND MEDALS STRUCK FROM DIES EXECUTED BY CELLINI.

(6) Gold two-ducat piece with Pope and Emperor on obverse, Sts. Peter and Paul on reverse (see p. 67). Legend on obverse: "Ut omnis terra adoret te." 29 mm diameter. Rome, 1529-30.

(7) Gold two-ducat piece with bust of Pope Clement VII on obverse and nude Christ (legend: "Ecce Homo—Pro eo ut me diligerent") on reverse (see p. 67). 29 mm diameter. Rome, 1529-30.

(8) Reverse of silver two-carlin piece with Christ stretching out His hand to St. Peter (legend: "Quare dubitasti") (see p. 68). 29 mm diameter. Rome, 1529-30.

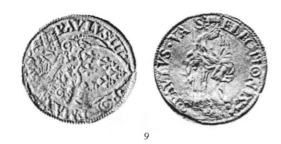

9

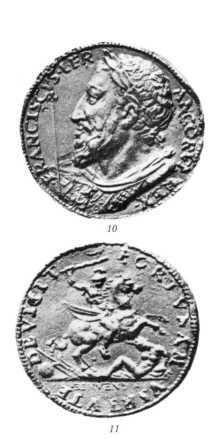

10

11

COINS AND MEDALS STRUCK FROM DIES EXECUTED BY CELLINI.

(9) Gold scudo of Pope Paul III, with Farnese arms on obverse and St. Paul (legend: "S. Paulus vas electionis") on reverse. 29 mm diameter. Rome, 1534.

(10) and (11) Medal of Francis I, with head of King on obverse and horseman trampling Fortune (legend: "Fortunam virtute devicit") on reverse.

half the thickness of a knife's back all round the circumference, and the face of each is then ground on a soft, polished stone until both *pila* and *torsello* are absolutely smooth. Then with the compasses the exact size of the coin is drawn upon them, & also with another pair of compasses the circumference of the letters that form the legend round is marked. In order that these compasses should not shift about, a pair should be specially made of thick steel wire and of the exact size needed. It is best to have at least two pairs of each kind, and also one pair that will open and shut as you please. When this is done, the *pila* is firmly set in a big lump of lead of at least 100 lbs. in weight. After this you can proceed to the engraving* of your coin on the die.

You very carefully cut upon the finest steel your design, *e.g.*, the head of whatever prince you are serving, and in order to do this nicely you must first have your steel well softened in the fire in the way I showed you the *pila* & *torsello* were; only take heed that your tool is of the very finest steel. And the tools with which you work have to be made specially for the purpose. Thus for a head I should make the tool in two pieces, and for the various figures on the reverse of a coin I should use a number of different pieces according to my discretion. Some have worked with very few, but in so doing have much greater difficulty in sinking the design into the die. The more such pieces you have, the easier it becomes; but you must always give great care in the combination of your punches. And this combining is done while the master is engaged in cutting the intaglios by taking frequent impressions on a piece of polished tin, to which you can give the right circumference with your compasses, until you get the results you wish.

The tools used for this purpose have two names, in some instances they are called *punzoni* (punches), and in other cases *madre* (matrices), and of a truth they are the mothers that may be said to beget the figures and all the other things you fashion in the die of your coins.† The men who did the best work in coining always did the whole of the work upon either the punches or the matrices, and never once touched up the dies with either gravers or chisels, for that would be a great blunder, as all the various dies necessary for making many impressions of the same coins, would be a bit different, and thus cause slight differences in the coins themselves, and that would be making things easy for forgers, whereas coins well wrought in the way above described could be less easily copied. But I must return to you, dear reader, where I left off above, with the *pila* stuck in the lead.

* *Cellini uses the words 'stampare' and 'intagliare' in their generic as well as their specific sense.* † *What we should call engraved punches.*

Take your *madre* or punches, and since it almost always is a prince's head that is cut into the *pila*, set to with the first piece of your combination, and, fitting each into its place, strike it a blow with the hammer, and lift hand and tool up as smartly and rapidly as you brought them down, for if the *madre* shift, even but ever so slightly, it will tend to blurr your work. In like manner add the limbs and the heads of your figures in such wise as your craft and your experience shall teach you, and so on similarly any other things, coats of arms, devices, beautiful alphabets, the beading for the coins' border, till all are well fashioned in both *pila* and *torsello*. And since I should omit nothing for your better guidance, know that the hammer needful for stamping in the larger *madre*, such for instance as a head would need, ought to weigh about 4 lbs., while those requisite for the smaller punches may weigh less; those for the smallest of all—for the beading for instance—may be very tiny—each according!

When the sinking by both *pila* and *torsello* is completed, set to and file off the superfluous margin right up to your border of beading. See that it is strongly blunted * where you have filed it towards the beading, for without this your die would spoil and quickly perish, but where it is blunted it will not spoil. Then set to and temper your steel;† to this end you heat it, and let it glow, neither too much nor too little, but just sufficient to temper it aright. And forasmuch as in the tempering a film is formed that would tend to spoil your fair impression, you must take great care to prevent it. As we say in the craft, the dies should be *rosso appunto*, to the point of redness, neither more nor less; and to make them so you do this. You take some clean iron scale ‡ and place it on a board and then rub *pila* and *torsello* alike on this until they are thoroughly bright, and the film quite gone from them, and in the same manner may you afterwards brighten your coins. And—another little hint—you clean out the deeper parts of your dies with pieces of pointed cork tipped with iron scale, & then everything is done & you can give your dies to the stamper, at the mint.

I must not forget to tell you, as I promised, how it was that the ancients never turned their coins out as well as we; & the reason of it was because they cut their dies out direct with goldsmith's tools, gravers, chisels, punches, & that was very difficult for them to do, especially as the mints needed a large number of these dies—*pile* and *torselli*.

* *Bolso forte. This might be: 'strongly backed,' i.e., the reverse of undercut.*
† *Cellini's description is not very clear; see note, pp. 68 & 74.*
‡ *Scaglia: perhaps fine oxide of iron. Professor Roberts-Austen suggests that this may have been what is now called 'rouge.'*

I need give you but one instance of what I mean, gentle reader, and you will see how right I am. On one occasion when I was making the dies for Pope Clement in Rome, I had to turn out thirty of these iron *pile* and *torselli* in one day; had I gone to work in the manner of the ancients, I could not have produced two, nor would they have been as good. Thus it was that the ancients had to employ a large number of die cutters, and these could never do their work as well as they wished to do it, having never attained our facility.

But now will I tell you of medals which the ancients made superlatively well; & whatever I may have omitted in dealing with coins I will make up for in treating of medals, so that you shall learn all in listening to both.

CHAPTER XV. ABOUT MEDALS.

IN dealing with these beautiful things I will first explain to you the method adopted by the ancients and then tell you how we are wont to go to work nowadays. As far as we can gather from the methods of this art, it appears that in the days when the art of making medals commenced to flourish in Egypt, Greece, and Rome, the rulers put the impressions of their heads on one side and on the other some record of the great deeds they had done. What strikes us professionals, however, who look deeper into the matter, is the variety of medals struck for each emperor by a number of different masters. And the reason of this is that when a new ruler was elected all the masters of the craft of medal stamping in his dominions, and especially those in his immediate residence, struck a medal for the occasion, the prince's head on one side, and on the other some commemoration of one of his deeds of honour. Then all the many medals were shown to the prince, and his ministers, and to him whose work was pronounced the best was awarded the Mastership of the Mint, or rather the making of the dies for the coins.

Now as to their making. The first thing to be done is to make a model in white wax of the head, the reverse, and whatever there may be, to the exact size and relief of the final work, for we know this was how the ancients did it.

The white model in wax is made as follows: Take a little pure white wax, add to it half the quantity of well-ground white lead, & a little very clean turps. It depends on the time of the year as to whether you put much or little turps, winter requiring half as much again as summer. With wooden sticks* it is worked on a surface of stone, bone, or black glass, & thereupon—for the ancients and the moderns are at one here—it is made in the gesso just as the cardinals' seals were, of which I erewhile told you. Then you take what are called the *taselli*, or iron implements used for stamping medals, just as in the case of the *pile* and *torselli* you used for stamping coins; only in this case they are made alike and not dissimilar like the latter. There is a further difference too, and this you must be careful about; whereas the latter were made of steel and iron, the former are of well-chosen steel and four-cornered in shape and the one just like the other. After you have softened them in the fire in the same way as I showed you above with coins, you smooth and polish † them very carefully with soft stones and mark out the size of your medal, the beading,

*Fuscelletti. † Ispianera 'gli.

the place for the inscription & so forth, with just such immovable compasses as you used before.

After this you begin to work with your chisels ever so carefully, cutting away the steel in order to round off the form of the head in just such manner as you have it in your gesso model. And in this manner, little by little, you hollow it out with your tools, but using the punches* as little as possible, because they would harden the steel and you would not be able to remove it with your cutting tools. This was the way in which the ancients, with their wonted diligence and patience, went to work; & in the same way, using the chisels and the gravers, did they engrave their letters, and thus it comes about that on no ancient medal have I seen really good letters, though some are better than others. So much for the methods of the ancients.

Now for another of our practical instances, gentle reader, always as I have promised you, something from my own hand. It was a medal for Pope Clement VII., and it had two reverses. On the front was the head of his Holiness, on the reverse side was the subject of Moses with his folk in the desert at the time of the scarcity of water. God comes to their help, bidding Aaron, Moses' brother, strike the rock with his staff, from which the living water springs. I made it just full of camels and horses, and ever so many animals and crowds of people, and the little legend across it '*Ut bibat populus.*' An alternative reverse bore the figure of peace, a lovely maiden with a torch in her hand burning a pile of weapons, & at the side the temple of Janus with a Fury bound to it, and the legend around of '*Claudunter belli portae.*' The dies for these medals I prepared † with the *madre*, of which I told you above, and the punches, using them first in the same way as I did with the coins. But I must remind you how I said that the dies for the coins were not to be worked on with cutting instruments, gravers and so forth; here, with the medals, the contrary holds good, & as soon as you have done what you can with your *madre* and the various little punches that go with it, you must needs finish the work ever so carefully with chisels and gravers. The letters are stamped in with steel punches, just as was the case with the coins. You must take heed, too, while striking, to fix your die on to a great block‡ of lead. Some, when they strike coins, have used hollowed wooden blocks§ for this purpose, but this will not answer for medals, as the dies have to be much deeper cut, the relief of the medal being so much higher. Just in the same way as with the coins you will do well to make wax impressions from time to time, while you are cutting, to see

*Ceselletti da ammaccare.
‡Tasello.

†*This might be translated, ' I sank.'*
§*Ceppi di legno bucati.*

73

how you are getting on. Likewise, before you temper* the die, make a few impressions on lead so as to see how the whole works together, and to correct any mistakes. When you are satisfied with the results, set to with the tempering of the dies, like you did for the coining. Don't, however, omit to have a pitcher containing about ten gallons† of water. When your die is aglow, grip it carefully with the tongs & quickly dip it into the water, and not holding it in one position but stirring it round, always keeping it under water till it hisses no longer and becomes cold. Then take it out & polish it up with powdered iron scale just as you did before with the coins.

*Perhaps: 'harden' (see pp. 68 & 70). I am indebted to Prof. Roberts-Austen for the following note: 'This passage is amplified in the next chapter where the author treats of the hardening of medal dies. He has shown that before working on the coin dies he has made them as soft as possible, but before they could actually be used for striking coins they would need "hardening" & "tempering." Hardening steel is effected by heating it to bright redness & then quenching it in some fluid which will cool the metal with more or less rapidity, cold water being usually employed for this purpose. Hence in this chapter Cellini states that there must be ten gallons of cold water in which the hot die is quenched, & kept moving (as in modern practice) until it is cold. "Tempering," on the other hand, to which he alludes here, consists in reducing the hardness of the quenched steel by heating it to a moderate temperature much below redness. Usually the die would be (in modern practice) heated until a straw-coloured film forms on its surface. Probably such a film is contemplated by the author when he indicates the necessity for removing a film, produced at the hardening stage, by polishing with fine oxide of iron.'
†The barila is about forty pints. Capt. Victor Ward tells me about twenty Florentine wine flasks.

CHAPTER XVI. HOW THE BE-FORE-MENTIONED MEDALS ARE STRUCK.

MEDALS are struck in various ways. I will speak first of the method called *coniare** a term derived from this particular method of medal stamping, and then I'll go on to the others of which I have also availed myself.

You make an iron frame† about four fingers wide, two fingers thick and half a cubit long, and the open space within it should be exactly the size of the dies (*taselli*) on which your medals are cut in intaglio. These dies you remember are square, and they have to fit exactly square and equal into the frame so that they may be in no way moved in the striking of the medal. Before beginning the actual thing, it is necessary first to strike a medal of lead of just the size you wish the gold or silver one to be. You do it in the usual way, taking the impression of it in caster's sand—you remember we spoke about it before—the same that all the founders use for the trappings of horses, mules, and brass work generally. From this pattern medal you make your final casting ‡ which you carefully clean up, removing the rough edges § with a file, and after that polishing off all the file marks. This done you place the cast medal between your dies (*taselli*). The medal, in that it is already cast into its shape, is more easily struck, and the dies are for the same reason less used up in the process of striking. When you have them in the middle of your frame, & the frame itself fixed firmly upright, push them down into the frame at one end, leaving a cavity of three fingers' space from the edge of it. Into this cavity fix two wedges of iron,‖ or *biette*, the thin ends of which are at least half the size of the thick ends and which in length are about twice the breadth of the frame. Then when you want to do the striking, set them with their thin ends over your dies, the point of the one set towards the other.¶ Then take two stout hammers, and let your apprentice hold one at the head of one of the wedges, and do you strike with the other hammer the opposite wedge three or four times, very carefully alternating your blows first on one wedge, then on the other. The object of this is as a precaution to prevent the shifting & facilitate the action of your dies ** or the

* *La qual dice coniare, as distinct from the method he describes in Chap. xvii..*
† *Staffa.* ‡ *In questo modo ti conviene formarla, egittarla agyrreso.*
§ *Barette.* ‖ *Coni di ferro.*
¶ *Mettile sopra i tuoi taselli le punte dell'una e dell'altra, le quali si vengano a sopraporre.* ** *Ferri.*

pieces of metal that are to form your medals. Then take your frame, set the head of one of the wedges on a big stone & strike the other head with a large hammer called in the craft *mazzetta*, using both your hands.

This you repeat three or four times, turning the frame round at every second stroke. This done, take out your medal. If the medal be of bronze it will have been necessary to soften it first,* for that is too hard a metal to strike straight off without heating; and repeat this three or four times until you see that the impression is sharp. True it is I could give you hundreds of little wrinkles yet, but I don't intend to do it, because I assume I am speaking to those who have some knowledge of the art, and for those who haven't it would be dreadfully boring to listen. So much for the method of striking medals that we call *coniare*. †

This may mean working the bronze hot, but more probably softening by annealing.

† The method described may be illustrated by the following diagram:

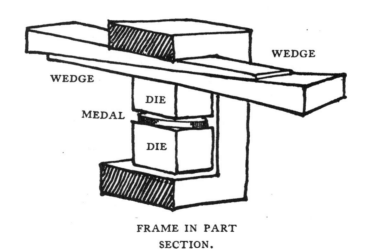

WEDGE

WEDGE

DIE

MEDAL

DIE

FRAME IN PART
SECTION.

76

CHAPTER XVII. ANOTHER WAY OF STRIKING MEDALS WITH THE SCREW.

YOU make an iron frame of similar size & thickness to the one described above, but of sufficient length to enable it to hold not only the two dies, *taselli*, on which the medal is cut, but also the female* screw of bronze. This screw is set beneath the male screw of iron; † one ought really to apply the term screw, *vite*, to this male screw only, the female screw being called *chiocciola*. The male screw should be three fingers thick and its threads ‡ square, because it is stronger thus than of the usual shape. The frame has to have a hole in the top of it to admit of the screw passing through it. When you have placed your dies, *taselli*, beneath the screw, with the metal you propose to strike between them, you tighten them up by the insertion of iron wedges§ so that they cannot possibly shift. You will find this necessary owing to the greater size of the bronze screw.|| Then having prepared a piece of beam about two cubits long, or more, you fix an iron rod of sufficient thickness and of about two cubits in length to the lower end of it, and it must fit into the beam;¶ then fix your frame into a cutting in the head of the beam made exactly to hold it. It is necessary, too, to bind the beam round with stout iron bands to give it strength at the place where the frame is set in, and to prevent it from splitting.

Round the head of the screw must then be fitted a stout iron ring with two loops to it, & these have to be made to hold a long iron rod or bar,** say six cubits in length, so that four men can work at it, and bring their force to play upon your dies and the medal you are striking. In this method I struck about one hundred of the medals I made for Pope Clement; they were done in the purest bronze without any casting, which, as I told above, is necessary for the process called *coniare*. I advise every artist to

* *La vite femmina.* † *Il mastio di ferro:* i.e., so that the male screw can fit into it. ‡ *Pani.* § *Biette.*
|| *Gli e di necessita che per la grandezza della chiocciola di bronzo, la quale ha da essere fatte in modo che la non balli nella staffa.*
¶ *A quella si attacca nella testa di sotto un pezza di corrente e bisogna che sia commesso in nella testa di sotto nella detta trave.*
** *Cioè a un lungo corrente. I give on the next page a diagram of what the upper portion of this machinery was probably like. Or it may be as Prof. Roberts-Austen shows it in the drawing in his Cantor Lecture on Alloys, Society of Arts Journal, March-April,* 1884.

note well this method of striking with the screw, for, though it be more expensive, the impressions are better, and the dies not so soon worn out. Of the gold and silver medals I struck many straight off without softening them first; & as for the cost, perhaps after all it only appears greater, for whereas in the method of striking with the screw* two turns of the screw will complete the medal, in the method of striking in the *coniare* process at least one hundred blows with the stamps are necessary before you get the desired result.

**Colpi di conio.*

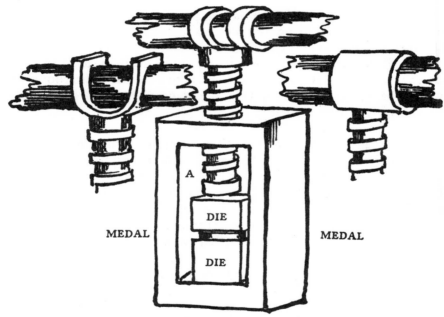

MEDAL MEDAL

AT 'A' WOULD COME THE
FEMALE SCREW, AND THE
WEDGES WOULD COME AT
THE SIDES OF THE DIES.

CHAPTER XVIII. HOW TO WORK IN LARGE WARE, IN GOLD AND SILVER AND SUCH LIKE.*

FIRST will I speak of the methods I learnt in Rome and then of those that are used in Paris. Indeed I believe this city of Paris to be the most wonderful city in the world, and there they practise every branch of every art. I spent four years of my life there in the service of the great King Francis, who gave me opportunities of working out not only in all the arts of which I have been telling you, but also in the art of sculpture, and of that too I shall speak in its proper place.

*Cellini applies the term 'grosserie' to all large ware of whatever process & as distinguished from 'minuterie.'

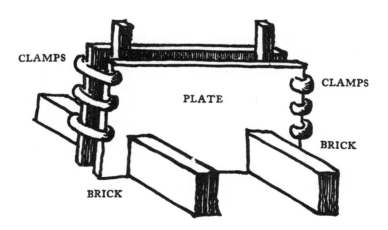

79

CHAPTER XIX. HOW TO BEGIN MAKING A VASE.

IT is quite wonderful what a variety of different methods there are for making silver vases. We might here begin with the casting of silver, and then little by little get on to other subjects. There are three ways of melting silver so that it shall not burn.* In the first you use the bellows, constructing round their mouth a little brick furnace sufficient to quite cover the crucible, even to be some four fingers above it; then rub the crucible all over, inside and out, with olive oil; put the silver into it & place it on the furnace; you should not have too many coals aglow at first for fear of cracking the crucible, for that is apt to happen with the sudden heat, but let it get gradually hotter and hotter, without touching your bellows, until it is red hot. At this point you gently start blowing with the bellows. After a while you will see the silver beginning to float like water; then you strew a handful of tartar over it, and while it stays a moment so, take a piece of linen folded four or five times & well soaked in oil, to lay this over the crucible when you remove it from the coals. Then swiftly take hold of the crucible with your cramping tongs,† a pair of tongs made specially for catching hold of earthen crucibles, for if you catch hold of these as you would of iron crucibles you would break them, but these special tongs support the earthen crucible so that there is no danger of its breaking. Meanwhile, the moulds for pouring silver in must be at hand; these are made out of two iron plates of the requisite size and as occasion shall demand, and beneath‡ them place a few square rods about the size of your little finger, more or less, as the work may need. The plates are then bound together with stout iron clamps, struck with a hammer till they grip the moulds equally all round. Of these clamps you need six or eight according to the size of the mould. Then you paint round the junction of the moulds with liquid clay so as to prevent the silver from coming through.§ When your moulds are well warmed, you pour a little oil into them, and stand them in an earthen pot of spent ashes, or even on the ground between four bricks, and so pour in your silver.‖ That is one of the methods of casting.

*Non si riarda. †Imbracciatoie. ‡'Infra': should perhaps better be 'between.' §Per cagione che lo argento non versi.
‖ The sketch on p. 79 may be taken as illustrative of the process.

CHAPTER XX. ANOTHER AND A BETTER WAY OF CASTING.

THE Florentine gold-beaters used to have another way of casting, which was called casting in the mortar,* for so was the furnace called in which the casting was done. You take a number of bands of clean iron† about half a finger thick and as broad as a thumb, and weave them into a round shape, about one & one-third cubits high, sometimes smaller, sometimes larger than this in accordance with the quantity of the work you have to cast. It must be interlaced into a domed shape to about two-thirds of its circumference, and from the iron that remains over you make four legs on which the furnace is to stand. Note that where these legs commence you must make a grating, the openings of which are wide enough to allow of one finger and a half being put through them, this serves as a base for the furnace. And the furnace itself you construct by means of fashioning a cake of earth mixed with cloth-shearings,‡ the kind of earth that glass-blowers use for their furnaces. Then you take a terra cotta tile and lay it on the base of your furnace, and strew a little ash over it. On this you stand your crucible filled with as much silver as it can hold, and set to work very carefully, much as you did in the previous method. You fill the furnace with coal, light it and leave it to get red by itself, for thus left, the draught will produce a tremendous fire, and you will cast better so than if you made fire with your bellows. I must warn you too, to make your crucibles out of clean iron, for earthenware ones would easily crack; this iron should however be coated over inside & out with a paste of clean ashes about half a finger in thickness, which must dry well before the silver is put in. Some take for this solution clay mixed with cloth parings, & the one is as good as the other. For the rest you proceed with your casting just as I showed you above.

* *Fondere nel Mortaio: perhaps better, mortar casting.*
† *Lame di ferro stietto.* ‡ *Cimatura.*

CHAPTER XXI. YET ANOTHER FURNACE. SUCH A ONE AS I MADE IN THE CASTLE OF ST. ANGELO AT THE TIME OF THE SACK OF ROME.

THESE kinds of furnaces are the best of all. It was dire necessity that taught me how to make them, because I had absolutely no means at hand for doing my work. Being in a confined place, where I had to set about using my wits, I made a virtue of necessity. I broke the bricks out of a room, & with these bricks I set to work to construct a furnace in the form of a bake-oven.* The bricks were arranged alternately, so that between every brick was an opening of about two fingers wide, & as I went on I narrowed them in upwards.† When I had raised it about a cubit's height from the ground, I constructed‡ a grating of shovel handles and spears which I broke. And from this point I continued building the furnace up and round to about one-and-a-quarter cubit's height, narrowing it in towards the top. Then I found an iron ladle which they were by chance using in the kitchen, & as it was pretty big I caked it round with a paste of ash & pounded clay,§ and filled it with as much gold as it would contain, and gave it the full fire straight off as there was no danger of the crucible cracking. When the first lot was cast I filled it up again, and so on, till I had melted up about 100 lbs. of gold. The whole thing went very easily, and 'tis about the best and simplest method you can employ. Perhaps you think that I ought to go and give you a diagram of it all here in my book, but I fancy that anyone who knows anything at all about the craft of founding will perfectly well understand by description. So that's enough for furnaces.

*Fornello a foggia di una meta.
‡Io lo avevo congegnato drento di modo che.

†E così lo andai ristringendo.
§Terra mescolata.

CHAPTER XXII. HOW TO FASHION VESSELS OF GOLD AND SILVER, LIKEWISE FIGURES AND VASES, & ALL THAT PERTAINS TO THAT BRANCH OF THE CRAFT CALLED 'GROSSERIA.'

WHEN the silver is cast in the manner described above, in the first furnace, it is as well to let it cool on the iron plates above mentioned because by so doing it contracts better.* When it is cold you clean off the rough edges from around it. This done, you make a scraper† about two-and-a-half fingers broad, & it should be blunted; to it you attach a stick shaped with two handles, and these are distant about half a cubit from the point of the scraper. Note that the scraper should be bent about three fingers,‡ and such as is used for sgraffito work, *graffiare*.§ With this scraper the silver plate is to be planed, and in this wise:

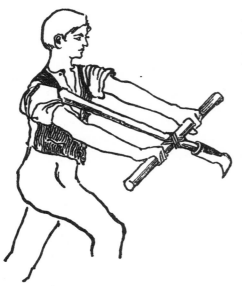

You make your silver plate red hot & place it on one of the iron plates you used for casting it on; fastening it on tightly with certain iron tools used for nailing or fastening,‖ then setting the handle of the scraper to your shoulder with your two hands to the two handles that you fastened to it, so that it comes to be in the form of a cross, you pare off the surface of your silver plate with very firm pressure till it is thoroughly clean.¶

* *Meglio e' si condensa.*
† *Rasoio: literally 'a razor.'*
‡ *Vuole essere piegato tre dite: perhaps, 'inclined.'*

§ *This may mean only hatching or cutting generally.*
‖ *Conficcare o congegnare.*
¶ *Mr. Heywood Summer tells me that the tool here described is not used in modern sgraffito work; it would by the description, however, be something like the diagram here shown.*

83

I won't omit to tell you of a method I once learnt. Whilst in Paris I used to work on the largest kind of silver work that the craft admits of, and the most difficult to boot. I had in my employ many workmen, and inasmuch as they very gladly learnt from me, so I was not above learning from them; the plates I planed with such diligence gave them cause for much marvelling; but, none the less, one charming youth, on whom I set great store, said to me, with the utmost modesty, that in Paris it was not customary to plane the plate in the way we did it, and albeit our method seemed very clever, he would undertake to produce the same result without all this planing, and so gain much time.

To this I replied that I should only be too delighted to save any time; so I gave him a pair of vases to do, weighing 20 lbs. a piece, and my models for them. Before my very eyes the youth melted his silver in the way I told above, & cast it between his iron plates. Then he cleaned some of the edges off and set too right away to hammer it into shape & give it its rotundity (of which more anon) without paring it in any way. Both vases he turned out in this way with great care and admirable technique.* It is just because in Paris more work of this kind is done than in any other city of the world that the craftsmen, from constant practice, acquire such marvellous technical skill. I should never have believed it had I not seen it for myself. Then, at first, I thought that it was the quality of silver that gave them a vantage, because they work here with a finer quality of silver than anywhere else; but my workman said no, & that silver of baser alloy would serve his purpose equally well. I tried him and found that it was so. From which I conclude, therefore, that a man can start straight away with shaping what he wants out of his silver without wasting needless time in planing it up first. Of course care has to be taken to remove certain little blemishes† from time to time. I do not go so far as to say that it is bad to plane the metal first: nay, I have found either way good.

Now let us consider how to make a vase in the shape of an egg. I follow, as always, my promised method of giving you of my own creations for different princes & great persons. In Rome I made, among many other vases, two big ones in the form of an egg each about a cubit high, with lips and handles spreading out from the top.‡ One was for the Bishop of Salamanca, a Spaniard, and the other for Cardinal Cibo; both were elaborately ornamented with foliage and animals of various kinds. These vases were called ewers,§ and were used by the Cardinals on their credence tables on occasions of state.

*Pratica.
†Sfogliette: probably little surface scalings of the metal.
‡Strette di sopra. §Aquereccie.
84

Inasmuch as I made numbers of these for King Francis, in Paris, and as they were all larger and more richly wrought, I shall draw my illustrations from them. You take your plate & trim off the rough edges, plane it on both sides, & slightly round the edges off,* and forasmuch as the plates are cast in somewhat oblong shapes, you beat them into a rounded shape with your hammer, and this is how you do it: you take your red hot plate, not too red, for then it would crack,† but sufficient, I would say, to burn certain little grains of powder or dust thrown on to it; & put it on the stake, and you beat it very firmly with the thin end of the hammer from one angle to the other driving the metal well to the centre,‡ so that when all the four corners of your plate are done it will be marked somewhat the shape of a cross.§ After this you reverse the process and work with the hammer outwards, annealing the plate some four times, till it is of such roundness as your good craftsman may see fit. And when it is rounded into the shape of the vase you have in mind you must see that the measurement of the diameter of your plate exceeds that of the future vase by about three fingers, and that the plate must be kept as thick as possible in the middle. Before you hit this size exactly you take an iron stake about a finger thick and six fingers long, as blunt as possible so as not to pierce the plate, this tool you put with its broad end on the anvil, and you very carefully balance‖ your silver plate on the point of the stake until it stands steady by its own weight. When the point is fixed, get one of your handy lads to strike it with the broad end of the hammer so that it makes a mark in the plate. I have no doubt there are masters who can find the centre point straight away without having recourse to this little dodge, especially when working on small plates, but for large pieces I have always found it very helpful. After this you turn the plate round again on the anvil & strike it in the same manner on the stake till the point, which so far was only indicated, is now boldly marked. Then you take your compasses & strike a circle which will show you how far your outline is out, and so on, hammering the silver in conformity with it by repeated heating and beating. All the while you have to be very careful not to lose your centre point, and to beat the silver out, as I said before, so that the diameter of the plate exceeds that of the future vase by some three fingers. Applying your compasses again, you strike a series of concentric circles about a half-a-finger apart from each other, & starting from the centre of the cup. Then you take a kind of hammer about one finger thick at the narrow end, and one-and-a-half at the broad end; this hammer is battered and rounded off¶ into somewhat the shape of the fleshy part of a finger, and with it you begin beating in the middle of

*Alquanto scantonato un poco. †Spezzerebbe.
‡E far che l'entri bene. §Verrà ferito in riscontro di croce.
‖Si congegna. ¶Scantonato e tonda.

the plate, at the centre point in fact, being careful always not to lose the point. The movement of the hammer should be in the form of a spiral,* and follow the concentric circles; you take turn about in beating and heating in this manner till you see the silver grow into the shape of a hat, or at least its crown,† & thus approximating to the form of your vase. The thing to observe is that the metal should spread equally all round, for if it gives more on one side than the other it would be uneven; and in this way you draw it inwards till it is as deep as the body of your model requires. Then with various different stakes, each adapted specially to the form you are at work on, you beat, now with the broad, now with the narrow end of the hammer, and right into the body of your vase till it is equally bellied all round; and when this has all been very carefully done, always working on the stakes—some of which are called 'cows' tongues'‡ because of their shape—you work up the neck of the vase to the necessary height, and similarly on other stakes specially curved for the purpose, you little by little narrow out the neck. Any little imperfections§ on the surface you remove as you go on, and so finally see the neck of the vase take the perfect shape you wish it to have.

When you have thus finished the neck, you can begin to work the bas relief on the body of the vase; like a vase, for instance, that I made for King Francis,‖ it was one among many, but it was the finest of the lot. I filled it with black pitch made in the manner I described to you before, then I divided out the body of the vase for the figures, animals & leaves, which I drew on it with a stylus of burnished steel. This done, I drew them over again with pen & ink, using all the delicacy that good drawing requires. Then I took my punches, these are of iron, about the length of a finger and about the thickness of a goose's quill. They are all shaped in different ways, some are fashioned like a C, beginning with a small c, and ending with a large one,¶ some are bent more, some less, and some are almost quite straight.** Others, again, are greater, diminishing from the size of a man's thumb to six different smaller sizes, and all these selections you ought to have. With them, and with a hammer weighing some three or four ounces, and striking most dexterously, you beat into relief whatever you have designed. Then you place your vase on a slow fire and melt out the pitch. After this you heat the vase once more and clean it with a solution of tartar and salt, in equal proportions as I described above. When the vase is quite clean you employ a set of iron tools like stakes and with long horns,†† technically termed *caccianfuori*, 'snarling irons': they are made of pure iron, long or short as the case may

*Chioccola. We had the word above as applied to the female screw. †Coppa.
‡Lingua di vacca. §Sfogliettina. ‖ See 'Vita,' p. 321. ¶ What our metal workers call semi-ring tools. **Curved chasers. ††Con le corne lunghe.

86

be, and as the work may need. These *caccianfuori* have to be fastened into the anvil stock,* then you put one of the horns into the vase, so that the point of the horn, which should be in shape and rounded like your little finger, is applied to the inside of the vase, & to the parts you want to beat out; and you very gently strike the other end of it with the hammer so that the blow passing to the end of the horn adjoining the body of the vase, bosses up the silver from within at such points as your learned and cunning master may deem well. When this process has been applied to all the figures, animals, and foliage, you heat and cleanse the vase once more, once more fill it with pitch, and with other sorts of punches, similar in all respects to the first, but having their ends shaped like beans, and large or small as the case may be, you begin the bossing again. Each master uses his own particular punches, & all have their own little ways of working, but all have this in common that the punches do not cut but only press the metal. The process of melting out & re-applying the pitch may now be repeated two or three times as may be thought necessary, till you have got your figures and foliage to the highest point of workmanship, then melt it out for the last time. After this you may proceed to fashion in wax whatever graces may have place at lip or handle, improving on the model or design with which you started. These finished, you can make them in all sorts of different ways, ways so many, that they were wearisome to recount. The easiest of these was the one I usually employed, and particularly in the vase I made for King Francis.† I took earth, such as the makers of artillery use, dried it and sifted it well, then I mixed it with fine cloth shearings and a little cows' dung sifted through a sieve, then I beat it all well together. After this I took some tripoli, such as jewellers use to polish their gems with, pounded it up very fine & made from it a pigment as for painting, streaking it over the wax ornaments. This I also did to the inlet holes and vent channels after I had duly affixed them to the models. I always took care to fix these vent holes down below, and pass them upwards, but at such distance from the inlet channel that none of the silver should spill into them, and thus prevent them doing their work. When I had applied the first coat of tripoli I let it dry. Then I took the clay of which I told you before & coated the work over to the thickness of a knife's back, letting it dry again, and repeating this process, till the different coats were about a finger thick. Then I bound it all round with iron bands as many as it could hold, over these iron bands I put more coats of clay, this time mixed up with rather more cloth shearings than I had used previously, & applied another coat again of a knife's back thickness. Then I applied the whole to a slow fire, holding the vent holes downwards, and so gradually melted out the wax, which I caught

* *Brinckman translates,* 'a vice.' † *This is the ordinary* 'cire perdue' *process.*

87

in a little receptacle down beneath. One has to be very careful not to have the fire too hot, for that would make the wax bubble, and so damage the mould within. When the wax is quite melted out, you remove the mould from where it is attached to the vase, clean it carefully of all wax, and close up the place where it is attached to the vase with the same earth that is used above. This done, you bind the whole thing round again with fine bands of iron wire, & cover it up completely with a further coating of the tripoli mixture. Then you heat it on charcoal, firing it and the charcoal together in a brick furnace; and mind to get it well baked, for this kind of earth differs from others, in that it should all be fired at one turn. Meantime, have your silver ready for casting, or I would say molten, and while this is in progress put your mould into a large receptacle filled with sand, which should be moist, not wet; & fix it in well as do the casters of artillery into their troughs, but with the greater delicacy that the handling of lighter metal requires.* When your silver is well molten, throw finely powdered tartar over it to keep it fresh. Then take a piece of linen, the size of the crucible, folded into four and soaked with olive oil, and spread it over the tartar that covers the silver; and grip the crucible with the tongs called *imbracciatoie*. You ought to have many kinds of these, small, medium, great, and adaptable to the quantity of silver you have to melt; they hold the crucible together and prevent it breaking—that happened to me many a time. Just as you've got your silver nicely molten and are pouring it into the mould, crack goes your crucible, and all your work and time and pains are lost! Take note therefore of this, while pouring your silver into the mould, let one of your assistants hold the linen rag from slipping from the crucible, for by so holding the rag on, it has two good results; it keeps the silver warm and it prevents the little bits of coal from falling into the mould. This also you may take note of: if you have little masks and suchlike conceits to apply to your vase, when you have fashioned them all carefully in wax and taken them off the vase having made moulds of them as above described, you lay in the hollow of the moulds a coating of wax, a thin knife's back more or less in thickness, or of such thickness as you wish your mask to be. This coating you spread equally all over. In the craft it is called the *lasagna*. When you have fixed on to it the inlet channel & the vent holes—just as I told you above, the latter fixed at the bottom & turning to the top—you fill in the whole with the clay, bind around with wire, and cast in the same way as before.† This method you can employ in the handles & the feet of your vase, where you find the hammer difficult to work with, and I counsel you in working large vases always to employ this method of casting.

*i.e., *smaller work.* † *This is probably what we should call a cored casting.*
88

CHAPTER XXIII. ANOTHER ME-THOD FOR GOLD AND SILVER IN SUCH THINGS.

LET us take another method of casting similar to the last; I have tried it often and found it splendid; 'tis this: You take some fresh, finely powdered and ground gesso, and you grind in like manner, & mix with it, a little brick dust, two-thirds of the latter to one-third of the former. Mix them well together with clean cold water into a paste; then take a hog sable, & working with its softest part, paint over your wax model as you did before with the clay. This time you put it all on at one go, because as you gradually paint along with your brush, the gesso as gradually sets,* so that you can soon lay it on to a finger's thickness with a wooden spoon. Then you bind the mould with fine well-tempered iron wire, weaving it all round, in and across, and, taking the thick rest of your gesso that has not been passed through the sieve, you moisten it with a little water & cake it on to the mould as before, to the thickness of a knife's back, till all the iron wire is well covered over. Of course, the larger your mould is the larger must this shell of gesso also be proportionately. You will do well, too, unless pressed for time in finishing your work, to let the gesso dry a bit in the sun or in a warm and smoky corner, so that all the moisture leaves it. Then you put it over a slow fire and melt out the wax as you did in the former process; let the fire grow greater when the wax has all melted out, & bake the mould just as you did before with the earthen mould. This is a good and an expeditious way to work in, and very useful if you want to finish anything quickly.

*Rappigliare.

CHAPTER XXIV. A THIRD ME-THOD FOR SIMILAR THINGS.

IN the third method the wax models are cut into small pieces, pow-dered and moulded in clay, and set in the troughs as described above. When the moulds are made, with due observance to the undercutting (I say this advisedly), lead castings are made from them, and these as well cleaned and worked up as the master may be minded; then they are cast in silver in the same troughs as I told you before. This is a particularly good way, because when the master has his lead model and has finished it up to suit his purpose, it can serve ever so many more times than a single casting.

CHAPTER XXV. OF FIGURES MADE IN SILVER & GREATER THAN LIFE SIZE.

NOW as to the way of making a great statue of silver; and when I say a great statue I mean as big as a live man or bigger. Statues of one and a half cubits high I have of course seen plenty of in Rome on the altar of St. Peter's, and albeit the making of these is pretty difficult and many excellent masters employ on them much admirable work, still these smaller statues present no great difficulties in the way of soldering, because they can be handled in the furnace entire; moreover they are made of thinner plates* of silver than the large ones. The actual process of both is much the same, but the large ones are so much harder to manage that I for my part have never seen any that were presentable. According to my promise of giving you some practical example either of work I have seen of others or of my own making, I'll tell you the following.

The Emperor Charles V. was passing through France in the time of Francis I., for the great war had ended, and Francis, my glorious king, among the other wonderful presents he had given to the Emperor, gave him a silver statue of a Hercules with two columns, which was about three and a half cubits high. You remember how I described above the beauty of all the things made in that great city of Paris—well, I have never seen anywhere else in the world such perfect hammer work as in that city, but with all their technique (in the methods of embossing) not even the best masters were able to give to that statue either grace, beauty or style;† and for the simple reason that they did not know how to solder properly, and so had to stick on the legs and the head and the arms by means of fastening‡ them with silver wire. Now King Francis wanted to have eleven statues like this made, and he complained to me that those men of his had not been able to undertake such a job, and he asked me if it lay in the art to do it & if I saw my way through. I replied that most assuredly did I see my way through, that I could do these things much better than talk about them, and that when done they would be one hundred times finer than was anticipated. And this was the way in which I began explaining it to that great king, and quoth I:

'There are many different ways of doing the thing & each master chooses

*Lamine. †From the point of view of the Italian cinquecento Master it would be correct thus to render the word 'arte' in this context.
‡'Legar la' Brinckman translates 'rivetting.'

the method to which his technical excellence or his fancy guides him. First of all you make a statue in clay of the size you want your silver statue to be, then you make a gesso mould of it in many pieces, and this is the way: The whole breast to the middle of the ribs at the sides, & to the juncture of the throat above & the legs at the groining below, forms one piece. The next piece comprises the back from the juncture of the neck and contains the shoulders and down to the buttocks. These are the two main pieces. In like manner must the arms, legs, and head all be formed into two pieces. And because the undercuttings would impede the removal of the pieces, these are filled up with wax. The gesso moulds are then respectively cast in bronze. And you have your sheet of silver handy of such size as may be deemed expedient by the skilful master, & commence to hammer it over the bronze with wooden hammers, carefully rounding the silver over the various forms; by means of frequent annealing these forms come to be beautifully covered. The discreet and cunning master in order to just connect separate pieces together* applies a few additional hammer strokes to their edges, and expands them to about two knife backs one over the other. These edges he cuts into jags about two fingers apart with a pair of scissors, fits the one into the other, and with nice judgment tightens them with a hammer, holding them over a round stake, or some other piece of iron as shall hinder the hammer from indenting the silver where it has nothing to back it. In this way all the pieces are done, first the body, then the legs, arms and head. After this they are filled with pitch, and wrought over with hammer & punches to an exact likeness with the original clay model, & finally soldered together into one.'

When I had delivered myself of these words to the King, he said it was all so clear & he had understood it all so well that he very nearly thought he would himself be able to undertake such work. Then I told his Majesty that there were other methods which a master thoroughly conversant with his craft might employ, and that these methods were really easier in execution though they seemed harder of explanation. Whereupon his Majesty retorted that verily he was a great lover of genius,† that I had spoken so convincingly of the first that he would willingly take my word for the other.

One of them was as follows: when I had cast the King's silver into sheets in the way I told above, and had my clay model of the subsequent size of

* I am not sure whether this gives the right shade of meaning to 'attestarsi,' but I follow Brinckman.
† Virtù.

the silver ready completed, I went straight at the job, with sheer ability of hammer work* together with my general skill of craftsmanship, striking from front and from back in whatever way the art demanded. By this method I got through much quicker than the first. Arms, legs and body I hammered out in separate pieces, and the head in one whole piece just as it were a vase, & in the manner I told of once before. When I had given them all their shape I soldered & fitted them together as before. The solder I used was *ottavo*, that is a solder composed of one-eighth part of an ounce of copper to one of silver. To do the soldering I had fixed to the tube of my big bellows several channels of such length as I deemed necessary for the purpose of blowing from below on the beds of coal that I had placed under the back of my work. When this and the coal was aglow, that is, of a golden colour, I blew the bellows on it gradually and made the solder run, and I kept on with this, now applying it from above, now from below, wherever I thought it necessary, and going from point to point.† I have said nothing about borax, for it stands to reason, as anyone who knows anything about his business is aware, that no soldering can be done without it. If it turn out that, owing to the length of the pieces, some of them are not completely soldered and that fresh solder and borax is needed, I used instead of water to take a bit of tallow candle in order not to have to cool the whole of my large piece, & on this ointment I put my new solder and borax, and this had the same effect as the water. Thus did I solder all the different members, head, arms, feet, each for itself, filled them with pitch, & with my punches gave the last finish but one‡ to my work. Then came the job of soldering the big pieces together, & that was where those great French experts failed.

I built in the middle of one of my large rooms—and I mean exactly in the middle—a little wall about one cubit from the ground, four cubits long, and one-and-a-half wide; and after fitting the parts to the body I bound them on with silver wire instead of iron wire which is usually employed, and in this way, doing three fingers' width at a time, and not without the greatest difficulty, I bound the two legs to the body. Then I laid it on the wall over a good fire, and applied *quinto* to it, *i.e.*, solder composed of one-fifth of an ounce of copper to one of silver—I say copper not bronze,§ because copper is easier to treat with the punches and holds better, albeit it does not run quite so easily. As I worked with eleven-and-a-half silver

Virtù del martello.
†*E nulla spequevo, etc. I take this to mean that he moved the heat of the flame about and about from point to point.*
‡*Penultima mana.*
§*Ottone. Cellini would have used the pure copper, not any alloy, for this purpose.*

to half copper* I had nothing to fear as far as the latter was concerned; & I would have everyone aware that if he wish to make his job succeed he must not employ inferior silver.

When my work lay in position I began, with four of my young men, to blow the fire with the aid of fans and hand-bellows until I saw the solder run, when I every now and then sprinkled a little soft ash over it, for if one were to use water instead of ash, one would not be able to add fresh solder where the old has run imperfectly. In this manner, following just the method I have described, I happily succeeded in soldering the whole piece with breast, legs, arms, & head; & ere ever a piece cooled I managed to solder it on; the whole thing succeeded most admirably, & was just lovely! So the entire statue, which was about four cubits high, was lifted off the fire all soldered; I cleaned it up with the tools for cleaning, which I described before, filled it with pitch, and gave it the final polish with the punches. Then I fixed it on a base of bronze, the latter about two-thirds of a cubit high, with sundry little subjects in bas-relief gilded and beautifully executed. The statue in question was a figure of Jupiter† holding the lightning bolt in his right hand, and from the lightning a torch was kindled; in his left he held a ball to symbolise the world. Round the head and the feet was abundance of ornamental detail; & all this was admirably gilded, the which was most difficult to do.

Nor will I omit to tell how I cleaned‡ up the silver of so large a piece of work, albeit I have already described to you the process of cleaning silver, for there were exceptional difficulties in this case. I did it thuswise: I went to the shop of a dyer of woollen cloth and got one of his big vessels,§ large enough to put my figure in, which, as I said, was about four cubits high, and weighed about 300 lbs.; then I took four iron rods, each about four cubits long, and four chestnut staves, somewhat longer than the iron rods. When the figure was carefully cleaned of its solder, and made smooth and polished and carefully pumiced over, we lifted it with the four iron rods on to a big bed of coal spread out on the ground, and large enough to hold the figure. This we did not do, however, till the coals were burnt out, had lost their vigour, and were well spent; then we covered the figure all over, shovelling the embers upon it, a very tiring job this, as you may imagine, because of the heat and fume of the embers. We went on shovelling them about over the statue wherever the need was, till the whole piece was of

* *Argento di undici leghe e mezzo. Twelve being quite pure, this would give about as little alloying metal as will work well.*
† *See references to this in the 'Vita,' p. 145, and elsewhere.*
‡ *Bianchire.* § *Caldare.*

94

an equal red heat all over. Then we raised it with the four iron rods, let it cool, and when it was cold had ready our vessel* with the blanching solution,† that is to say, water with tartar and salt composed as I described to you above, and into it we placed the figure by means of the four wooden staves, for the solution must not be touched by iron. When inside we stirred it about and scrubbed it all over with certain big hog sable brushes much like those used for whitening walls & objects of similar size. When we saw it getting white, we took it with great care out of this vessel and put it into another similar one, but filled with pure water, & here we carefully washed all the blanching solution off it. Then we poured off the water and dried it very carefully; after which we set to gilding whatever parts had to be gilded. Though the gilding of this statue was a much harder job than you can possibly imagine, I do not intend here to enter into those difficulties of detail, but will confine myself to saying a word or two about gilding in general. Forsooth, it is a beautiful and marvellous craft this, & it well becomes your big masters to know of it, so that they may guide such as practise professionally. I knew many, both in France and in Rome, who applied themselves only to gilding. But none the less I say that great masters ought not to practise this themselves, for the quicksilver that has to be used for it is a deadly‡ poison, and so wears out the men that practise in it that they live but a few years.

*Caldare. †Bianchimento.
‡Smisurato: Cellini refers to the fumes.

CHAPTER XXVI. HOW TO GILD.

WHEN you want to gild you take the purest, cleanest, 24 carat gold, & you beat it out with clean hammers on an anvil, until you get it to the thinness of a sheet of writing paper. Then you cut up as much as you want into small pieces. After this you take a new crucible never yet used & such as goldsmiths melt silver and gold in, and into it you put so much quicksilver, free from all impurities, as may be needed for the gold you want to employ. The proportion is at the rate of one ounce to a scudi's weight, that is to say, one part of gold to eight parts of quicksilver, rather less than more of the latter. Note that you should first mix together the quicksilver and the gold in a clean vessel of earth or wood, and you put the crucible on a fire of glowing embers, but not using the bellows. When the crucible is red you throw into it some of the mixed quicksilver and gold, hold it over the fire, and with a glowing ember gripped in a pair of tongs stir it thoroughly together. Your eye & the feel of your hand will tell you whether the gold be dissolved and united with the quicksilver. Great care has to be taken to aid the solution by rapid stirring, for if you hold it too long, the gold, or rather the amalgam will get too thick; if, on the other hand, you hold it on too short a time, it will be too thin, and the gold not well mixed. The great care which this requires can only be got by practice. When it is all mixed & dissolved, & everything done in the manner described, you take the hot mixture & pour it into a little beaker or vase in accord with the amount of the gold you have mixed, and this vase is filled with water, so that you hear it hissing when you pour the mixture in. Then you wash it thus two or three times in other clean water, till finally your water is quite clean and pure, and then you set about the actual gilding as follows.

Wherever you want to gild on your work you have to get it well polished & scratch-brushed,* for so it is called in the craft. These scratch-brushes are made of brass wire about as thick as thread† & done up into bundles about as thick as a man's finger, more or less, in accordance with the size of the work you want to scrub, & tied round with brass or copper wire. Of course you can buy these brushes at a grocer's, but there they are usually sold only of one size; so that your skilled workman if he wants to do his work well, and has a large piece to do, binds up his own brushes himself according to the size he wants.

After the scrubbing, you put the amalgam on with an *avvivatoio*,‡ for so we call the little rod of copper set in a wooden handle, & much the same

* *Grattapugiata.* † *Refe di cucire.* ‡ *See 'Vita,' p. 252.*

size and length as a table fork; here, again, the size accords with the requirements of your work. Carefully then do you proceed to spread the amalgam over the places you want to gild. True it is that some have put quicksilver on first, and then spread the amalgam after, but this is not a good method, for too much mercury dulls the colour and the beauty of the gold. Others, again, have thought to do better by putting the gold on in successive times. This I have likewise seen done, but have come to the conclusion that the best way is to put all the gold on at once that you want for your gilding, and then heat it over a slow fire, till all the quicksilver goes off in fumes. If you notice that the gold on your work is not even, you can, while it is still warm, very easily add on as much as may make it so, till all is covered with gold. Then let it cool by itself. I forgot to say in its proper place that if the gold won't stick on you will do well to have a little of the whitening water* of which I told you above, and you dip your *avvivitoio* with the gold in this water, & if that still won't help you, take a little aquafortis evaporated and weakened, and there's no doubt that will do it.

Bianchimento.

CHAPTER XXVII. A RECIPE FOR MAKING COLOURS & COLOURING THE GILDED PARTS.

THE first is colour for thin gilding. You take equal proportions of sulphur, tartar well pounded, and salt, grinding them separately, then you take half a part of cuccuma* and you mix them all four together. When you have the gilded parts well cleaned & scratch-brushed, as I described above, you take a little urine of children or boys, put it tepid into a clean pipkin and apply it with hog sables, and the virtue of the urine and the sables will remove any dirt or grease that may have come on the gold. This done, you get a copper cauldron, or mayhap an earthen pot, & in one of the twain, after filling it with boiling water, you put your colour composition & stir it well up with a rod or a bunch of twigs till it is thoroughly dissolved and mixed. Then you tie a bit of string, long enough to hold it by, on to the work, and dangle it in for such time as one might say an Ave Maria; after this you pull it out and dip it into a vase of clear cold water. If it has not taken colour enough you put it back again into the hot water, and so on for two or three times till it be sufficient, minding, however, not to let it stay in over long or else it will turn black and spoil the gilding. This colouring matter is the weakest one can make and can only be used for one turn.

*More correctly, 'curcuma' : turmeric root.

CHAPTER XXVIII. A RECIPE FOR MAKING ANOTHER SORT OF GILDING COLOUR.

TAKE red chalk,* verdigris, saltpetre, vitriol, † and salts of ammonia, but half as much of the first as of the other ingredients; take each by weight, and pound each separately; and be careful to pound them very fine; when pounded stir them up in clear water to the consistency of a paste, and while you are stirring see that you go on grinding them up till all the particles are well blended. This done, you must put them in a rather big vase because the composition bubbles up; and mind that the vase has a glazed surface, or better still be of glass, and let it be corked. In order to put the colour on, your work must needs be thickly gilded, or else it will turn black, for this colour is very powerful. But if it be sufficiently strongly gilded the work will colour beautifully. The colouring stuff is applied with a paint brush, but you must mind not to touch the silver or you will black it. Painted over in this wise you set your work to the fire, give it a good steaming and dip it into fresh water, but you must mind not to overdo the steaming or the gold would be eaten away and not hold.

* *Matita rossa.*
† *Vitriuolo: probably green vitriol*, i.e., *sulphate of iron.*

CHAPTER XXIX. HOW TO MAKE A THIRD GILDING COLOUR FOR VERY THICK GILDING.*

TAKE the work you want to gild, & in the same way as described above, clean it† and gild it, then skilfully dry it; don't be particular as to drying it too much, only let it be free of all quicksilver, then clean it again lightly and heat it over live embers. Whilst it is in process of heating spread on it a kind of wax which I will describe below.

When the wax is spread, let the work cool, then have a fire ready of such nature as shall melt off the wax without heating the metal to redness. When heated in this way, rinse it out in a solution of tartar and water—what among goldsmiths is called *grommata*. This done, let it stand for such time as you can say an Ave Maria, then clean it with a brush in fresh water, rubbing it well.‡ If your work has been well gilded, you may further colour it with the process I shall tell you of shortly. But as to do so you have first to wax it, I had best tell you to begin with how that wax is made ; and 'tis in this wise.

Che sia abbondantemente carico d'oro.
†*Cellini refers to the preliminary cleaning with urine described in Chapter xxvii.*
‡*Ristiara di buon vantaggio.*

CHAPTER XXX. HOW TO MAKE THE WAX FOR GILDING.

TAKE five ounces of new wax, half an ounce of red chalk (that is to say, red stone chalk for drawing*), half an ounce of Roman vitriol,† three pennyweights‡ of *feretto di spagna*,§ that is of the weight of a ducat, or one-eighth of an ounce, or it may be a bit less, half an ounce of verdigris, & three pennyweights of borax. Mix all these things together and melt them with the wax, & apply them as above described. After this, when the wax is cleaned off, you can give it the colouring that follows hereunder.

* *Lapis rosso da disegnare; French, 'sanguine.'*
† *Vitriouolo romano : sulphate of iron.*
‡ *Denari.*
§ *Possibly calcined sulphate of iron ; French, 'ferret.'*

CHAPTER XXXI. HOW TO MAKE YET ANOTHER COLOURING.

TAKE half an ounce of Roman vitriol, half an ounce of saltpetre, six pennyweights of salts of ammonia, half an ounce of verdigris, and pound them upon a stone, do not use iron. Pound the salts of ammonia first very carefully, then all the others together. Then mix them in a glazed vessel* with as much water as shall make them have the consistency of a sauce, stir them over the fire with a piece of wood, & let them boil for such space as you can say two Paternosters. Do not give them a strong fire for that would spoil them. Everything in moderation. Let them cool, and use them as is here written in the manner following.

*Pentolino.

CHAPTER XXXII. THE MANNER OF APPLYING THE SAID COLOUR.

LET your work be dried with a clean cloth, then by means of a few feathers streak it over with the above concoction in the same way as you did when colouring the gold with the verdigris mixture. Then put it on the fire. When you see it drying and beginning to steam hard (do not let it steam quite dry) dip it in cold water. Then clean it up, & once again let it simmer slowly in the tartar solution* for such space as you may say an Ave Maria; yet again clean it in water and polish it where you will. This gives the loveliest gilding and of the most beautiful colour that can be made, and lasts for ever.

*Bollire freddo nella grommata.

CHAPTER XXXIII. WHAT YOU DO WHEN YOU WISH TO LEAVE BARE THE SILVER IN CERTAIN PLACES.

WHEN you have cleaned up the parts where the gold is not to stick, you take some flour dust, such as you may gather on the walls and cornices of mills, & we in Florence call *fuscello*, and you mix it with water to the consistency of a paste, and with a (camel's) hair brush lay it thick on the parts not to be gilded, after which you dry it well before a slow fire, and can gild safely.

Another way, too, may be employed where the flour dust is not used. You take gesso in the cake,* such as the shoemakers use, pound it up well, and make a paste of it either with stag glue,† or better with fish glue,‡ but mind that either glue be well mixed with water, so that it does not get too stiff. And inasmuch as I want to omit nothing, I bid you note that this gesso is best employed when you merely want to gild and leave the silver white, whereas the flour dust method is best used when you want in addition to colour the gold as above described. This is as much as you need know about such matters.

Now though, of a truth, the prime merit of every craft is your being well able to practise it yourself, yet none the less it were better to leave these processes of gilding to those who are specialists, for it is as I said very unhealthy§ to practise. Know *how* it's done, that's all.

**Gesso in pane.*
†*Colla cervona. Probably a glue made of stags' skins or chippings. In 'Cennino Cenini' is a footnote on glues, quoting from 'Dioscorides' a glue, colla taurina, hence possibly 'cervona' from 'cervo.'*
‡*Colla di pesce.* §*Perniziossima.*

CHAPTER XXXIV. HOW TO MAKE TWO KINDS OF AQUAFORTIS, ONE FOR PARTING,* THE OTHER FOR ENGRAVING & ETCHING.

FIRST I will talk of that mixture with which you etch on copper instead of cutting with the graver, this is an easy and a very beautiful method. Aquafortis for etching is made thus: you take half an ounce of sublimate,† one ounce of vitriol, half an ounce of rock alum,‡ half an ounce of verdigris, and six lemons; and after having care to pound the first mentioned substances well, you boil them a little in the lemon juice, but not so as to let them get too dry. The boiling should be done in a glazed pot, and if you have no lemons you may take strong vinegar which will give a like result. When you have well smoothed your copper plate you can take any ordinary varnish,§ such as is used for the lacquering of the ornaments on daggers and other iron work, & heat it gently, putting a little wax with it, this you do to prevent the varnish from cracking when you draw upon it. It must not be too hot when you spread it on your copper plate. When you have etched on your design make a ridge of wax round the plate and pour on the parting water, letting it stand not longer than half an hour. If then it be not bitten deep enough, do it again. Then remove it and clean it well with a sponge. You draw on the varnish with a stylus of well tempered steel, that is an iron needle, which in the craft is termed a *stile*. You wash the varnish off the plate with a sponge of warm oil, but very softly so as not to destroy the intaglio. Then you use the plate & stamp impressions on to card-board from it in just such a manner as plates done with the graver. It is true that this sort of plate is produced very easily, but then, you see, they don't last near so long as those done with the graver.

Acqua da partire is the acid into which you put alloys and clippings, filings, etc., to separate gold from silver, or silver from copper, or gold from gilt copper, in other words nitric acid. Partitore is the man who exercises this trade. Hoepli's Manual, 'Oreficeria,' published Milan, gives information about the modern way of using acids for 'separating or parting.'
†Solimato : can this be sublimed sal ammoniac ?
‡ Allumi di ròcca.
§ Vernice ordinaria.

CHAPTER XXXV. HOW TO MAKE AQUAFORTIS FOR PARTING.

AQUAFORTIS for parting* is made thus. You take 8 lbs. of burnt rock alum† & an equal quantity of the best saltpetre, and 4 lbs. of Roman vitriol, & put them altogether into the alembic,‡ add to these things a little aquafortis that has already been used, exercising your discretion as to the quantity. And in order to give a good luting§ to your alembic take horse-dung, iron filings & brick-dust in equal proportions, and mix them up with the yolk of a hen's egg, then smear the mixture over the alembic as far as the furnace will allow. Then for the rest put it to a moderate fire, as the wont is.

*Partire.
†Allume di rôcca arso. Prof. Church tells me that this is probably sulphate of alumina, from alum shale.
‡Boccia. Biringoccio in the fourth book of his 'Pirotechnica,' Venice, 1540, Chap. I., gives an illustrated description both of such an alembic and of how aquafortis for parting is distilled. See also the French edition of the same book translated by 'Jaques Vincent.' Rouen, 1627.
§Loto: the closing of the joints.

CHAPTER XXXVI. HOW TO MAKE ROYAL CEMENT.

TAKE the gold you wish to refine and beat it thin, cut it into little pieces of the size and the thickness of a golden scudo. Sometimes the scudi themselves are taken and a twenty-four carat cement refined direct from them; and this simple* cement has such virtue that it can draw all the alloy† out of the scudo itself without destroying the impression on the coin, but drawing from it only what was of base metal.

The cement is made in this wise: Take tartar and brick dust and make a paste of them; construct a round furnace‡, & into the joints of the furnace between one brick and another spread the paste; put your pieces of gold, or the scudi themselves, if you use them, into the paste, and cover them well up with more of it; then fire for twenty-four hours, at the end of which time they will be refined to twenty-four carats.§

Know, gentle reader, that this screed of mine is not writ for the purpose of teaching such as are refiners‖ by profession how to make aquafortis, my only care is to show how & to what end it may serve the art of goldsmithing; for it came about that having made certain golden figures half-a-cubit high for King Francis, when they were near the ending, during the softening in the fire, it happened they got a film of lead fumes across them, and had I not covered them over with this cement lotion they would have gone brittle as glass.¶ Then I gave them six hours moderate firing, and so in this way freed them from so evil a blemish.

*Cellini may intend a stronger sense to the word 'semplice.'　　　†Lega.
‡ See above, furnace construction.
§ Cellini appears not to have quite understood the process. Geber, who gives the oldest description of it, 'Alchemiae Gebri Arabis Philosophi Solertissimi Libri, etc. Joan: Petreius Nurembergen denuo Bernae excudi faciebat,' anno 1545, p. 51, gives the ingredients thus : 'Vitriol (ferrous sulphate), sal ammoniac, flower of copper (scale of oxide of copper formed by heating the metal with access of air), ground old earthen pot, sulphur in the smallest quantity or none at all, man's urine, together with similar sharp and penetrating substances,' etc. See Percy's 'Metallurgy,' Murray, 1880; Part I., p. 385. Prof. Roberts-Austen adds that 'usually the " cement," and the gold to be purified, were placed together into a porous earthen pot, and not between the joints of the brickwork.'　‖Partitore.
¶ I am assured that this is a point of considerable scientific interest.

THE END OF THE TREATISE
ON GOLDSMITHING.

THE TREATISE ON SCULPTURE.

Nymph of the gateway of Fontainebleau (see p. 111). Louvre.

THE TREATISE ON SCULPTURE.

CHAPTER I. ON THE ART OF CASTING IN BRONZE.

AS in other places I have done, so now will I do afresh, & in order to give more surety & confidence to him that reads this screed of mine, adduce examples from sundry great works in bronze that I made for King Francis while in the glorious city of Paris. Those bronzes in part I finished, the greater part I left imperfect. One of the completed ones was a lunette about eight cubits across, made for the gateway of Fontainebleau. For this arch I fashioned a statue about seven cubits long in rather more than half relief, it was a figure personifying the fountain. Under its left arm were vases, from which water seemed to flow, and its right arm was posed upon the head of a stag, a great part of whose neck was brought out in full relief. On one side of the lunette were a number of dogs, that is to say setters* & greyhounds; on the other side were fashioned stags and wild boar. Above the lunette I made two little angels with torches in their hands as signifying victory, & over the whole was the salamander, the emblem of the King. There was abundance of rich festoonment, and two great satyrs for the pilasters of the gate. These latter were not cast, but were left in a state ready for casting. The lunette, however, was cast in several pieces, & the first and biggest was the nymph of Fontainebleau herself.† Her head & other portions of her body stood out in full relief, while the rest were in half relief. The way I fashioned her was as follows. I made a model in clay of just the size the figure was to be; this done, I estimated that the shrinkage would be about one finger's thickness. So I very carefully went over the whole, touching it up and measuring it as the art directs.‡ Then I gave it a good baking, and after that I spread over the whole an even coat§ of wax of less than a finger's thickness, similarly adding wax where I thought it needed it, or even taking a little away from off the waxen coat that was over the whole.

*Bracchi. †See Cellini's allusion to this in the 'Vita.'
‡Misurando come prometta l'arte.
§I interpret this to mean that he made measurements with a view to regulating the subsequent wax coat which was in the end to be replaced by the bronze. Brinckman interprets it otherwise; according to him the meaning would be that because of the shrinkage Cellini gave the figure another coat of clay, but this appears to me to imply a misunderstanding of the process. See also, Symonds' interpretation of this method in the 'Vita.'

This method I pursued till I had completed it with infinite diligence and care.

After this I pounded up some ox bone, or rather the burnt core of ox horns. It is like a sponge, ignites easily, and is the best bone that you can get anywhere. With this I beat up half a similar quantity of gesso of tripoli,* and a fourth part of iron filings, & mixed the three things well together with a moist solution of dung of horses or kine, which I first passed through a fine sieve with fresh water, till the latter took the colour of the dung.

The whole formed a composition which I applied to my model with hog sables, arranging the bristles so that their softer and external ends formed the end of the sable, and were thus tenderer to work with; and so gave the whole figure an equal coating of the composition all over, then I let it dry, and similarly gave it two more coats, each time letting them dry. These coats were every one about the thickness of an ordinary table knife's back. This done, I gave it a coat† of clay about half a finger thick, let it dry, gave it another coat about a finger thick, let that dry too, and finally gave it a third, of the same thickness.

*Gesso di tripolo. †Camicia.

CHAPTER II. HOW THE ABOVE-MENTIONED CLAY IS MADE.

THE clay you use is made thus: You take such clay as is used by the ordnance makers for their moulds. It may be found in many places, but preferably near by rivers, for there it has a certain sandiness,* still it must not be too sandy, suffice it if it be thin, for the rich clay is delicate and soft, such as is used for small figures, cups, plates, and so forth, but not good for our purpose. Also you will find it in hills and grottoes, particularly round Rome and Florence, and in France at Paris. The clay from the latter city is the finest I ever saw; but as a rule the clay from grottoes is better than that from rivers.

In order to obtain a good result you must let it dry, and sift it carefully through a rather coarse sieve in order to get rid of any pebbles or bits of root or of glass, & such-like things. Then you mix it with cloth frayings, about half as much of the latter as you have clay; and take note that here is a wondrous mystery of the craft that has never yet been used by any but me. When the clay and the cloth frayings are mixed and bathed with water to the consistency of a dough, you beat the mixture up well with a stout iron rod about two fingers thick; and, for this is the secret, you let it decompose for at least four months or more, the longer the better; for then the cloth frayings rot, and owing to this the clay gets to be like an unguent. To those who have not had experience of this little trade secret of mine the clay will appear too fatty, but this particular kind of fattiness in no wise hinders the accepting of the metal,† indeed it accepts it infinitely better, & the clay holds a hundred times more firmly so than if it had not rotted. I have used this kind of clay in ever so many most difficult works, all of which I shall tell of in their proper place.

*_Aliquanto renosa._ †_Lo accettare il metallo._

CHAPTER III. ANOTHER METHOD OF CASTING FIGURES IN BRONZE OF LIFE SIZE OR A LITTLE UNDER.

MODEL the figure you wish to cast direct in the clay and rag composition above described. Finish your model most carefully as regards its proportions and its details of design, in fact just as you wish to see it completed. When you have finished your figure, working it part in the fresh & part in the dry clay, as the art may require, and wishing to cast it in bronze, you give it a covering of painter's foil* in order to do which you first take a certain quantity of turps, heat it in a cauldron or pail, and when it is heated to boiling, streak it very carefully all over the figure with a hog's sable, taking heed not to injure a single muscle, vein or other subtlety, and so very carefully apply your foil. This foil has to be beaten into very fine sheets such as the painters use in many places, as for instance on their canvasses for painting coats of arms; it is well enough known all the world over. Well, you put this foil over the clay figure, and as you have to make a mould of gesso over that, you oil the whole figure well first. Were it not for the foil it would be but ill protected against the humidity and cohesive† power of the gesso, but with the foil it is well protected. In this way you work to great advantage, for after the figure is cast in bronze you still have your fine original model before you; and many youths & able workmen can help you clean the bronze figure up, while if you have no model to work to, this cleaning up takes a long time, is little to the poor master's liking, and has but a sorry result. This was what happened to me when I made the Perseus for the most illustrious Duke Cosimo, and which may still be seen on his Excellency's piazza. This, which was a figure of more than five cubits high, was made in the first of the two described methods; that is to say, it was modelled in the clay composition, & finished one finger's thickness under actual size;‡ then it was well baked, and the coat of wax modelled over it as in the case of the nymph of Fontainebleau. After this it was cast all in one piece. In order to remove the core§ so that the figure might be lighter, I made through the wax a number of holes in the flanks, shoulders, and legs, and at such places where I required them; the result of this was that the core was kept in its place. Moreover, I put over the wax those unguents which I referred to in the case of the nymph of Fontainebleau, then the two or

* *Stagnuolo, i.e., tinfoil.*
‡ *E finito magro in circa un dito.*

† *Forza.*
§ *L'anima, or internal block.*

The Perseus *of the Loggia dei Lanzi (see p. 122).*

three coats of clay, next I bound it round with the iron of which I shall tell directly, & then I cast it. This casting was, owing to its size, the most difficult casting ever made. But because I am now minded to tell of the casting of a smaller figure, I will not muddle things too much by leaving my theme. Later on I shall not fail to enter upon a little dissertation about my Perseus.

Now I have to repeat, then, that the clay figure must have a kind of paste spread over it with a very soft paint brush, & little by little the foil is laid upon it. This paste is made of flour dust, and prepared in the way shoe-makers do it, or the mercers, when they make barettas & satchels and such like, and you must mind to make it very fine and thin, and when you have put the foil in little pieces all over it and the whole figure is covered, you can make your gesso mould.

There are divers ways of making the gesso moulds. The best, however, that I have come across and that I mostly use myself, is to make as many small pieces as when put together would make a complete man, and that without any undercutting—as for instance feet, hands, head. These small pieces must be made with great care; and while the gesso is moist you fit into each of them an iron wire bent double, and projecting out of the gesso much like a little ring, so as to be capable of holding a thread through it. Each time that one of these small pieces is finished it must be tested, and you must see if you get a good impression from it & if the piece relieves. Then if you see that the impression relieves without spoiling a single trifle of your work's delicacy, you put the piece in its place again, and with all a good master's ingenuity take the next piece off it, leaving no rift whatever in between them such as would scar the work; & so you go on little by little, making the whole series of pieces, observing the undercutting and what-ever is demanded for the head, hands, feet, &c. In this manner you care-fully make your division right down one half of the figure, I mean the half, taken lengthwise, coming over the belly and the breasts down to the hips, and from the bottom of them to the half of the heels.* Mind, however, that with these small pieces the figure is not entirely covered, but leave a part of the breasts, a part of the body, a large part of the thighs, and as much of the legs. You must take care, too, that the pieces be so placed that they may be fitted together as one, but there must be no undercutting be-cause over this half figure will have to be cast a coat† of fine gesso more than two fingers thick. Before doing this, however, you must mind to cover up with a little clay the iron rings which I told you before were to be put on the small pieces, so that in putting on the coat they do not hin-

*E da basso in sino alla metà dei talloni. †Camicia.
115

der it from being lifted off. After this you carefully paint over with a brush of olive oil all such parts as shall come in contact with this coat in order that when the gesso is set the coat may easily relieve. When you have tried a piece to see if it will relieve, put it back in its place, and finish the other or back half of the figure in the same way as I bade you do the front. You must be very careful when you have finished your mould to take some strong thick cord and bind the whole figure together from top to bottom, putting a lot of little wedges of wood in order to tighten the rope yet more and prevent the gesso from twisting* and buckling. In order not to run any risk of such twisting you keep it thus bound up till all the moisture has gone from the gesso. When you see it quite dry you unwind the cord and open the mould, and that is your first mould.† This in small figures may be of two pieces only; when I say small figures I mean life size or less, these may be made in two pieces; if they be larger than that you must make them in four pieces, *i.e.*, one piece on each side from the top to the navel, & another on each side from the navel to the bottom of the figure. In order to fit better together these pieces must overlap the one upon the other a distance of about two fingers. This all minutely accomplished, you proceed to open the mould and lay it back downwards on the ground, that is to say with the concave sides of it facing upwards, and you take off one by one all the little pieces sticking to the figure and put them into the cavities made by them in the mould;‡ at the same time removing the little bits of clay which you put on the iron rings; and in every place where the clay has left impressions, bore a hole with a small gimlet§ into the mother mould, and attach to each iron ring a piece of strong cord. This cord you pass through the holes in the mother mould, and tie each piece up in this manner with a little splint of wood. When you have thus fitted all your little undercut pieces into the mother mould,‖ you grease the whole mould with soft lard, & proceed to give it what is technically termed the *lasagna*, which is a cake about a good knife's back thick of wax or clay or paste.

This is made thus: you take a piece of wood and with the chisels cut out in it a square cavity the shape of a man's palm and of the depth of a good knife's back, more or less, in accordance with the thickness your figure is to have. Then you keep squeezing your cake (or *lasagna*) into this wooden shape, & apply it to the gesso mould of your figure so as to let one piece touch the other. Then you lay the two halves together on the ground side by side, and construct an iron framework which serves as a skeleton for

Torce. †Che viene a essere quella prima camicia.
‡Or 'mother mould' as the sculptors would call it.
§Succhiellino di tutti quei pezzi che ti tenevano i sotto squadri.
‖ Da poi che tu arai vestito tutta la tua camicia.

116

the figure, and this must be made tortuously and in accordance with the direction of the legs, arms, torso, & head of the figure. This done, you take clay beaten together with shavings of cloth—the thin clay of which I told you before*—and little by little fit it round the skeleton, letting it dry, now by patient waiting, now by holding it before the fire, till the whole of your mould is filled. Then you test the two parts by repeatedly applying the one to the other. When this framework of earth and iron, which is called the kernel, *nocciolo*, fills the figure so completely as to tally all round with the *lasagna*, you take it out, bind it round with thin iron wire from head to foot and give it a good firing. Then you streak it over with a thin solution made of powdered bone and thin brick dust mixed with a little of the clay and cloth frayings, and apply it again to a rather slighter fire, this time so that the solution shall also be fired, then you take the *lasagna* out of your mould. You must be very careful, too, to leave some pieces of the iron skeleton sticking out in at least four places, for they will keep the kernel from shifting, and these projections must tally with the gesso mould. When the *lasagna* is removed you once more grease the gesso mould with fat, a little soft bacon fat is best, and it is also well to have it warm, for then it combines better with the gesso.

Then you make the inlet holes in which you want to pour your wax, and fit the kernel into the mould; then stand the figure up straight & make at least four vent holes, two at the feet and two at the hands, the more you make the surer you will be to fill your figure with wax.

The vent holes you make thus. The first two you place right at the very bottom of the feet, and it will be better for you to set your figure on a little eminence in order to do this more easily. You must take a stout gimlet,† and carefully bore a hole with it, and this is best done if slanting downwards, and see that you leave no fragments in the mould as you do it. When you have made these holes, you take a number of canes, which you skilfully bend, & so fit together that they start from the holes below and turn up straight alongside the figure, binding one cane to another & all together into one up towards to the top of the figure. You must be careful, too, wherever the bits of cane join, and wherever they fit into the holes, to smear them well round with a little moist clay so as to prevent the wax from oozing out.

After this you can heat your wax, &, when it is well molten, pour it in. This process now can be easily effected, however difficult the pose of the figure may be, if you observe the various little hints I have given you,

*Page 113. †Succhielletto.

117

& above all give heed to the vent holes at the base. After you have filled it with wax let it thoroughly cool for a whole day—if it be summer, say two days. Then undo the bindings with great care; & loosen all the little bits of string that tie the pieces together within, and are made for the undercuttings as I so carefully explained to you before. When you have uncovered the one half, you may complacently begin to try it from either front or back; & I tell you this, the fact of your having let the wax stand for that day or two according to the season of the year, will cause a slight shrinkage in the wax of about the space of a horse's hair, and so you will find it quite easy to remove this first piece from your figure. Then lay it down, and proceed to do the like to the next piece, & you will do well to lay both on long narrow benches, so that you can get underneath them with your hands.

After this you remove from the figure all the pieces of the mould attached with the bits of string through the iron rings one by one ever so carefully, and you polish & remove very nicely all the rough edges that may have been left on the figure by reason of the joinings of all the different pieces, and in this manner you touch up the whole. In doing this, moreover, if you are minded to add any subtle labour or fancy to your work, you are easily able to do it. After this* you fashion in wax, just as you erst made them for the earthern mould† all the vent holes for the bronze casting, & mind that they all slant downwards to the bottom; later when the figure has its last & earthen mould on, these vents may easily be turned up with clay. The method of doing this I shall describe minutely later as soon as I have shown how all the different coatings‡ from first to last are applied, the mould bound up and the wax emptied out.

Here all I want to insist on is that the vents must be made to bend towards the bottom, because, when that is the case, the wax is more easily melted out; if they were otherwise you would have to turn the mould up and down, which would give trouble, & you would run risk of spoiling it. But if you do it as I tell, you are absolutely safe. Then note this too, it is of the utmost importance that in melting out the wax your fire be so tempered that the wax does not boil in the mould, but comes out with the greatest patience. When the wax is all out give the mould yet another but very moderate firing, in order to get rid of any moisture that may be left in the mould. Then you may give it a regular good firing, first casing the mould in a coat of bricks set one above the other, & at about a three fingers' distance from the mould; this firing should be of soft wood, such as elder, lime, beech or twigs. Any green wood, or

*E di poi che tu ti sei resoluto. †Tonaca ‡Loti.

the wood of the oak, is to be avoided, and use no charcoal whatever, because all these fuse the clay and make it become like glass. There are some earths that do not thus cohere, and such are used in glass & bronze furnaces. I shall not fail in the proper place to tell you of these, but at present let me continue my narration of how to prepare our mould for the casting of the bronze.

Dig a pit near your furnace in front of the plug at the outlet hole,* which pit should be so big as not only to contain your figure, but also be half a cubit deeper, and in order that you can give the proper fall, the mouth or inlet hole† must be at least a quarter of a cubit above the head of your figure. So also as in the case of its depth, the pit should be half a cubit larger in width than would be needed to hold the mould. Then take the mould out of the bricks in which you baked it, and when it is cool bind it very carefully with a rope which should be strong enough to carry it, then fasten a pulley to a beam in the roof, & the rope through the pulley, and see that you provide a windlass sufficiently strong to lift your figure. As I don't want to omit certain little details, which may be well learnt from experience, I may mention that when I made my Perseus, for that the work was so very large, I lowered it into the pit with two windlasses, which were weighted with more than 2,000 lbs., but a small figure of three cubits would not need more than one. 'Tis true you might do without any windlass at all for the latter, but that would be very risky, because it might tend to move the kernel of the mould, that is the core‡ or inner block, or again it might knock the shell§ outside it. The windlass obviates this danger. And so you very very gently hoist the figure up, & move it to the mouth of the pit, & with equal care you unwind the windlass and lower it to the bottom.

When the figure is standing in position, with the inlet hole† in a line with the plugs‖ at the outlet hole,* the first thing you have to do is to fit on to the vent-holes certain tubes of baked clay such as are used for water-pipes. Of these there are plenty to be got in Florence, so that I was provided, and I used some of them bent, & those for the bottom pieces, and in all such instances when the vents were turned downwards; and fitting one tube on to another, I brought them into one straight line upwards.

This done, you take the earth you dug out of the trench and sift it well; then mix it with sand, which, however, ought not to be too soft, with this mixture you fill up the pit. The mixture of sand & earth it may be

*Dinanzi alla spina. †Bocca. ‡Anima. §Spoglia. ‖Spine.

observed need only surround the figure to the extent of a quarter of a cubit, for the rest, the plain unsifted earth as you dug it out of the trench, will suffice to fill up the remainder of the cavity. When the earth has been piled in to the extent of about one third of a cubit, you go into the pit with two rammers,* which are a kind of wooden instrument three cubits long & about a quarter of a cubit broad at the bottom. And with these you pound the earth and weld it well together. In doing this you must take great care in no way to knock at the mould, it will be quite sufficient if you come within four fingers of it, and instead of the rammers, press it with your feet, still take great care not to shake the mould. This ramming in you will repeat every time you have shovelled another third of a cubit of earth into the pit. Every time, too, that the earth fills up to the level of the top of the vents, take another of the terra cotta pipes and add it on, binding the juncture round well with a little clean tow in order to prevent the earth getting into the vents, for that would stop the passage of air and so hinder your figure from coming. In this way, taking heed of the vents as you fill in the earth, you pass from base to legs, from legs to flanks, from flanks to arms, till at last you get earth and vents on a level with the top of your pit. Then you proceed to make the passage† down which the bronze is to flow. Also you must take care that as soon as you begin putting your figure into the trench, you begin at the same time to fill your furnace with the bronze and heat it, so that your mould shall not get damp from too long standing. All these things if they be not observed ofttimes prevent the mould from filling.

When the pit is filled up to the mouth of the main entrance‡ where the bronze is to be poured in, and also having allowed for the necessary fall from the mouth of the plug§ whence the bronze is to issue from the furnace, & having carried up all the vents as described, you keep both them and the mouth of the main entrance carefully plugged with a little tow. Then you take a lot of square tiles and make a pavement of them round the vents. As there will be more than one entrance channel for your bronze, you must take note that the flooring in question comes right up to the ingress holes of the bronze. Then you take bits of hard dry bricks broken up into pieces of three fingers or more in thickness, according to your cunning master's discretion and according to the fall your bronze may need, & then these bricks you plaster together with liquid clay and cloth shavings in lieu of mortar, on the top of your flooring. Note further, that of these same bricks you construct a channel from the wall of your furnace and running right round the ingress holes of your figure.

*Mazzapicchi. †Via. ‡Bocca principale.
§Bocca della spina, i.e., the egress channel.

Then you take bricks, baked or unbaked (the latter are better, though there's not much difference)* and wall up the channel to the requisite height, the thickness of a brick wall will suffice. You construct it by laying brick upon brick & making the height of the wall equal the width of the channel.† When you have carefully joined together with your moist clay instead of mortar all the cracks through which the bronze might ooze out, you remove the tow plugs in the ingress holes of the bronze, and in their stead fit some easily removable stops of moist clay made so that you can take them out without difficulty, for you have almost immediately to bring glowing coals into your channel, and with these you cover all the parts that have been walled up with clay till they are well dried, and the fire must be renewed several times till they are not only well-dried but baked.

When all this is accomplished, and your metal meanwhile has got well fused, carefully blow with the bellows all the ash and cinders out of the channel, till none remains to hinder the passage of the metal; then take out all the plugs that close the vent holes, and the earthen stoppers in the ingress holes, & throw some two or three tallow candles, under one pound in weight, into the channel. Hereupon run to the mouth of your furnace and refresh it with a certain quantity of pewter of rather more than the ordinary alloy, *i.e.*, half a pound per cent. (*i.e.*, of bronze)‡ more than what you have hitherto used. When this has been very rapidly done, heap up more and more fire of green wood in your furnace, and then with your iron crook (*mandriano*) for thus the instrument is called, boldly strike away the plug of the furnace, & let the bronze run; gently at first, holding a point of the iron crook in the mouth of the plug, till a certain quantity of the metal has run forth, & its first fury be spent, for if you did not do this you might run the risk of your mould being stopped up with wind. Then you can remove the iron crook from the mouth of the plug and let all the bronze go till the furnace be emptied. To this end it is necessary to have a man standing at each of the furnace mouths, who, with the scraping iron§ which is used in the craft, drives the bronze

Con tutto ci sia poco differenzia.

†*Accomodandoli intorno al tuo canale tanto quanto viene alto.*

‡*E rinfrescala con una certa quantita di stagno di piu della lega ordinaria, la quale vuole essere circa una mezza libbra per cento di piu della lega che vi arai messa.* Professor Roberts-Austen is of opinion that this implies an additional half-pound of pewter for every 100 lbs. of bronze you have in the furnace. If it is not so, should the word 'pewter' be translated 'tin'? that is the lead-tin alloy should contain half-pound more tin (than is usual) in every 100 lbs.

§ *I rastiatoi.* Brinckman has 'kratzeisen.'

121

towards the outlet, until all is cleared out. Such of the flowing metal as is still left after your mould is filled you dam by means of throwing on to it with a shovel some of the earth you erstwhile dug out of the trench. That is how you complete your mould.

Not to be omitted are divers and terrible mishaps that occur from time to time, and often bring to nought all the poor master's pains. So 'tis a wise thing to profit in good time by the experience of others. Ofttimes we figure casters call in the help of ordnance founders* to aid us, but the most terrible misfortunes not infrequently occur owing to their insufficient experience and want of care, and all our labour is lost. Just such a thing very nearly happened to me when I was casting my Perseus, for, calling to aid some of those fellows, I found them so absolutely devoid of sense that in their stupidity they all swore my mould was spoilt, and that there was no means of righting it, and all this thanks to the muddle they themselves had made with my metal.† The statue was more than five cubits high & its pose was a difficult one, for in its left hand it held raised aloft the head of Medusa, in the hair of which was much rich detail of serpents; while the right hand was held behind in a vigorous action, & the left leg was bent. All this variety of limbs made the casting most difficult, and for this reason I was ever so keen to get it good, and also because it would be the first big work I had produced in Italy, my fatherland, & the veritable school of all the arts. So I was moved to even greater pains and diligence than I had before used to complete my figure well. So, therefore, I set to making a great number of air vents, and ever so many flowing-in mouths that all diverged from one main one, the which ran down at the back of the figure from the height of the head down to both heels and spreading out a bit at the calves. All these little hints are part of the craft, and in this manner did I practise it when I wrought in France. As I had to do almost everything with my own hand, owing to the intense bodily fatigue to which I was subjected a violent fever seized upon me. I struggled against it for many hours, but in the end it floored me, and I was brought to bed. As I had those different masters of ordnance and statuary founders working for me, I explained to them before I laid me down, exactly the methods I had begun, and how these were now perfectly easy to understand, as more than half the figure was already covered, & the greater part of the difficulties surmounted. All that they had to do was to follow my instructions in detail, and that appeared easy enough, so, being utterly incapable of holding out any longer, I flung myself on my couch.

* Maestri d'artiglierie. See above.
† See the account of this in the 'Vita,' p. 420 and onwards.

Meantime the men worked at my furnace which I had so well prepared and in which the bronze was nearly molten* and ready for completing. Now they had a good six hours' work still to employ them in order to fulfil all my instructions in proper sequence, because they were not quite skilled in the technique of the craft, and because my methods were different from those they usually employed. Well, instead of doing what they were told they began larking about, neglected the furnace so that the metal commenced to curdle, or, as it is called in the craft, to cake, *migliaccio* they call it in their lingo. Nary a one knew a remedy for this blunder, for in a round furnace like this one the action of the fire upon the metal is from above, were it from below it would be easy enough to heat the curdled metal again; so not one of them knew a remedy. Then as I lay there prostrate on my bed with fever, one of them in whom I had a little more confidence than the rest, came to me, and speaking very gently, said: 'Benvenuto, resign yourself to the worst, the furnace has been ill prepared,† a cake has formed on the metal.'

Then I turned myself toward him and had all the other craftsmen summoned in whom I put any confidence, and asked them if they knew any remedy. Whereupon these precious fine fellows said there was no other remedy but to break up the furnace, & in so doing, as the mould was buried six cubits in the ground, they could not see (they said) how the mould could help being spoiled. For even if I tried to dig up the ground round it, which had been plugged fast, there were so many ingress holes & vents that it was dead certain to be spoiled. That, forsooth, was the only remedy they had!

Now, gentle reader, picture to yourself my state,—I in all my ills & sickness—this new trouble thrust upon me—all my honour at stake—why I felt the keenest grief that ever man could imagine! But this was no time to give way to grief. Suddenly, as in a frenzy, my old inborn daring came upon me; it's not a thing one can learn, this! it's in a man's nature! Furiously I leapt from my bed & literally frightened away that grievous fever with the biting words I shouted at those fellows.

'Oh you good-for-nothings! who not only know nought, but have brought to nought all my splendid labours, at least keep your heads on your shoulders now and obey me; for from my knowledge of the craft I can bring to life what you have given up for dead, if only the sickness that is upon me shall not crush out my body's vigour.' Thus hounding them on I ran with them into the workshop, and in one go ordered six of them to different

*Condotto il mio bronzo in bagno. †Stata a disagio ei s'e fatto un migliaccio.

duties. First I bade one of them fetch me a load of dry oak that was stacked opposite the house of Capretta, the butcher; & as soon as this came I began throwing it into the furnace several pieces at a time. Now, though I've said it once before—as it's so very important I'm going to tell it you again, & it's this: in bronze furnaces the only woods you use are elder, willow, and pine, for all these are soft woods; in this particular instance, however, I used oak, because I wanted the greatest possible heat, and thus the metal began to move at once. To two others I bade with long iron rods to keep poking into the furnace mouths because it was storming with wind, and raining cats and dogs, & wind and rain was blowing into my furnace; by these means I showed them how to stave off wind & rain. Two others I set to work to quench the fire, because a part of the workshop had caught alight, and several great wooden windows were blazing like the devil, so that I was in terror lest the whole roof should be aflame, so tremendous was the fire. With the others, and there were plenty of them, I set to work clearing the channels, through which the metal was to run, and to opening all the vent holes. Scarce was this done when, all on a sudden, just as the work was being completed, owing to the terrific heat of the burning oak, the whole cap of the furnace was blown up into the air, and the metal began to well over on all sides; they stood in utter astonishment, all of them, —for they had obeyed me fearsomely—to see the caked metal thus again liquified. The strength of the fire, however, had consumed all the tin alloy, so I ordered to be thrown in a thick pig of fine pewter. When I saw this was of no avail, and that by God's grace the metal was already beginning to flow & to spread itself on the sides of the furnace, I ordered two others to run into my house and fetch hither all my pewter plates and dishes, 200 lbs. weight in all, and threw them in bit by bit. Then I made another take iron crooks and strike out first one & then the second of the plugs, which were very hard. Then, as the metal began to flow through the channels, I, little by little, threw the thin pewter plates into it, which, owing to the immense heat, combined with the other pewter, so that my mould was soon filled. Seeing all this mass of metal run in so well without any bubbling or even a single hitch, I concluded that all my vents were doing their work. The amount of metal left over just corresponded exactly to the extra quantity thrown in, so that my mould was completely filled. When this was accomplished I gave thanks to God, and turning to the lot of them, said: 'D'ye see how everything has its remedy?' Spite of the pain such was my delight that I felt no more fatigue; the fever just went to the devil, & I sat down to eat and drink with a light heart, together with all the lot of them, and everyone marvelled thereat.

Once, too, in France, when serving King Francis, & being anxious to cast a lunette of over six cubits in diameter, and containing numbers of figures

and animals, and other things, much the same occurred owing to a like blundering of my assistants. For although the founders in those parts, especially in & around Lutezia, where they turn out more of it than in any other place under the sun, are safer in their technique than any others, still, as they are deficient in the fundamental principles of the art, they lose their heads and give all up in despair when anything exceptional occurs. I anticipated a similar accident to that which I have just described with my Perseus on another eventful occasion; for, though the incidents were very different, there happened to be one thing that differed from customary methods.* My people were all in despair, and even I myself was much troubled at seeing them so, but with my wonted pluck, and owing to my thorough knowledge of the art I was here again able to bring a dead horse to life.† When those ancient masters of the art (who were present on that occasion) saw this they blessed the day and the hour that they made my acquaintance; though I, who was their pupil, knew well that it really depended upon what I had learnt from them. They worked according to tradition,‡ this tradition I mastered; and I will gladly describe the rule on which it was based, and how this rule stood me in stead.

But let us return somewhat in order to continue the course of our narration. For though we have digressed a bit we have not diverged from the method of our subject, and can easily return to it. We have shown how the mould is made and the casting done, and we have evidenced this with a statue about three cubits in size; there yet remains another method, in itself much easier, but not so safe as the above-mentioned one. The point of this is that instead of making the core§ of your figure in clay, you make it of gesso mixed with burnt bone and pounded brick. Provided the gesso be of good quality this method is more easy to practise, because instead of applying one coat after another, as you do in the clay method, you can make the gesso liquid; that is to say, having combined the ingredients just stated, one portion of gesso & an equal portion of bone and brick, you make a sort of paste of it which you pour into the mould over the solution (*lasagna*) and which soon sets.

After this, having taken off the mould,‖ you bind the core well round with iron wire, and cover this very carefully with a similar coat of paste, only rather more liquid. This done, the core is well baked in the same way as the earthen one was in the previous method, and the wax poured over it into the mould just as described above.

* *Una cosa la quale usciva di quella ordinaria praticaccia.*
† *Un morto:* our workshop slang of the 'dead horse' would seem to meet Cellini's meaning here. ‡ *Una continova pratica.* §*Nocciolo.* ‖ *Di poi sciolto il suo cavo.*

When the mould is removed the wax is cleaned round and the air vents arranged also just as before described, then you case the whole over with a shell of gesso also as before. When this shell is completed to the thickness of about two and a half fingers, you bind it all round with the same bands of iron two fingers wide, & then once again cover it all over with another coat of gesso.

After this the figure is placed in a furnace made entirely of bricks, & so arranged that when the fire is lighted the wax can be melted out into a receptacle set in a hole in the ground beneath the furnace, the wax flowing through the air vents, and these vents arranged in the manner above stated. When the wax is out you make up a good fire of wood and charcoal till the outer mould* of your figure is well baked, but you may take note that the gesso does not need near so strong a fire as the clay. True it is that the gesso in our part of Tuscany does not lend itself so well to works of this nature as that of Mantua, Milan and France. Several very able youths who have worked for his Excellency the Duke of Florence, have been taken in not once but two or three times, owing to the delusion that ours was the best way of making gesso. The most excellent Duke, who was ever a lover of thoroughness, very thoughtfully had patience with them, but our young men, unacquainted with the difference between the one gesso and the other, stuck to their own method, & remained unenlightened. From this you may take note that when a master wants to do a work he should make trial, not only of his clays and his gessos, but of all the things he proposes to use. In this way alone will he get credit by his work, and in no other way. In this connection I may make mention of the sorts of lime I have seen in Rome, in France, and in other parts of the world. The lime that keeps longest in the slacked state is the best & makes the firmest composition, but our Florentine lime ought to be used immediately after slacking; if this is done it makes the best lime and the firmest composition in the world, but it loses its virtue if left standing; with the foreign lime, however, the reverse obtains.

*Tonaca.

CHAPTER IV. HOW TO CONSTRUCT FURNACES FOR CASTING BRONZE, WHETHER FOR STATUES, ORDNANCE, OR OTHER SUCH-LIKE THINGS.

FURNACES for casting bronze have to be made by each master according as the special needs of his piece of work require it. Inasmuch as at the beginning of my book I promised always to illustrate what I was describing by work of my own, I will do so with furnaces also. When working for good King Francis, I had to make a great bronze gate, for which a special furnace had to be constructed. This I did in my own castle, given to me in royal letters patent by his Majesty, whom I served most loyally for four years; and these letters patent I brought back with me to Florence, if only to show in Italy & my native land what great treasures may not be acquired, and how good it is after having been trained in Italy to leave home, and reap such useful & honourable fruits abroad.

Well, then, having to make a furnace, this was the way I did it. The hollow within was three Florentine cubits wide, which made it about nine cubits in circumference, the height of the vault of the furnace was equal in size and shape to the half circle of the bed.* To this bed, most gentle reader, I want you to give special attention; I do not intend making a drawing of it, because I have seen so many architectural drawings altered and spoiled, so I shall content myself with words only to convey what I mean, and such as I trust may suffice.† In a furnace of this nature, the bed, *i.e.* the place where the metal is put, must be constructed with a fall, just as I made the little one in question. The total fall to the bottom of the bed should be about one-sixth of a cubit, and see that it is shaped in the manner of the streets you go a-walking in that have in the middle of them what in Tuscany we call a *rigaguolo* or gulley; this gulley runs direct to the mouth of the outlet hole out of which the metal is to flow. The shoulders‡ of the gulley should slope up ever so gently, till they come to within about one-third of a cubit at the two gates§ where you put the bronze. This third you can increase or not by one-sixteenth of a cubit according to whether you wish to increase or decrease the

* *L'altezza della volta di detta fornace si era il mezzo tondo della pianta della sua rotondita.*

† *See note, p.* 133. ‡ *Spalle.* § *Porte.*

depth of your furnace. The third door, about which you need not be so particular, is the one through which the fire enters, &, as it is not brought into direct connection with the bronze, it need only be blocked with a little mound of earth about three fingers high. The bed of your furnace should be of bricks, specially constructed, they should be small, but bigger at one end than the other, & measuring one-sixth of a cubit in either direction; by far the best are those used for glass furnaces, which are made much in the same way as other bricks. Some have shaped their bricks with a cutting instrument* as they went along, but I find, after having tried one way & another, that the best results can be obtained by having them all the same size. Care should be taken to make the bricks of a clay that does not yield in the fire; in my native city of Florence we use a kind of white clay, said to come from Monte Carlo, and all our glass furnaces were constructed with it. In France I found another and ever so much better way. The bricks are one-fourth of a cubit long, & the same width as the above, they call them *ciment*, and they make them out of crucibles used in founderies, of which there are no end in those parts. But your master has got to accomodate himself to the conditions of workmanship in every place he works in. When your bricks are thus made, they must when quite dry, be carefully worked over with iron tools, somewhat in the nature of axes or large chisels made specially for the purpose, so as to make them cohere as well as possible. After this they are gradually cemented with quarry stones† to the thickness of about half a cubit, so that you get an absolutely firm floor for your furnace. These quarry stones should be at least one-third of a cubit in size, and ever so firmly united. The first or lower part of a furnace of this description should be, in diameter two-thirds of a cubit larger than the upper portion. Both must be walled with ordinary lime, provided it be good, and after the lower, you proceed to wall the upper, the portion in which the bronze has to be placed.

Having fashioned your bricks out of the fire-resisting earth just referred to, you take some of this earth, and make a paste of it as you would of lime, minding however, that it is well sifted and clean, and with it wall the whole base of your furnace. I insist again upon the need of your working over the bricks with your chisels carefully, & smoothing them well, so that they fit together absolutely, and in thus fitting them, you must make the jointings as thin as possible. Sometimes it happens, owing to some little negligence on the master's part, if he mix the liquid earth too

*Literally, a knife. †Pietre morte.

coarsely, that the tiniest little cracks form in the drying. These cracks, however small they be, are mighty dangerous, & may cause incalculable mischief; for, when the bronze grows liquid, such is its terrific force, that it penetrates into them, be they never so small, and I myself have seen the whole thing burst up owing to this.* But when due care is observed, & the walling made with the finest possible liquid earth, there is no need for cracks, your bronze may be safely melted, and all your work come scatheless from the furnace.

After the bed you build up the vault with similar bricks in the same way, in doing which you must remember, as I said before, to make your two openings for putting in the bronze; two-thirds of a cubit wide and three-quarters of a cubit high will suffice them, and they must be semi-circular atop. There must also be a third opening two-thirds of a cubit wide and one cubit high for the fire to enter in at, so that the flame, as is its wont, may curl powerfully to the top of the vault, and thence curl down again,† and with great heat play upon the metal, & melt it rapidly. Four air vents have to be distributed round the spring of the top of the furnace vault.‡

In one of the vault bricks, at the lower end of the channel, a mouth must be made much like the air vents, & big enough for you to put in two fingers quite comfortably. The air vent too must be the same size. This mouth, out of which the bronze is to flow, must be made from one brick; & mind that it is a good sound one. The said brick, too, must, moreover, be built into its place just as the others were, and helping with them to gradually lock in the vault at the top. So that you don't think me inaccurate, I would have you know that this mouth is called *bocca della spina*, the mouth of the plug; it must be half a finger wider inside than out, and before you pour out the metal you keep it stopped with an iron stopper luted with a little ash made into a kind of paste. Then you take a quarry stone about half a cubit square & make a hole through the middle of it. This hole is to be exactly the size of the mouth just made in the brick, that is to say on the side adjoining the brick, but on the other side, the side away from the furnace, it is to be six times as big, and it should be cleaned off § outside. Then you join it to the brickwork wall of the furnace with the earth, & in the manner mentioned above; but because the base and sides of the furnace have also to be considered, as I said before, you cement these with good ordinary

Levato il fondo in capo: perhaps better rendered as the base blown up to the top.
†*In modern language, reverberate.* ‡*Dove la muove.*
§*Pulitamente sbavato: perhaps, well rounded off.*

lime. Similarly all the quarry stones must be the same size as the first piece, and be attached to the walling in the same manner, & they must be carried up to the height of the vault, but straight; so that in the event of any accident happening to the vault, for to that the craft is often liable, it may be mended or put in order. When you have walled your furnace round in this way you must be careful to join at the shoulders* of the principal orifice, by which the flame enters,† a hearth two-thirds of a cubit square & two cubits deep, measured from the bottom of this hole of the hearth. In this cavity you put six or seven iron bars, these are about two fingers thick, & of such length as to project beyond the sides of the hole about four fingers each way, and they rest upon pins set at intervals of about three fingers apart. This hearth made over the fire bars is constructed in just the same way, & with just the same bricks, and cemented with just the same mortar as was the furnace; it must stand from the ground to about the middle of the hole where the fire enters the fire bridge, and the part above this point must be narrowed to one-eighth of a cubit. Straight through this hole the wood is put. Under the grating a trench must be dug, & five or six cubits long, in the direction in which the draught is to pass through the grating into the hearth. Care must be taken that the draught only blows in one way, and that long-ways. We craftsmen call this trench *bracciaiuola*, the ash-pit, because all the ashes fall into it. How long the fire is to be kept up must be a matter of judgment; sometimes the master may have, owing to work he has to do on his mould, to keep it up for quite four or six hours. When the wood logs are burnt through, they fall into a great pile below the grating. And sometimes they heap up in such a way as to obstruct the force of the draught through the hearth, that it cannot do its work; heed must be taken then, that when the pile begins to grow big, the ashes must be raked asunder from time to time. To do this, you must have what we call a *rastrello* or rake, which you make as follows. You take a piece of iron half a cubit long and one-eighth of a cubit thick; on to the middle of this piece and at the upper and thicker side of it you weld an iron rod two fingers thick and two cubits long, at the other end of this is fashioned a ferule,‡ into which is fitted a wooden handle at least four cubits long.

Take heed, too, that when your whole furnace is duly made as above directed, you gird it round with two stout iron bands, the one round near the base, the other about one-third of a cubit higher up; the thicker and stouter these hoops are, the better, for I know by the experience of the

* *Spalle.* †*That is what would now be called the fire bridge.* ‡*Gorbia.*

casting of my Perseus how terrific the might of the fire is. The opening of the hearth through which the wood is put must be kept closed. The covering must be made in the form of an iron spade, of such a size as shall well cover the opening, and to this spade a handle of such convenient length that when, now and again, you have to manipulate it for putting on fresh wood or otherwise, you don't burn yourself. It stands to reason that before all these things are accomplished, the metal has already been put in the furnace, & it must be stacked up in such a manner as to admit of flames playing easily through it, for this will make the working of your furnace much more effective.

Know, too, gentle reader, what up to now I have forgotten to tell you, that when with due care your furnace is made, you must, before putting the metal into it, heat it well through for a space of twenty-four hours; for if you do not do this, you will not get the metal to melt, nay rather will it stiffen,* and certain fumes will result from the damp earth that will so impede your work that it may be eight days before your metal begins to flow. That is what happened to me in Paris. I had made a little furnace and had put my trust in a very excellent old fellow, quite the best of his craft and about eighty years of age; but he hadn't dried the furnace properly, and, sure enough, just as it was on the point of melting, & the fire at its fiercest, out came these earth fumes. When the old worthy saw that for all his heeding the metal was stiffening, he got into such a stew, the poor old chap, that what with his mighty exertions to overcome the difficulty, he fell flat down, and I took him for certain dead. Howbeit I had a great beaker of the choicest wine brought him, & since there was no such great risk in leaving the work as there was in the case of my Perseus; since, too, I served that most admirable of kings, and thus had not to bother so much about the peddling trivialities of making it pay, for however big it was it never mattered with him—I mixed a large bumper of wine for the old man, who was groaning away like anything, and I bade him most winning-wise to drink, & I stretched out my hand to him and said: 'Drink, my father, for in yonder furnace has entered in a devil, who is making all the mischief, and, look you, we'll just let him bide there a couple of days, till he gets jolly well bored, and then will we, you and I together, in the space of a three hours' firing make this metal run like so much butter, & without any exertion at all.' The old fellow drank, & then I brought him some little dainties to eat, meat pasties they were, nicely peppered, and I made him take down four full goblets of wine. He

*Agghiada.

was a man quite out of the ordinary, this, and a most lovable old thing, and what with my caresses and the virtue of the wine, I found him soon moaning away as much with joy as he had moaned before with grief. When the appointed day came the fumes had duly evaporated, the furnace was quite ready and well heated, & in two hours we cast 1500 lbs. of metal, with which I finished certain portions that were left of my lunette of Fontainebleau. And that is why I insist upon your well heating the furnace, and also upon making two little quarry-stone doors* at the furnace openings, and you make in each of them two holes one and a half fingers wide respectively, and four fingers apart from each other, and these holes serve for the insertion of an iron fork made specially to fit into them, with which now and again, as need occurs, you may open & shut the doors.

Remember, too, that each time new metal is to be put into the furnace it must be first put up against the doors† till it becomes red hot, for if you put it in too soon with the other metal already in, you run the risk of cooling the latter, & so caking it,‡ much as before referred to. Hence the very greatest care must be taken on that point.

In Paris have I seen craftsmen cast the most wonderful things imaginable, and also make equally wonderful blunders. And this is due to the fact that technical skill§ serves you up to a certain point, but in some accident, for instance, you need the deeper knowledge of the principles of the art that leaves technical skill on one side, as I have evidenced to you above.

Indeed I may add that I have seen 100,000 lbs. of metal cast at one time with so much ease that I marvelled at it, so great was the technical skill with which it was done; at another time I saw a little error made that might easily have been remedied. I stood & watched whether they knew how to put it right, and I saw them throw it up, work and all, and so lose hundreds of scudi. Willingly would I have shown them what the remedy was, but their presumption was so huge that had they not known how to

*Sportelletti.
‡Fare un migliaccio.
†In su li sportelletti.
§ La pratica.

put my remedy into practice, they would have been quite capable of saying that I myself was the cause of all the ruin. So I stood mum and grew wise at their cost.

Gentle reader, let that suffice about furnaces and bronze casting, and let us now turn to other branches of the art.

[*It is interesting to note that Biringoccio, a professed metallurgist, and a contemporary of Cellini, describing the reverberatory furnace* (reverbero) *in his celebrated metallurgical treatise 'della Pirotechnica,' 1540* (see above, p. 106), *the first accurate treatise of its kind, gives fewer details than Cellini; he gives, however, diagrams which are very precious. Cellini's decision not to give diagrams is much to be regretted. Biringoccio has, however, the following among other drawings of reverberatories. It serves to show what Cellini's furnaces would have been in sectional plan. The letters are mine. It will be observed that no chimney is shown.*

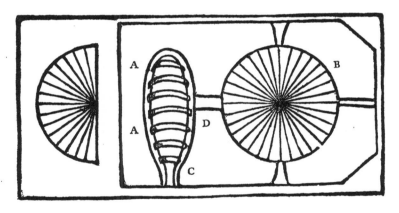

A. FIRE BARS WITH ASH PIT UNDER.
B. FURNACE BED.
C. FIRE DOOR.
D. FIRE BRIDGE.

133

CHAPTER V. HOW TO CARVE STATUES OR INTAGLIOS, OR OTHER WORKS, SUCH AS DIVERS BEASTS, IN MARBLE OR OTHER STONES.

THERE are many kinds of white marble, & since those of Greece are the most desired,* and the loveliest, let us consider them first. And well may I speak, for I spent some twenty years in the wondrous city of Rome, and while there, though I gave my attention to the craft of the goldsmith, I always had a desire to do some great works in marble; & I worked along of some of the first sculptors that lived in those days; and among them that I knew best was our great Michaelangelo Buonarotti, the Florentine, the man that wrought better in marble than any other ever known. Of the reason of this I shall duly speak to you in its place.

Let us tell, then, in the same way as we did before in other matters, of the qualities of marbles. I have seen five or more different sorts of marble. The first of these has a very coarse grain,† and in the grain appear certain bright points running close along side of each other. This marble is the most difficult of all to work, because it is the hardest; it is particularly difficult to fashion the more delicate forms in it without the chisel damaging or cracking them; if you do manage, though after much effort, to bring them off in this stone, they look lovely. I have found that the grain gradually softens through the five different sorts above mentioned, & the softest of all I have found verging in colour to a delicate flesh tint rather than a white. This sort is the most cohesive, the most beautiful and the tenderest marble in the world to work in.

Piu orientali. †*Grana grossissima.*

134

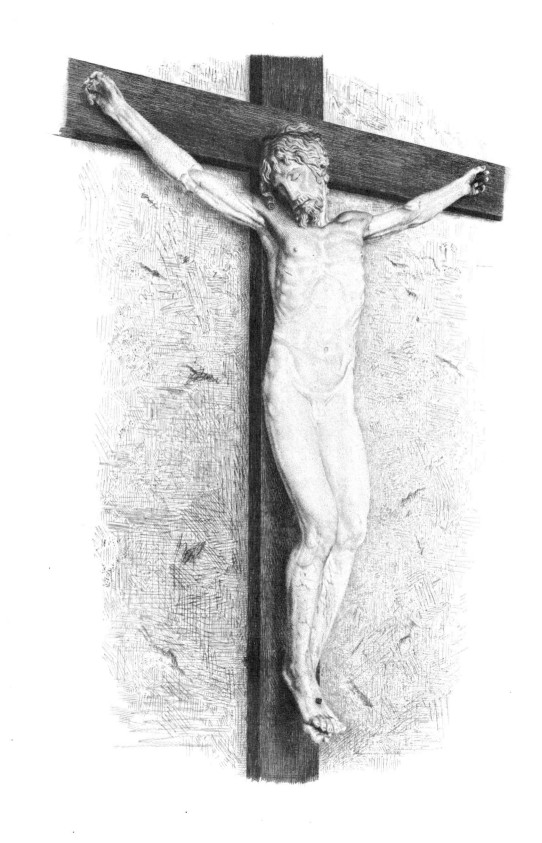

CHAPTER VI. OF CARRARA MARBLES.

THESE marbles are again of several different sorts. Some are coarse-grained with plenty of stains, * and spotted with black; these are very difficult to work in because the particular kind of stains they have in them eats into the workman's chisels. 'Tis bad luck to him if he happens on one of such stained blocks; for many times they deceive you with a lovely surface outside, while within are all these blots. At Carrara and in the mountains round are many different quarries, and here our great Michaelangelo came himself and spent much time and labour in choosing the quarry from which came all the great statues of his hand in the sacristy of St. Lorenzo, that he made for Pope Clement. Let us discuss this marble a bit.

Just as I kept my promise in dealing with the other branches of the art, of illustrating from my own notable works, so will I do likewise with this most noble art of sculpture. Indeed I have always held it to be most wondrous and beautiful, and, what is more, a good deal easier than any of the others; and so I decided to set my hand to a piece of work such as no man before had ever done. The work in question was the Crucified in marble. I fashioned Him in life size, of noble proportions, & set him upon a cross of black marble; this likewise was of Carrara, & is a very difficult marble to work by reason of its being so hard and brittle.

I destined this work for a tomb for myself; and I comforted myself with the reflection that even if the work didn't quite succeed, at least the intention was good; but so great was the determination that I put into the work, that what with all my previous careful studies, I overcame all the difficulties, and satisfied everybody. So, though of course † I have done lots of other works of this kind, I may content myself with instancing this one alone in illustration of marble.

To succeed with a figure in marble the art requires a good craftsman first to set up a little model about two palms high, and in this model he carefully thinks out the pose, making his figure draped or nude as the case may be. After this he makes a second model of the size his marble is to be; & if he wants it to he particularly good he must finish the large model much more carefully than the small one. If, however, he be pressed for

*Smerigli. †See 'Vita,' p. 475, etc., and note. This crucifix is in the Church of S. Lorenzo, in the Escurial. I give an illustration of it opposite.

time, or if it be the will of his patron who needs the work in a hurry, it will suffice if he complete his big model in the manner of a good sketch, for this may be quickly done, whereas the working out in marble takes a long time. True it is that many strong men have gone straight for the marble with all the fury of the chisel, preferring to work merely from a small and well designed model, but, notwithstanding, they have been less satisfied with their final piece than they would have been in working from a full size model. This was noticeable in the case of our Donatello, who was a very great man, and even with the wondrous Michaelangelo, who worked in both ways. But it is perfectly well known that when his fine genius felt the insufficiency of small models, he set to work with the greatest humbleness to make models of the size of his marble; and this have we seen with our own eyes in the Sacristy of St. Lorenzo. When you are satisfied with your model you draw the principal views of your statue on to the stone, and mind it be well drawn, for if not you may miscut your block. The best method I ever saw was the one that Michaelangelo used; when you have drawn on your principal view you begin to chisel it round as if you wanted to work a half relief, and thus gradually it comes to be cut out. The best chisels for doing this are those that have got, I might say, very fine points, but the handles of which are at least as small as the little finger. With this chisel, *subbia*, you approach to within at least half a finger of what is called the *penultima pelle*, the last skin but one; then you take a chisel, *scarpello*, with a notch in the middle of it,* and carry on the work further till it be ready for the file, *lima*, & this file again is called the *lima raspa*, or roughing file, or occasionally *scuffina*. There are ever so many sorts of this tool; there is the blade-shaped file, the semi-circular file, and others of varying sizes, five or six of them, from such as are two fingers thick to such as are the thickness of a very slender penholder. Stone borers, *trapani*, too, may be employed wherever you have to undercut any difficult piece of drapery, or any pose of the figure that stands free. These borers are of two kinds, one that you turn by means of a thong and a handle with a hole through it; with this you can do all the more delicate and minute interstices in hair or drapery; the other is larger and called the *trapano apetto*, which you use in those parts for which the first is inapplicable.

When the chisels, whether *subbie* or *scarpelli*, the files, and the borers have all done their work to the due completing of your figure, you proceed to polish the surface with a fine white, close-grained pumice stone. I must not omit to say for the guidance of those who are unskilled in working marble, that they may strike boldly in with their *subbie;* for the more delicate *subbia*, provided it be not inserted straight into the stone, does not

Con una tacca in mezzo.

crack the marble, but just chips off as lightly as possible whatever may be necessary; while with the *scarpello a tacca* the rough edges may then be brought to an even plane, & you go over the work with it just as if you were making a drawing for the surface. And this truly is the right method, and the one which the great Michaelangelo employed. Some have tried other ways, and thinking to have their work done quicker have sought to get their figure out by taking a bit off first in one place and then in another, but it took them all the longer in the end, and wasn't near so good; and indeed they mightily mistook, for oftentimes they had to piece up their figures, and yet with all their patching and piecing they could not remedy the mistakes which a want of discipline* and patience at the outset had led them into.

Gladly would I go on to describe the various kinds of *subbie*, *scarpelli*, and *trapani*, and likewise the mallets, all of which are of iron tempered, or of the very finest steel; but as everybody in Italy, nowadays, knows all about these things it really isn't necessary. Had I been writing in France I should have described another sort of stone which is very soft to work in, & also white, but not the brilliant white of marble, rather a dull white. This stone, after it is first quarried, is so soft and easy to work, that some masters, especially those of Paris, and I too, while there, wrought it with wooden chisels, only we notched them in various ways in order the easier to cut the work out according to the sketch. After this it was finished with delicate and close chisels, pointed tools† and *scarpelli* of all sorts. This stone, in course of time, hardened almost like marble, especially its external surface, but I never saw any that came up to marble when it was cleaned.

The ancients, you know, had so great a joy in things of this kind that they paid their sculptors with fine liberality, and so they came to investigate the most difficult things; amongst others they wrought in a sort of green stone, often nowadays called Greek stone, of the hardness of agate or chalcedony. Now though I have seen fair-sized figures in this stone, I have never been able to imagine how it was worked, for, though it admits of being smoothed with lead‡ and emery for the purpose of pavements and such things, I can only conceive that for carving figures out of it the ancient masters must have had some secret of tempering their steel, and so were enabled to overcome the stone's tremendous hardness.

There are yet other kinds of stone of which I have in Rome seen statues, both many and great, serpentine and porphyry, but more of porphyry, for the stone is somewhat softer. Up to our own day there was no one

* *Ubbidienzia.* † *Gorbie.* ‡ *Il piombe.*

137

who worked in this stone, till one of our Fiesolé carvers took it up, his name was Francesco del Tadda. This man with a fine cunning found out the way of working in porphyry. His patience was great, & he used little hammers, *martelleti*, sharpened like chisels, *subbie*, and other *scarpelletti*, which he tempered by a special process of his own.* Francesco made Porphyry busts just as fine as the ancients. Had he been equally strong in designing he might have done over life size work too, but let it suffice that he has the credit of being the first among moderns to practise this art. Would that his example might inspire all who have great work at heart, princely patrons as well as artists !

We have yet another kind of stone which is called granite. It is somewhat softer than porphyry and there are two kinds, the one is red and comes from the East, the other is white or black & comes from the quarries at Elba; it is very hard to work. The column of Santa Trinita that came to Florence from Rome is of this sort. Moreover it is durable and beautiful, but no statues have been made from this stone in our time.

There are still some other stones that must not be passed over, stones that we get from near Florence, Fiesolé, Settignano and other places. Of these, there is one of a blue colour, very delicate, & as charming to work in as to look at, the country folk call it *pietra serena*. Great columns are made of it, because it is found in large masses in the quarry, statues are made of it too; but it is no good for open-air use, for though it is beautiful it has no durability. Another sort & a veritable quarry stone† is the tan-coloured. It is soft to work in, statues are made of it, and it is so durable that it will resist all effects of wind and weather. Yet another sort, and this likewise a tan-coloured variety, is called the *pietra forte*, the 'strong stone,' & strong it is indeed, for it is desperately hard to work in, statues, weapons, masks, & many other things are made of it. You cannot, however, quarry it in very great pieces as you can the Fiesolé or Settignano varieties. I have mentioned these three sorts of stone because statues may be made in them. There are many others in and around Florence, beautifully marked stones, some hard, some soft, but as they are not used for figure work, I shall have no more to say about them.

*Altri scarpelletti pur fatti con sue tempere. †Pietra morta.

CHAPTER VII. A DISQUISITION ON COLOSSAL STATUES, WHETHER MODERATELY OR VERY GREAT.

MOST gracious of readers, forasmuch as I have always promised to illustrate my words with instances from my own created works, I would like now to tell you of another branch of the subject, and one that is both the most difficult and the most admirable of any so far described; allow me then to make the following digression, so that those who read may have means of pondering it well. I mean colossi; not necessarily the very great ones, because whenever a statue is three times bigger than life size it may be termed a colossus. I have seen plenty of such, both ancient and modern. But of the very great ones I have only seen one, and that was in Rome; it was in many pieces, & I saw the head, feet, part of the legs and other fragments of its great limbs. Upon measuring the head, which was standing upright and without the neck, I found as I stood alongside it that it came up to my nipples, so that it would measure more than two & a half Florentine cubits, the complete statue therefore must have been about twenty cubits high.

When I served the great King Francis,—it must have been about the year 1540,—knowing his consummate taste and his delight in everything rare and masterful, knowing, too, that such an object had never yet been fashioned by any living artist, I made among the other works before-mentioned a model for a fountain at Fontainebleau, or as one might translate it ' *Fontana Belio*,' 'the fountain of fine waters.' This model was square in form, and in the middle of the square was a square base rising four cubits above the water. It was richly ornamented with many pleasing designs, and devices appropriate to the King and to the fountain. Upon the base was a figure representing the God Mars, and at the four corners were figures having reference all of them to his Majesty. When I showed it to the King it was to a smaller scale, but in its full size the central figure would have been forty cubits high, the side figures being proportionately smaller. When the King saw the model he examined it a long while with the greatest satisfaction, and then asked me of the central figure. It was a God of War, I said, and hence most appropriate to his Majesty. Then he asked me of the other figures. They represented, I said, the four virtues in which he especially delighted. Just as the central figure betokened the glory of arms, so did this one at the corner

represent the glory of letters; this one again sculpture, painting, and architecture; the next music and every sort of musical harmony; while the last personified liberality, the cause, mainspring & foster-mother of all the other virtues, and one that was most abundant in his Majesty. His Majesty promptly gave me the commission to proceed with the work, which I did, inspired by his delightful encouragement and with abundance of all sorts of things placed at my service. After the careful completion of my little model, as it did not seem to me possible to retain all the proper proportions if I worked direct from it into the full size, I determined to make another model three times the size of the small one,— about the stature of a well-formed man therefore. This model I made in gesso, so that it should the better resist the much handling that is inevitable from frequent measuring. After setting up the iron skeleton I covered it with gesso, and finished it beautifully, putting more care and detail into it than the little one.

I would take this opportunity, gentle reader, of bidding you bear in mind that all the really great masters have followed life, but the point is that you must have a fine judgment to know how the best of life is to be put into your work, you must always be on the look out for beautiful human beings, and from among them choose the most beautiful, & not only so, you must from among even these choose the most beautiful parts, and so shall your whole composition become an abstraction of what is beautiful. So alone may work be created, that shall be evident at once as the labour of men both exquisite in judgment and humble in study. Such men are rare! Now such zeal had I, and so many conveniences were placed at my service by that most liberal King Francis, that I brought this three-sized model of mine to completion; not only was I satisfied with it myself, but it pleased everybody who knew what good work was. Truly great Art is infinite, & the more study you put into your work the easier it is for you to see its blemishes than others, but for all that it is sometimes good to cry 'hold, enough!' even to one's own work, so meseemed here I ought to content me, and therefore I arranged for setting my work up in due order from the scale model to the final forty cubits. This was how I went about it.

140

CHAPTER VIII. THE MYSTERY OF MAKING GREAT COLOSSI.

TO begin with, then, I divided the model, which was to be translated from three cubits to forty, into forty small parts, each of these parts again I divided into twenty-four parts. But as I knew that this method alone would not suffice to arrive at the requisite size, I devised another method, a method entirely my own, never invented by anyone before, & the outcome of my own great researches. As I am always generously inclined, I will impart it to such as have good work at heart. It is this: I took four square pieces of wood measuring respectively three fingers each way, they were very straight, and planed nice and smooth, and they were exactly the height of my figure. These I fixed into the ground, plumbing them absolutely straight, and at such distance from the figure as to admit of a man entering in between; they were then match-boarded* all round, the boards being likewise perfectly straight, & a small opening at the back to enter by. Up against this match-boarding I began making my measurements, & then I drew out on the floor of a long room a profile† of the whole statue, forty cubits in size. Finding this plan work out with delightful accuracy, I proceeded next to make a skeleton three cubits high, similar to that of the model. This skeleton was all joined together with pieces of wood, fastened respectively to a very straight rod, the latter served for the left leg, upon which my figure rested. I took the measurements of the body of the figure off the case, making allowance in doing so for the thickness of the flesh and bone work it had subsequently to be clothed with. Thereupon I erected a great mast forty cubits high in the centre of the court of my castle, and round it I set up four other masts just as I had done it with the model, and these also I cased round with match-boarding just as I had done the small model. Then I joined together the life-size skeleton, taking the measurements exactly from the small skeleton, for every little piece a large piece, and so marking off every measurement of every part of my figure proportionately from one case on to the other.

Had I scaled the work off in the usual way I should have had no end of difficulties, but this method of mine with the cases avoided all that, and I got as fine a proportion in my life size as in my small figures. Now as my figure was posed upon the left foot, and had the right foot resting on a helmet, I so arranged the skeleton as to make it possible to get inside the helmet & climb easily through the foot right up into the head. The skele-

*Soppannata.　　　　　　†Proffilo.

ton completed, I clothed it in flesh, that is to say in gesso, and laid it on rapidly in the same manner. When I had got the work completed to the last skin but one, I had the front of the casing opened, and stepped back to view it some forty cubits, which was as much as there was room for in my court-yard. Everybody was delighted with the result, not only connoisseurs, many of whom came to see, but, what was much more important, I myself, who had given so much labour towards its fulfilment. What pleased me most, however, was the fact that there was not the slightest discrepancy between the small and the large model. By this method of mine I set working a number of labourers & people unskilled in the profession, it wasn't in the least necessary for them to know what they were doing. Indeed so masterly is my invention that nothing but patience and diligence are needed, for the rest you may be a perfect ignoramus in the art, and not even the hand of a Michaelangelo help you. In a colossus of this kind the masses of muscle, &c., are so huge that it is impossible to take them in from the ordinary point of vision, which one may put at twice the length of a man; & if you approach the figure at arm's length in order to work it you see nothing; if, on the other hand, you go a long way off you do see a little more, but still not enough to remedy the great errors that must arise. You see, therefore, that without this method of mine it is impossible to carry out a large colossus with fine proportions. Truly, many a statue of ten cubits high has been spoilt by some blunder or other; and I really think that not even statues of six cubits high can be properly made without this method of mine. Of course it is quite conceivable that just as I have discovered this method so some greater genius than I may discover a better one still; but then it's always easy to improve a patent!

When the King came to Paris, he lay, as was his wont, at his castle, the Logro (the Louvre); it was opposite my castle of Little Nello, for there was only the Seine in between. I crossed the river and waited upon his Majesty. He was quite charming to me, and asked me if I had anything lovely to show him. I replied that as for the loveliness I wasn't so sure, but I had done some work with great study and with all the devotion that so noble an art demanded, and that if it was good it was due to him who allowed me to want for nothing, such freehandedness being the only way of getting the best work done. To this the King yeasaid me, and the day following he came to my house. After I had shown him a variety of different work I made him enter the court-yard, placing him at the point whence my great statue told to the best advantage. He obeyed me with the greatest condescension and the most perfect breeding;* and, indeed,

*Virtu. See also Brinckman's rendering: ' Als grösserer Liebhaber der schönen Künste.

never have I met any prince who had such a wonderful way with him. Now while I was conversing with his Majesty I ordered Ascanio, my pupil, to let the curtain down. Instantly the King raised his hands & spoke in my praise the most complimentary words that human tongue ever uttered. After which, turning to Monsignor d'Aniballe,* 'I command you,' he said, most emphatically, 'to give the first good fat Abbey that falls vacant to our Benvenuto, for I do not want my kingdom to be deprived of his like.' At this I bowed deeply and thanked the King, while he, well satisfied, went back to his castle.

Now knew I what pleasure my labour caused this great King, encouragement brought encouragement, and I set to yet greater labours still. I took 30 lbs. of silver of my own money & gave it to two of my workmen, with the designs and the models to make two large vases of. As it was a time of great wars I had asked no money of the King, and also left untouched six months of my salary. Setting to work lustily at my own vases, I finished them in a month's time, and set out with them to find the King who was in a city by the sea called Argentana. When I gave him the vases he was most engaging, & said: 'Be of good heart, my Benvenuto, for I am one that both can & will reward your labours better than anyone else in the world.' To which I replied that from earliest recollections my mightiest labours had been the discovery & application of my method relating to the founding of great colossi; that now, thanks to God, my model had come up to my expectations, that the casting had now to be considered, and that this would have to be done in over one hundred separate pieces, fitted together with swallow-tail joints. Nor would it be very difficult for us to do, as I had already devised a skeleton of iron upon which to attach the various portions of the colossus as I cast them, commencing at the feet and piece by piece fitting them together up to the head. The only difficulty would be the putting together of the iron skeleton; but this, too, I would take credit for surmounting, observing the same process as I had carried out previously in the wooden one. It would be necessary, then, for me to fix the first rods of the skeleton straightway into their final position, that is to say, at his Majesty's residence at Fontainebleau, where I should have to be provided with a room sufficiently large for the purpose. To this the King replied that, if there were no other rooms suitable to my purpose, he would give up to me his own private apartment, so great was his desire to see a work of this kind finished. I might take courage, then, and be of a light heart, and, he added, I might return to Paris to this end. The two big vases were standing on the table before his Majesty, & as he was fingering and praising them, I preferred the request to him that, as the time

*Claude d'Annebault, Marechal de France.

was opportune, it being the time of war, he would grant me permission to return for four months to Italy, to revisit my fatherland, my relatives & friends. At these words of mine his Majesty grew very sour of aspect, and turned to me, saying, 'I wish you to gild these two vases from top to bottom with dull gilding!' This remark he repeated twice, and then rose quickly from the table and said nothing further. By 'dull' I fancied he meant two things: firstly, that I was a 'dull fool' to ask such a liberty; & secondly, that the gold on the vases was to be left unburnished. When his Majesty had withdrawn I begged the Cardinal of Ferrara, to whom was entrusted the duty of looking after me, to procure the leave for me. The Cardinal bade me go back to Paris, and that he would let me know what I should do. In the space of a fortnight he sent word by one of his servants that I could go, but that I should return as soon as possible. I praised God and set out.

Of the property in my castle I took absolutely nothing with me, neither the stuffs nor the house furniture, the silver nor the gold, nor the embossed vases, nor any of the other works made independently of the agreements entered into with the King, works all of them carried out by my workmen and paid for by me. The great works enumerated in this book, and made for the King, his Majesty had himself valued at over 16,000 scudi. I not unnaturally thought that, as I had not only taken nothing, but was likewise a creditor for so large a treasure, I should come back quick enough.

So I came to Italy and reached Florence my native city, & went to Poggio in Caiano, and shook hands with the grand Duke Cosimo, and he received me very charmingly. Two days after, the grand Duke gave me an order to make a small model for a Perseus, which was most gratifying to me, & two months sufficed to do it in. When his Excellency saw it he was beyond measure pleased, & he said to me in the presence of a number of gentlemen: 'Had you the courage to carry out the work as finely in a great piece as here in your little model, it would be the grandest work on the Piazza.' To these gratifying words I replied: 'My lord, in the Piazza are works by Donatello and the great Michaelangelo, both of them men that in the glory of their works have beaten the ancients; as for me I *have* the courage to execute this work to the size of five cubits, and in so doing make it ever so much better than the model.' At this there was no end of argumentation.

Now, as the war was still raging hotly in France, I thought I should have plenty of time to cast one at least of the two figures.* But when they heard

* *The Perseus and the Medusa.*

144

in France that I was working in Florence for the grand Duke Cosimo, his Majesty took it very ill indeed, and he said on several occasions: 'Didn't I tell Benvenuto that he was a dull fool?' Upon which the Cardinal of Ferrara did me a bad turn and made matters worse, so that in the end the King said he would never call me back again. All this was notified to me in writing on behalf of the King. To this I replied that what alone troubled me was leaving so great a work unfinished, but that I should never think of going anywhere where I wasn't called. And so it came about that what with the encouragement of his Excellency I set to work to get my Perseus through. After some time, it must have been several months, the King relented, and, discussing the matter with the Cardinal of Ferrara, said to him that it had been a great mistake ever to have let me go. The Cardinal replied that it needed but a wink to fetch me back again. To this the King said that it was the Cardinal's duty to have prevented it; & instantly turning to one of his treasurers, by name Giuliano Buonaccorsi, one of our Florentines, said to him:'Send Benvenuto 6,000 scudi, & tell him to come back and finish his great colossus, and I'll make it up with him.' The treasurer wrote to me all about his Majesty's making it up, but he didn't send any coin, saying, however, that upon hearing my reply he would at once give the order for the money. To this I, on my part, replied that I was quite ready & would make it up too. In the midst of these negotiations to and fro, the good King departed this life; thus was I deprived of the glory of my great work, the reward of all my labours, and of everything that I had left behind me. So I set to work to finish my Perseus.

END OF THE TREATISE ON SCULPTURE.

THE GLOSSARY HERE FOLLOWING DOES NOT PROFESS IN ANY SENSE TO BE COMPLETE, NOR ARE THE WORDS IN IT TO BE REGARDED AS BEARING ONLY THE SIGNIFICATION GIVEN IN EACH CASE: THE ATTEMPT, HOWEVER, IS TO RENDER CELLINI'S MEANING IN THE TREATISES AND AUTOBIOGRAPHY, AS I HAVE UNDERSTOOD IT.

A GLOSSARY OF ITALIAN TECHNICAL TERMS FOR THE USE OF STUDENTS.

The references, where given, are to the paging respectively of the Trattati (Tra.) and the Vita (V.); the former to the Italian of Milanesi, 1857 edition, the latter to Symonds' Translation, 1893 edition. Where I have adopted Symonds' definition of a word I have acknowledged it with an (S.).

ABBASSARE: to bring or hammer down, as of relief work in metal. Tra. 143.

ACCETTARE: to accept or take; of the accepting of metal from the gesso or clay mould. In Tra. 164, Cellini describes how the metal accepts better when the clay is fatty from decomposition.

ACCONCIARE: to set. Tra. 40. *See* also SERRARE, LEGARE.

ACQUA: the water of a diamond. Tra. 60, 65.

ACQUA DA PARTIRE: *see* PARTIRE.

ACQUA DI DRAGANTE: *see* DRAGANTE.

ACQUA FORTE: aquafortis in its various uses. *See* Tra. 31, 149, 155.

ACQUAIO: a pipe for carrying off water. Tra. 173. *See* CANNONETTO.

ACQUA MARINA: the aquamarine. Tra. 39.

ACQUA MORTA: urine. V. 282.

ACQUERECCIA: a large metal ewer for holding water. Tra. 130.

AFFARE: to make, to tell well, to give a good effect, as of a well-set stone. Tra. 41.

AFFATICARSI: to wear; of the wear and tear of the dies in stamping. Tra. 123. More generally, to be affected by. Tra. 186.

AFFINARE: to fine, of gold. Tra. 156.

AFFUMARE: to besmoke, as with a candle or lamp flame. Tra. 102, 103. For substantive Cellini uses *spolverezzo*.

AGGHIADARE: to curdle, to stiffen; of metal when it does not fuse. Tra. 192.

ALIETTA: a wing or bracket of iron to strengthen the frame that holds the dies for stamping. Tra. 122.

ALITARE: to blow or kindle with the bellows. Tra. 124.

ALLACCIARE: to fasten. Tra. 80.

ALLUME DI ROCCA: rock alum. Tra. 155. Probably sulphate of alumina from alum shale.

ALZARE: to stand or be bossed up. Tra. 95.

AMATISTA: amethyst. Tra. 39.

AMATITA NERA: a hæmatite stone. Tra. 49.

AMATITA ROSSA: *see* MATITA.

ANCUDINE, ANCUDINETTA, ANCUDINUZZA: an anvil, or more usually a stake head for hammer work.

ANELLO: a ring; *anello del granchio.* A metal ring of lead or copper, now worn in Italy under the name *anello di salute* (S.).

ANIMA: the core or inner block of a *cire perdue* casting. Tra. 165. V. l.

APPICCATO: standing or picked out; of a figure from its field. Tra.78.

APPOMICIATO: treated with pumice, as of metal work for the final cleaning. Tra. 145.

APRIRE: a term employed in enamelling to express the effect of a firing upon red enamel, when the same turns to a yellow scarce distinguishable from gold. Tra. 35.

ARCHIMISTA: an alchemist.

ARCHIPENZOLO: a geometrical plane. Tra. 205.

ARENA DI TUFO: a tufa earth. Tra. 102.

ARGANO: a windlass. Tra. 173. V. 420.

ARGENTO VIVO: mercury. Tra. 147.

ARMADURA: a framework, such as would admit of the model of a large statue being built upon it. Tra. 206.

ARRENARE: to treat with sand or sand-paper. Tra.76.

ARRUOTARE: to polish or burnish, as of dies upon a smooth stone. Tra. 111.

ARTIGLIERIE (MAESTRO DI): ordnance founders. Tra. 163.

ASSOTIGLIARE: to softly polish over, as of enamel with sandstone. Tra. 35. *see* FRASINELLA.

ASTA: the hasp or handle of a chisel. Tra. 198.

AVVIVATOIO, also ISVIVATOIO: a metal rod with a wooden handle used for polishing rings, and applying mercury gilding.Tra.149. V. 252.

BACINELLA: a mortar. Tra. 30.

BAGNO (CONDOTTO IN): a bath, *i.e.*, of bronze brought to the liquid state. Tra. 178.

BALASCIA, BALASCIO: the balas ruby. Tra. 38, 50.

BARILA: a measure of about 40 litres; 20 Florentine wine flasks.Tra.119.

BATTILORO: a gold beater. Tra. 125.

BAVA, BAVETTA, BAVUCCIA: roughness; the rough edges of a casting. Tra. 120, 129, 174.

BERILLO: the beryl. Tra.63.

BIACCA: white lead. Tra. 116.

BIANCHIMENTO: blanching solution. BIANCHIRE, to use this solution, or more generally to clean or whiten silver. Tra. 48, 146, 149. *See* also GROMMATA.

148

BIETTA: a wedge of iron, such as is used for fastening the dies into the frame for minting. Tra. 122. Or of wood for tightening up a plaster mould. Tra. 167.

BOCCA: a mouth; the lip of a jug; the channel in which to pour the metal in a casting, &c. BOCCA PRINCIPALE, the main entrance. BOCCA DELLA SPINA, the mouth of the plug, from which the molten metal flows into the mould. BOCCA DEL MARTELLO, the thick end of a hammer. Tra. 131.

BOCCIA: a retort; an alembic. Tra. 156.

BOCETTA: a flask or bottle. Tra. 15.

BOLO ARMENIO (TERRA DI): bole of Armenia, a red earth used for gilding grounds, &c. Tra. 111.

BOLSO: blunted. Tra. 131.

BORDELLERIE: lumber (S.). V. 39. Large, clumsy rubbish.

BORRACE: borax. Tra. 17.

BORRACIERE: a borax crucible or pan. Tra. 20, 73.

BOTTONE: a button or clasp, or more specially a morse. Tra. 49, 80, 89.

BOZZA: a sketch. Tra. 197.

BRACCIAIUOLA: a pit beneath the grating to receive the ashes from the furnace. V. 423; Tra. 191.

BRACCIO: a cubit, i.e., about 48 inches.

BREVE: a trinket in the nature of a locket. Tra. 20.

BRUNIRE: to burnish; the process of burnishing as in niello. Tra. 18, 153. BRUNITOIO, a burnisher, usually of tempered steel. Tra. 18.

BULINO: a graver. Tra. 13.

CACCIANFUORI: snarling irons, a species of small stakes for repoussé work. Tra. 96, 134.

CALCIDONIO: calcedony. Tra. 67.

CALDANUZZO: a pan or brazier. Tra. 58.

CALDARE: a large vessel used for the blanching solution. Tra. 58.

CALDERONE: a cauldron. Tra. 16, 150.

CALDO: a cooling, e.g., dare un caldo. Tra. 124; as of enamel work from the furnace.

CAMICIA: the coat or vest of wax drawn over the baked clay mould in a cire perdue casting; or the mould generally. Tra. 162.

CAMOSCIARE: a method employed in embossing metal by working over the backgrounds with a broken steel tool; what we should call 'matting' or 'frosting.' Tra. 92.

CAMPO: the field or background of a piece of work. Tra. 76, 91.

CANALE: the channel through which the metal flows in a casting. Tra. 175. Also, in other uses, an ingot mould. Tra. 48, 175.

CANAPO: rope. Tra. 173; V. 420.

CANNELLA, CANNELLO: Tra. 170. *See* CANALE.

CANNONE, CANNONETTO: tubes or pipes of metal or earthen-
ware. Tra. 173, 174.

CAPPA DI FRATI: a grey colour of that name. Tra. 33.

CARATO: a carat; 3·17 grains troy. Tra. 47.

CARBONCULO: a carbuncle. Tra. 38.

CARBONE (MISURADI): troy-weight. V. 205.

CARICARE: to fill in, or cover up; as of enamel in its cloisons, or gold
on metal; also more generally, to load or weight. Tra. 25, 173.

CARTONE: cartoon. V. xlix.

CASTAGNUOLO: chestnut wood.

CASTONE: the bezel; or more generally, setting of a stone. Tra. 40.

CATINELLETTA: a little vessel. Tra. 136.

CATINOTTO: an earthen pot. Tra. 125.

CAVO: a mould.

CENERATA: a brew of charcoal, usually from oak, in boiling water, for
cleaning niello work, &c. Tra. 16.

CEPPO: an anvil stock. Tra. 134. Also of a wooden block for striking
coins on. Tra. 119.

CERVONA: *see* COLLA CERVONA.

CESELLO, CESELLINO, CESELLETTO: a punch. CESELLARE:
to work with the punch. *Passim.*

CHERMISI: Kermes. Tra. 42.

CHIAVAQUORE: a trinket in the shape of a key; a hearts key. V. 27.

CHIOCCIOLA, CHIOCCIOLETTA: the female of the screw; or more
generally, a spiral; also a snail or scroll in design. Tra. 92, 122, 132.

CIAPPOLA, CIAPPOLETA, CIAPPOLINTA: a chisel; sometimes
a sculper. Tra. 93. *See* GRAFFIARE.

CIBORIO: pyx; a vessel for holding the Eucharist. V. 132.

CIMATURA: cloth shavings or frayings.

CIMENTO: cement; of the royal cement, the recipe for the making of
which is described. Tra. 156.

CIOTOLINA: a beaker. Tra. 17, 21.

CITRINI, CITRINO: citron quartz. Tra. 65.

COGLIONERIE: gewgaws, shoddy trifles. V. 39.

COLLA: a gum or glue as of pear or quince seeds. Tra. 37. COLLA
CERVONA: a glue made of stag's horn. Tra. 154. COLLA DI
PESCE: fish glue.

COLMETTA: bent or curved, of the sheet of gold to be hammered
over bronze in the method of Caradosso. Tra. 72.

COMPARTIMENTO: a cloison in enamel; or a division in filigree.
Tra. 24.

CONCIARE: to cut or polish stones. Tra. 51. CONCIATORE: a stone cutter. Tra. 66.

CONFICCARE: to clamp. Tra. 128.

CONGEGNARE: to nail. Tra. 128.

CONII: the dies for minting. V. 114. CONIARE: the process of striking with them. Tra. 120.

CONO: an iron wedge used in the frame for minting. Tra. 120.

COPERCHIO: the cap of a furnace. Tra. 181; V. 424.

COPERTO: suffused, clouded; used of the colour of stones. Tra. 38.

COREGGE: straps. V. 172.

COREGGIUOLO, CORREGGIOLETTO: a crucible. Tra. 15, 29, 126.

CORNA, CORNETTO: a horn, e.g., of a *caccianfuori* stake. Tra. 134.

CORNIOLO: cornel wood from which punches for delicate metal work were made. Tra. 72.

CORNIUOLO: the carnelian. Tra. 67.

CORRERE: to fuse or run, of enamels in the furnace. Tra. 35.

COSTA DI COLTELLO: a knife's back, a term of measurement, where we should use a guage, e.g., Birmingham guage.

CUCCUMA: turmeric root. Tra. 150.

DIGUAZZARE: to stir. Tra. 150.

DITO: a finger, used as a standard of measurement.

DOMMASCO: damask. Tra. 28.

DOPPIA, DOPPIO: a stone artificially pieced together of several pieces. Tra. 45.

DRAGANTE: gum tragacanth. Tra. 21.

FACETTE (A): facetted (*a facette* as distinct from *a punta* and *in tavola* in the cutting of the diamond). V. 393; Tra. 49.

FALSATORE: a cheat; a dealer in false stones; a coiner. Tra. 44, 113.

FATTORETTO, FATTORINO: a shop assistant. Tra. 137, 68.

FEMMINA: the female screw. Tra. 122. *See also* VITE FEMMINA.

FERETTO DI SPAGNA: calcined sulphate of iron (French, *ferret*). Tra. 152.

FERRAMENTI: tools and appliances generally. Tra. 46.

FERRI, FERRETTI, FERRUZZI, FERROLINI: iron or steel tools used for various processes, e.g., as applied to dies for minting.

FIASCO: a flask holding more than a quart. V. 187.

FIBBIA: a buckle, brooch, or pin. Tra. 9.

FILETTI: the sharp lines that divide one facet from another. V. 394.

FILO: filigree.

FILO TIRATO: metal wire or thread. Tra. 25.

FOGLIA: foil; usually of thin hammered metal for setting beneath stones, or covering gesso models to prevent the suction of the cast. Tra. 47.

FOGLIAME, FOGLIAMETTO: foliage; spray work. Tra. 19, 24, 79.

FONDERE: to cast. FONDERE NEL MORTAIO: a special method of casting described. Tra. 125.

FORBICE (UN PAIO DI), FORBICINE: a pair of forceps or pliers. Tra. 147.

FORMA: the mould, e.g., for casting metal in. V. l.

FORMARE: to model or mould.

FORNACE, FORNACETTA: the furnace.

FORNELLO, FORNELLETTO: a stove.

FORNIMENTO DA CAVALLI: the metal trappings of horses. Tra. 120. DI SPADA: the inlay or damascening on swords. Tra. 155.

FRASCONCINO: a birch rod or bundle of twigs. Tra. 150.

FRASINELLA: a fine grained sandstone used for whetting the more delicate sorts of steel instruments and enamels; equivalent to hone rather than to whetstone. Tra. 36.

FREGIO: a border or framework. Tra. 92.

FUMMICARE: to steam. Tra. 151.

FUSCELLETTO, FUSCELLINO: a small twig, or tool of wood for working wax. Tra. 73, 116.

FUSCELLO: flour dust, described by Cellini as gathered on the walls and cornices of mills, and used as a paste for gilding. Tra. 154. See also, in another sense, FUSCELLETTO.

GALANTERIE: little devices or conceits of design. Tra. 135. GALLETTA: a strip, or shaping of wire, e.g., in filigree work. Tra. 21.

GAMBA, GAMBETTO: a claw in the setting of a stone. Tra. 53. A small clamp or attachment. Tra. 79.

GANGHERO: a hinge. Tra. 91. V. 41.

GATTA: see OCCHIO DI GATTA.

GESSO: plaster of Paris, or one or other of the various compositions made from it with resin, beeswax, &c. Cellini has GESSO VOLTERRANO: gesso of Volterra. Tra. 100. GESSO COTTO: Tra. 100. GESSO IN PANE: gesso in the cake. Tra. 154. GESSO DI TRIPOLO: see TRIPOLO.

GETTO (ARTE DEL): the art of bronze casting. Tra. 7.

GIRARE: to reverberate; of the flame in the furnace. Tra. 189. Also, v. tr. to handle, as of the graver, GIRARE IL BULINO. Tra. 13.

GIRASOLE: the girasol opal. Tra. 43.

GITTARE: to cast (of metal). Tra. 48, 76. Also in another sense, to lean or verge towards, *e.g.*, of the colour of marble. Tra. 195.

GIULIO: a Tuscan coin of 56 Italian centimes or 8 Tuscan *crazie*, which in Florence was also called *barille* or *gabellotto*, because the sum had to be paid as duty on a barrel of wine. (S.).

GOCCIOLA, GOCCIOLINA: a drop, as of the water distilled from pear or quince seed, used for enamelling. Tra. 36.

GOLA: the neck, *e.g.*, of a vase. Tra. 133.

GOMMA, used alternately with GROMMA & GROMMATA: Any solution for the blanching or cleaning of metal. More strictly, the incrustation in wine casks, tanks, & water pipes. *Gomma* or *gromma di botte* is the tartar of wine casks used for the cleaning of metals and gilding silver; tartrate of potash. Tra. 48, 106.

GONFIARE: to boss or belly out. Tra. 79, 82.

GORBIA: a ferule or throttle of iron. Tra. 191. Also generally, a pointed tool for working soft stone. Tra. 200.

GRAFFIARE: in the sense used by Cellini, Tra. 128, to hatch or to grave upon the metal by means of a well sharpened *ciappola*, a cutting instrument, different from the *bulino* & the *cesello*, used especially for hatching. From *graffiare*, used in this sense comes the better known word *graffito*.

GRANAGLIA: grains, or granulated metal for filigree. Tra. 20.

GRANATO: the garnet. Tra. 39.

GRANIRE: a method employed in embossing metal for working over the backgrounds with a sharp pointed steel tool. Tra. 92.

GRANITURA: beading, *e.g.*, around a coin. Tra. 112, 114.

GRATICOLA, GRATICOLETTA, GRATICOLINA: a grating, a grill. Tra. 126, 190.

GRATITUDINE: the gratefulness, charm, or delicacy of a stone. Tra. 38.

GRATTAPUGIA: a scratch-brush. GRATTAPUGIARE: to clean or polish with the scratch-brush. Tra. 148.

GREMBUILO: an apron. V. (l.).

GRISOLITA: the chrysolite. Tra. 39.

GRISOPAZIO: the chrysoprase. Tra. 39.

GROSSERIA: metal work of the larger sort, as opposed to *minuteria*. Our term, hammered hollow ware, would partly express it. It mainly included the beating of large vessels into shapes, but it did not exclude the processes of casting.

IACINTO: the jacynth. Tra. 39.

IMBRACCIATOIE: special tongs for holding earthenware crucibles. Tra. 124, 137.

INCARNATO: flesh-tinted, as of stones or enamels. Tra. 33, 195.

INDACO: indigo. Tra. 60.

INDOLCIRE: to soften, as of the tempering of steel. Tra. 112, 117.

INFRANGERE: to beat or dent in as opposed to cutting out or removing the surface of metal. Tra. 75.

INTACCARE: to notch, to cut a tally, *intaccatura*, in metal. INTACCATO: notched. Tra. 142.

INTAGLIO, INTAGLIARE: cutting in intaglio; more generally, carving. INTAGLIATORE: a carver.

INTERSEGARE: to cross or plait, of wire. Tra. 138.

INTRONARE: to crack or spring, of stone beneath the chisel. Tra. 199.

ISPIANARE: to plane or pare the metal plate. Tra. 117. *See* RASOIO.

ISVIVATOIO: *see* AVVIVATOIO.

LAGRIME DI MASTICO: tears of mastic, used in stone-setting. Tra. 59.

LAMA: a band, as of hoop iron. Tra. 125.

LAMINE: plates of metal. Tra. 141.

LAMPEGGIARE: to flash, glow, or blaze, as of a red stone. Tra. 74.

LASAGNA: the coating of wax, clay, or paste, applied to the mould of a casting. Tra. 137, 168, 170.

LEGA, LEGHA: alloy; also generally, for the metal of a setting, and so of a setting itself. Tra. 144. V. 424. LEGARE: to set. Tra. 8, 37, 41.

LEGATURA: setting. Tra. 43.

LEGNETTE, LEGNUZZI: faggots; small logs or pieces of wood for burning. Tra. 17, 22.

LEVARE: to remove or cut away, as of metal background to be removed with the chisel. Tra. 75.

LIMA: a file, of which Cellini describes several sorts, *e.g.*, LIMA A COLTELLA, LIMA MEZZA TONDA, LIMA RASPA. Tra. 198. LIMARE: to file. Tra. 20.

LIMATURA: filings, as of the solder, *limatura di saldatura*, sprinkled over the filigree. Tra. 21.

LIMUZZA: Tra. 92. *See* LIMA.

LINGUA DI VACCA: a cows' tongue stake-head. Tra. 132.

LISTRE DI FERRO: bands of iron, as of the bands used for holding together the moulds in bronze casting. Tra. 183.

LOPPA: dregs, lees, scum, as of the glass scum, *loppa di vetro*, in the metal vent of the crucible described. Tra. 198.

LORDO: greasy, as of the surface of metal in the working. Tra. 28.

LORDURA: literally *lordura di untume*, fatty substance, removable with aquafortis. Tra. 31.

154

LOTO: a paste or composition, as of ashes. Tra. 126. Also a luting, as of the closing of the joints in an alembic. Tra. 156.

LUSTRO: the shine or glimmer on the metal left by the use of the punches, &c. Tra. 28, 195.

MACINARE: to pound. Tra. 104, 148.

MADRE: the matrices of the dies; the mother punches. Tra. 118.

MAGLIA, MAGLIETTA: an eye or socket of iron fitted into the plaster mould of a casting. Tra. 167, 168.

MAGRO: coarse and thin; used of clay as distinguished from the rich and fatty quality. Tra. 163.

MANDORLA, MANDORLETTA: literally, an almond shape; used of jewellery thus shaped, & of the shapes of Cardinals' seals. Tra. 20, 99.

MANDRIANO: an iron crook; a pole fitted at the end with a curved iron. Tra. 176, 181; V. 421.

MANICA: a funnel shaped furnace (S.). V. li.

MANICO: a handle. Tra. 107, 137.

MANIGLIA: a bracelet. Tra. 37.

MANTACO, MANTACETTO, MANTACUZZO, MANTICHE, MANTICO, MANTICETTO: a pair of bellows. Tra. 15, 17, 34, 74, 124. MANTACETTO A MANO: the hand-bellows. Tra. 144.

MARTELLO, MARTELLETTO, MARTELLINO: a hammer, whether of wood or iron. Tra. 32, 78. MARTELLO A DUE MANI: a large hammer wielded with both hands, commonly called *mazzetta*. Tra. 121.

MASCHERA, MASCHERETTA: a mask, a favourite form in Renaissance design. Tra. 137.

MASELLI (DI RAME): sizes of copper. V. 420.

MASTICO: the varnish resin, commonly called gum mastic. Tra. 57. *See* also LAGRIME.

MASTIO: the male screw; as in the process of striking coins with the screw. Tra. 122.

MATASSINA: a skein. Tra. 42.

MATITA ROSSA: red chalk; red hæmatite (Dict., Baretti); perhaps, jewellers' rouge. Tra. 150, 152.

MATTONE, MATTONCELLI: tiles; baked bricks.

MATURO: ripe, mature, of the colour of the ruby. Tra. 38.

MAZZAPICCHIARE: to ram. Tra. 174.

MAZZAPICCHIO: a rammer; a wooden instrument three cubits long and widening to the bottom to a quarter of a cubit, used for tightening in the soil into the pit that contains the mould. Tra. 174.

MAZZETTA: *see* MARTELLO.

MAZZUOLO: a mallet. Tra. 199.

MESTOLETTA: a spoon or ladle. Tra. 138.

MEZZANA: a flooring brick or tile. Tra. 175.

MEZZO TONDO: a half relief.

MIDOLLO: pith. MIDOLLO DI CORNA: pith of cornel wood. Tra. 103.

MIGLIACCIO: a curdling of the metal. V. 423; Tra. 179.

MINUTERIA: small metal ware, as distinguished from *grosseria*.

MISURA DI CARBONE: troy weight. V. 205.

MODELLO, MODELLINO, MODELLETTO: a model.

MOLLA, MOLETTE: a pair of tongs or pliers. Tra. 21, 125.

MORDERE: to bite, cut, or wear away, as of the cutting of the diamond by the diamond. Tra. 52.

MORTAIO: a mortar. Tra. 125.

NASTRETTO, NASTRETTINO: a streak or strip. Tra. 97, 25. NIELLARE: to work in niello, of which the various processes are described in Tra., Ch. I.

NOCCIOLO: the 'kernel,' or the framework of clay or iron that fits into a casting, and tallies in its various parts with the *lasagna* or coating of the mould. Tra. 173, 183.

NOTTOLINO: any little knot or tie of metal in jewellery. Tra. 94.

OCCHIO DI GATTA: the cats' eye stone. Tra. 43. OLIO DI GRANA: linseed oil. Tra. 58. OLIO DI MANDORLE: almond oil. Tra. 59. OLIO D'OLIVA: olive oil. Tra. 59.

ORIVUOLO: a clock. Tra. 11.

ORLO: a ridge or mound of wax, *e.g.*, round the copper etching plate. Tra. 155.

ORO MATTO: dull gilding. Tra. 210.

OSSATURA: the framework or sketch upon which the various portions of a colossus are pieced. Tra. 209.

OTTAVO: a species of silver solder formed of one-eighth part of an ounce of copper to one ounce of silver. Tra. 143.

OTTONAIO: a brass caster. Tra. 120.

OVATO: an octagonal or eight-sided figure or arrangement. Tra. 97.

OVOLATORO: a metal founder. V. 121. OVOLATORE DI ZECCA: metal founders of the mint (S.).

PADIGLIONI: the pavilion or back facets of a stone. Italian stone-cutters distinguish in a stone the following parts: *il bordo, la tavola, le facette, i padiglioni.*

PAGONAZZO: peacock blue. Tra. 38.

PAIUOLO: a pail. Tra. 164.

PALA: a spade; a shovel. Tra. 177.

PALETTA, PALETTINA: a palette or placque, as of iron. Tra. 192.

PALETTIERE: a hand-shaped palette, such as Cellini constructed specially on a leaden stand to hold enamels. Tra. 32, 36.

PALLA, PALLOTTOLA: a ball; a sphere. Tra. 79, 97.

PANE: pig or cake, e.g., of metal. Tra. 73, 181. PANE DELLA VITE: the threads of a screw. Tra. 122.

PANNACCIO LINO: a linen rag. Tra. 16.

PARTIRE (ACQUA DI): the acid into which you put alloys and clippings, filings, &c. PARTIRE: to separate gold from silver, or silver from copper, or gold from gilt copper. Tra. 155, 156. PARTITORE: the man who exercises this craft.

PASTA: a paste; a coating. Tra. 148, 166.

PECE GRECA: powdered resin (white pine) from which the oil has been evaporated over hot water. Tra. 27. See also Hendrie's 'Theophilus,' p. 70.

PELLE: a skin, surface, or coating, e.g., of metal or stone; also of the working of the tools over a surface. Tra. 92, 96, 128, 134, 200.

PENDENTE: a pendent.

PENDIO: a fall, as of the fall in a furnace. Tra. 186.

PENNA: the thin end of a hammer. Tra. 130, 132.

PENNELLO, PENNELLETTO, PENNELLINO: a paint brush of hog's hair or sable, &c. Tra. 21, 93, 104.

PENTOLINO: a vase or pipkin. Tra. 153.

PERLA, PERLETTE: a pearl.

PESTARE: to pound. Tra. 31. PESTATA: the substance pounded. Tra. 93.

PIANO DEL MARTELLO: See PENNA.

PIASTRA, PIASTRETTA: a plate; as in PIASTRA DI RAME: a copperplate. Tra. 13.

PICCIUOLETTO: see GAMBETTO.

PIEGATO: bent, inclined, as of the tool described. Tra. 128.

PIEGHETTA: used by Cellini to describe little raised carved pips or patterns on the metal field with a view to their showing through the translucent enamel to express damask or diaper, &c. Tra. 28.

PIENO: full, rich; of the colour of a stone. Tra. 38.

PIETRA FORTE: a stone used by the Florentine sculptors; of hard substance & tan coloured, & found in small quantities in the neighbourhood of Florence. Tra. 202. PIETRA MORTA: quarry stone; in general, of any rough stone fragment. Tra. 187, 189. More specifically of a soft tan coloured stone found in the vicinity of Florence, and much used because of its durability for all sorts of carving.

Tra. 202. PIETRA SERENA: a very soft, blue-grey coloured stone found in large quantities in the neighbourhood of Fiesolé and Settignano, but used mostly for internal work owing to its want of durability. Tra. 201.

PIETRUCCOLA, PETRUCCOLA, PIETRUZZA: a little stone or gem. Tra. 69, 163.

PIGLIARE: to take, generally. PIGLIARE IL CALDO: to take the heat; to grow warm, *e.g.*, of the enamel plate when held to the furnace before its insertion. Tra. 34.

PIGNATTA: any large receptacle. Tra. 136, 155.

PIGNERE: to paint; to streak or paste over as with liquid gesso. Tra. 101, 104.

PILA: the lower of the two dies for minting, fashioned in the form of a small stake or anvil, and described with the whole process. Tra. 111, 113. *See* also TORSELLO.

PIOMBO: the bureau for affixing the leaden seals to papal bulls; an ecclesiastical office in Rome sometimes given to laymen (S.). V. 125.

PITTORACCIO: an indifferent painter. Tra. 84.

PIVIALE: a cope. Tra. 49, 80.

POMICE, POMMICE: pumice stone. Tra. 92.

PORFIDO: porphyry. Tra. 30.

PRASMA: the plasma; possibly, the prase. Tra. 39.

PRATICA, PRATICACCIA: the practice or practical skill as distinguished from the theory or scientific study of a craft. Tra. 27, 42. CONTINOVA PRATICA: workshop tradition. PRATICO, PRATICONE: a craftsman, a professional, as opposed to an amateur. Tra. 11.

PRATICONACCIO: a humbug or pretender at a craft; a botcher. Tra. 6.

PROFFESIONE: the practice of an art. Tra. 46. *See* PRATICA.

PROFILARE, PROFFILARE: to outline, *e.g.*, as of the outlining with the punches in embossed work. Tra. 133. PROFILO: an outline.

PUGNELLETTO: a pinch; a small quantity. Tra. 168.

PULIRE A MANO: to hand polish; of a method of finishing enamel by scouring it with tripoli. Tra. 35.

PULITEZZA: precision; neatness; cleanness of execution (S.). What in a modern workshop one might call 'finish,' in contradistinction, however, to 'trade finish.'

PUNTA (IN): point cut, as applied to a stone. Tra. 51. V. 393.

PUNTALO: buckles or pins for belts. Tra. 20.

PUNTERUOLO: a pin or skewer. Tra. 38.

PUNZONE, PUNZONCINO, PUNZONETTO: a punch, in various uses.

158

RADERE: to plane or pare, as of a metal plate. Tra. 48, 128, 129.

RAFREDDO: cooled. Tra. 171.

RAMAIUOLO: a ladle. Tra. 127.

RAMO: a pipe. RAMO DI GITTO: the conduit of a casting. V. li. 418.

RAPPEZZARE: to patch up, to re-piece, as of the holes in the hammered gold coating upon bronze figures. Tra. 83, 199.

RAPPRESO: set or hardened from cooling, *e.g.*, of metal in the furnace. Tra. 179.

RASOIO: a razor, a sharp flat knife. Tra. 128.

RASTIARE: to scrape. Tra. 59. RASTIATOIO: a scraper, or instrument used for assisting the flow of the bronze into the mould. Tra. 177.

RASTRELLO: a special sort of rake constructed to rake over the cinders from the ash-pit in bronze casting. Tra. 191.

RENELLA DI VETRO: glass-paper. Tra. 76.

RIARDERE: to scorch up, to harden from heat. Tra. 59, 124.

RIBOLLIRE: to re-heat, to consume with heat, to burn, as of the wax in the gesso mould, from too rapid heating. Tra. 22, 172.

RICERCARE: to search out, to pick out with the tools; *e.g.*, of the minute workmanship on a highly-wrought piece of repoussé. Tra. 95.

RICESELLARE: *see* CESELLO.

RICORRERE: to run together, as of different solderings in later firing. Tra. 75.

RICUOCERE: to heat, to put to the fire, to anneal. Tra. 25, 142.

RIGAGUOLO: a gully. Tra. 186.

RIGONFIARE: to swell or bubble up. Tra. 151.

RILEVARE: to raise, boss or work up into relief. Tra. 78.

RIMACINARE: to pound or mix together. Tra. 153.

RIMBOTTARE: to refill. Tra. 127.

RIMENARE: to stir. Tra. 153.

RINALZARE: to boss or beat out from within. Tra. 134.

RISCHIARE: to clean. Tra. 154.

RISERRARE: to stop or fill up, as of the bubble holes in niello work. Tra. 18.

RISTIARARE: Tra. 151. *See* RISCHIARE.

RITONDARE: to round or body a piece of work, *e.g.*, of Michael Angelo's method of hewing his figures from the stone direct, without recourse to the clay model. Tra. 199.

RITURARE: Tra. 18. *See* RISERRARE.

ROSTA: a fan or blower. Tra. 144.

ROVESCIO: the reverse of a medal.

RUBINO BALASCIA: *see* BALASCIA.

RUOTA: a wheel, as of the steel wheel on which diamonds are cut. Tra. 52.

SACCACCIO: a sack or a piece of sack cloth. Tra. 16.

SALDARE: to solder. Tra. 21,73,90. SALDARE A CALORE: a term used by Cellini of the first soldering given to a piece of minuterie work; it should be, says he, termed rather, 'firing in one piece,' than soldering. Tra. 73,74.

SALDATURA: solder. Tra. 75, 143. And of its various consistent alloys in *saldatura di lega, di ottavo, di quinto, di terzo. See* also LIMATURA.

SALE ARMONIACO: sal ammoniac. Tra. 73.

SALIERA: a salt cellar.

SALNITRO: saltpetre.

SANGUE DI DRAGO: dragon's blood. Tra. 44.

SAVORE: an ointment; a paste.

SBIANCATO: bright, clean, as of fresh grains of mastic. Tra. 57.

SBORRACIATO: free from borax, *e.g.*, of fiigree work after it has been cooked in the tartar solution. Tra. 22.

SCAGLIA, SCAGLIETTA DEL FERRO: scale of iron. Tra. 114.

SCALDARE: to aneal. Tra. 131,151.

SCANTONATO: to round or trim off, as of the edges of a metal plate in its first stages to the cup form. Tra. 130.

SCARPELLO, SCARPELLETTO: any chisel or cutting tool, and of its different sorts, *e.g.*, SCARPELLO AUGNATO: the wood-carvers' chisel, and SCARPELLO A UNA TACCA: a notched chisel. Tra. 21, 199.

SCASSARE: to open; to unpick; as of the setting of a stone. Tra. 43.

SCATOLETTO, SCATOLINA: a little box or casket. Tra. 85.

SCHIACCIATO: *see* STIACCIATO.

SCHIUMA: *see* STIUMA.

SCHIZZARE: to crack or spring, as of enamel. Tra. 28.

SCIOGLIERE: to take out, as of a stone from the setting. Tra. 43.

SCIORRE: *see* SCIOGLIERE.

SCODELLA, SCODELLETTA, SCODELLINO: a pipkin or pot, of glass, earthenware, or metal. SCODELLINO INVETRIATO: a glazed earthenware pipkin.

SCOPETTA: a rod of birch or twigs. Tra. 150.

SCOPRIRE: to uncover, disclose, lay bare. Tra. 198.

SCORRERE: to run, as of enamel in the firing. Tra. 25.

SCORZA: bark, crust. Tra. 196.

SCREPOLATURA: a crevice, crack, fissure. Tra. 188.

SCUFFINA: *see* LIMA RASPA.

SERPENTINO: a serpentine stone. Tra. 30.

SERRARE: to set. Tra. 41. *See also* ACCONCIARE, LEGARE.

SESTA, SESTOLINA: the compasses. Tra. 27, 111. SESTA IMMO-
BILE: compasses of which the legs were fixed to a definite angle;
used (as in marking out medals) for striking a number of equal cir-
cles. Tra. 117.

SETOLA, SETOLETTA, SETOLINA: a brush, usually of hog sables.
Tra. 16, 74, 94.

SFASCIATA: freed; disconnected from, as of a mould freed from the
bricks in which it is baked. Tra. 172, 173.

SFIATATOIO: a vent hole in a *cire perdue* casting. SFIATARE: the
verb form of the same word used of the working of the *sfiatatoi*.
Tra. 137, 170, 173.

SFOGLIETTA, SFOGLIETTINA: a blemish, a roughness; as a rule
some surface scaling of the metal. Tra. 129, 133.

SFUMMARE: to steam. Tra. 151.

SILIMATO: *see* SOLIMATO.

SMALTO, SMALTARE: enamel; the art of enamelling; to enamel.
SMALTO ROGGIO: a particular kind of red enamel described
by Cellini. Tra. 36. Also SMALTO ROSSO TRANSPARENTE.

SMERALDO: an emerald. Tra. 40.

SMERIGLIO: the stain or blemish in marble. Tra. 196.

SODO: the base. Tra. 96.

SOFFIARE: to bubble or blow; of metal flowing into a mould for which
the vents have been improperly prepared. Tra. 181.

SOFFREGARE: to rub; as of stone against stone in the cutting of the
diamond. Tra. 52.

SOLIMATO: corrosive sublimate. Tra. 155.

SOPPANNATO: match-boarded. Tra. 206.

SOTTIGLIEZZA: delicacy; subtle detail in a piece of work. Tra.
164, 166.

SOTTO SQUADRO: undercutting. Tra. 141.

SPADAIO: a sword cutler. Tra. 49.

SPAGHETTO: string. Tra. 171.

SPALLA, SPALLETTA: shoulder, end, roof; as of the ends of the fur-
nace bed, or the ramparts of earth around a wax seal that is to be
cast. Tra. 105.

SPANNARE: to spread or paint over. Tra. 150.

SPAZZATURE: sweepings; refuse of old bits of metal in goldsmiths'
work. V. 20.

SPECCHIETTO: the reflector, or piece of square glass set beneath a

diamond in the bezel; sometimes in conjunction with the process of tinting. Tra.65. *See* also TINTA.

SPEGNERE: to dip or quench. Tra.48.

SPIANARE: to smooth, planish, polish; as of enamels with the *frasin-elle*; or a metal plate before commencing work. Tra.21,26.

SPICCARE: to pick out or raise, as of a figure from its background. Tra.78.

SPINA: a plug, as at the outlet hole of a furnace, & thus used for the outlet hole itself. Tra.172; V.li.,421. *See* also BOCCA DELLA SPINA.

SPINELLA: spinell. Tra.39.

SPINGERE: *see* SPICCARE.

SPOGLIA: the shell or outer mould of a *cire perdue* casting between which and the core, *nócciolo*, is the cavity which subsequently receives the bronze. Tra.173. *See* also TONACA.

SPOLVEREZZO, SPOLVERIZZATO: *see* AFFUMARE.

SPORTELLI, SPORTELLETTI: the doors of a furnace; the little doors that open into any closed fire place. Tra.191,193.

SPRUZZARE: to sprinkle. Tra.74.

SPUGNUZZE: bubble holes. Tra.18.

STACCIARE: to sift. STACCIO: a sieve. Tra.138.

STAFFA: a frame, *e.g.*, the frame for sand casting, or for holding dies for stamping. Tra.132.

STAGNO: pewter. V.424; Tra.176.

STAGNUOLO: tinfoil. Tra.165. *See* also FOGLIA.

STAMPA: a die for minting. V.114; Tra.108,116. STAMPARE: used in several senses, *e.g.*, to cut or engrave into metal generally. Tra.14. To make medals of coins. Tra.110,119. To make an impression as of a seal. Tra.100.

STECCA: a board. Tra.27.

STIACCIARE: to stretch or flatten. Tra.25.

STIACCIATINA: a flat cake. Tra.103.

STIANTARE: to chip; to split. Tra.196.

STILETTO: a style, as of the burnished steel style with which Cellini outlined on metal. Tra.133.

STIUMA: scum, as of the lead in the crucible for niello. Tra.15.

STOPPA: putty. Tra.174.

STRACCIO: a rag. Tra.137,173.

STRACCO: spent, as of cinders. Tra.145.

STROFINARE: to scour; to polish; as of the dies on a wooden board with iron scale. Tra.114.

STUCCO: a composition variously described as of pounded brick, yellow wax. *See* PECE GRECA. Tra.27,75. STUCCARE: to paste or cake over with *stucco* or other earthy substance.

162

SUBBIA, SUBBIETTA: sculptors' chisels. Tra. 198.
SUCCHIELLETTO, SUCCHIELLINO: a tool of the nature of a gimlet. Tra. 168, 170.
SUGHERO: cork, as of the cork tipped with iron scale for cleaning out dies. Tra. 114.

TACCA: a notch. Tra. 198.
TAGLIA: a pulley. Tra. 173.
TANAGLIA, TANAGLIETTA: tongs. Tra. 52, 119.
TANE: tan coloured.
TASSELLI: the dies for stamping medals as distinguished from those for stamping coins, which were termed *pila* and *torsello*. Tra. 117.
TASSELLINO: a little cup or clip, as of the metal cup in which the diamond is set against the wheel. Tra. 52.
TASSETTO: a stake or stake head. TASSETTINO TONDO: a rounded stake head. Tra. 48, 78.
TAVOLA (IN): table cut, as applied to a stone. V. 393; Tra. 51.
TEMPERARE: to temper steel. Tra. 114, 119.
TESSUTO: a woven fabric; also for the alternate or reticulated arrangements of bricks in furnace construction. Tra. 125.
TINTA: *dare la tinta* or *tingere*, a process used in jewellery of blackening the bezel to give value to diamonds. Tra. 37, 52, 60.
TIRARE: Cellini uses this word in several technical senses in relation to metal work, *e.g.*, to lay or prepare a plate or sheet of metal. Tra. 72. To prepare the threads for filigree. Tra. 20. Or more generally, to bring into shape with the hammer. Tra. 129. TIRARE DI MARTELLO: hammer work. Tra. 48, 140. In another sense the word is used as of translating from a small to a large scale. Tra. 203.
TONACA: the tunic or outside mould of a *cire perdue* casting, between which and the *anima*, or inner block, the metal ran, displacing the wax. V. 421; Tra. 171. Also generally, of a coat of gesso.
TOPAZIO: a topaz.
TORCERE: to twist or warp. Tra. 168.
TORSELLO: the upper of the two dies for minting. Tra. 111. *See* PILA.
TRAFORARE: to fashion the forms or perforations of filigree work. TRAFORO, TRAFORETTO: a filigree scroll or perforation.
TRAPANO: a borer. Tra. 198. TRAPANO A PETTO: described as a larger sort of borer. Tra. 199.
TRARRE DI FUOCO: described by Cellini as being the technical term for completing the process of soldering before the commencement of the cleaning, &c. Tra. 91. TRARRE DI PECE: similarly described as the term for carrying the work of embossing and chasing through to the moment of removing the pitch. Tra. 134, 135.

TREMENTINA: turps.

TRIPOLO: Tripoli clay; a silicious earth consisting of the remains of diatoms. Tra. 103.

TUFO or ARENA DI TUFO: a sand tufa, a volcanic spongey rock like pumice, used for silver casting. Tra. 102.

TURCHINA: a turquoise.

UNTICCI: messy; untidy. Tra. 28.
UNTUME: grease or fat, used in soldering. Tra. 143, 144.
USCITE: the issues for the metal in a casting. V. 417.

VERDEMEZZO: a term signifying not too dry nor yet too moist, probably tacky. Tra. 104.
VERDERAME: verdigris, *i.e.*, acetate of copper. Tra. 73, 93, 94.

VERDOGNOLO: greenish; used in describing the colour of stone. Tra. 200.

VERMIGLIA: the vermeil. Tra. 39.

VERNICE: varnish. VERNICE ORDINARIA: described as the ordinary varnish used for sword hilts. Tra. 155. VERNICIARE: to varnish.

VESCICA: a crack or flaw, *e.g.*, in glass. Tra. 65.

VESTA, VESTIRE: *see* TONACA.

VETRIVUOLO, VETRIVUOLO ROMANO: Roman or green vitriol, *i.e.*, sulphate of iron. Tra. 150, 152.

VIRTU: a word used with many and double senses. For its larger uses *see* Symonds' 'Vita,' *passim*. In its more technical uses Cellini has *virtù* for the glory of a ruby. Tra. 42. VIRTU DEL MARTELLO: excellence of hammer work. VIRTU DEI FERRI: general technical ability with punches and chisels.

VITE: a screw. VITE FEMMINA: the female screw as used in minting with the screw process; and termed also FEMMINA & CHIOCCIOLA, which *see*.

VIVACITA: the flash and brilliancy of a stone. Tra. 66.

VOLTO: turned, bent, *e.g.*, of the form of a semi-ring punch. Tra. 133.

ZAFFIRO: the sapphire. Tra. 40, 66.
ZAFFO DI FERRO: a stopper of iron. Tra. 189.
ZANA: a division or space. Tra. 97.
ZECCA: the mint. Tra. 115.

HERE END THE TREATISES OF BENVENUTO CELLINI ON METAL WORK AND SCULPTURE, MADE INTO ENGLISH FROM THE ITALIAN OF THE MARCIAN CODEX BY C. R. ASHBEE, AND PRINTED BY HIM AT THE GUILD'S PRESS AT ESSEX HOUSE, WITH THE ASSISTANCE OF LAURENCE HODSON WHO SOUGHT TO KEEP LIVING THE TRADITIONS OF GOOD PRINTING REFOUNDED BY WILLIAM MORRIS, THE MASTER CRAFTSMAN, AND LIKEWISE OF T. BINNING & J. TIPPETT, COMPOSITORS, AND S. MOWLEM, PRESSMAN, WHO CAME TO ESSEX HOUSE FROM THE KELMSCOTT PRESS TO THAT END. BEGUN APRIL, 1898; FINISHED OCTOBER, 1898,

ERRATA.

Page 28, *for* but putting it in water, not cooling it with the bellows,
 read but not putting it in water, nor cooling it with the bellows.
Page 150, *for* CIAPPOLINTA *read* CIAPPOLINA.

A CATALOGUE OF SELECTED DOVER BOOKS
IN ALL FIELDS OF INTEREST

A CATALOGUE OF SELECTED DOVER
BOOKS IN ALL FIELDS OF INTEREST

RACKHAM'S COLOR ILLUSTRATIONS FOR WAGNER'S RING. Rackham's finest mature work—all 64 full-color watercolors in a faithful and lush interpretation of the *Ring*. Full-sized plates on coated stock of the paintings used by opera companies for authentic staging of Wagner. Captions aid in following complete Ring cycle. Introduction. 64 illustrations plus vignettes. 72pp. 8⅝ x 11¼. 23779-6 Pa. $6.00

CONTEMPORARY POLISH POSTERS IN FULL COLOR, edited by Joseph Czestochowski. 46 full-color examples of brilliant school of Polish graphic design, selected from world's first museum (near Warsaw) dedicated to poster art. Posters on circuses, films, plays, concerts all show cosmopolitan influences, free imagination. Introduction. 48pp. 9⅜ x 12¼.
23780-X Pa. $6.00

GRAPHIC WORKS OF EDVARD MUNCH, Edvard Munch. 90 haunting, evocative prints by first major Expressionist artist and one of the greatest graphic artists of his time: *The Scream, Anxiety, Death Chamber, The Kiss, Madonna*, etc. Introduction by Alfred Werner. 90pp. 9 x 12.
23765-6 Pa. $5.00

THE GOLDEN AGE OF THE POSTER, Hayward and Blanche Cirker. 70 extraordinary posters in full colors, from Maitres de l'Affiche, Mucha, Lautrec, Bradley, Cheret, Beardsley, many others. Total of 78pp. 9⅜ x 12¼. 22753-7 Pa. $5.95

THE NOTEBOOKS OF LEONARDO DA VINCI, edited by J. P. Richter. Extracts from manuscripts reveal great genius; on painting, sculpture, anatomy, sciences, geography, etc. Both Italian and English. 186 ms. pages reproduced, plus 500 additional drawings, including studies for *Last Supper*, Sforza monument, etc. 860pp. 7⅞ x 10¾. (Available in U.S. only)
22572-0, 22573-9 Pa., Two-vol. set $15.90

THE CODEX NUTTALL, as first edited by Zelia Nuttall. Only inexpensive edition, in full color, of a pre-Columbian Mexican (Mixtec) book. 88 color plates show kings, gods, heroes, temples, sacrifices. New explanatory, historical introduction by Arthur G. Miller. 96pp. 11⅜ x 8½. (Available in U.S. only) 23168-2 Pa. $7.50

UNE SEMAINE DE BONTÉ, A SURREALISTIC NOVEL IN COLLAGE, Max Ernst. Masterpiece created out of 19th-century periodical illustrations, explores worlds of terror and surprise. Some consider this Ernst's greatest work. 208pp. 8⅛ x 11. 23252-2 Pa. $5.00

DRAWINGS OF WILLIAM BLAKE, William Blake. 92 plates from Book of Job, *Divine Comedy, Paradise Lost,* visionary heads, mythological figures, Laocoon, etc. Selection, introduction, commentary by Sir Geoffrey Keynes. 178pp. 8⅛ x 11. 22303-5 Pa. $4.00

ENGRAVINGS OF HOGARTH, William Hogarth. 101 of · Hogarth's greatest works: *Rake's Progress, Harlot's Progress, Illustrations for Hudibras, Before and After, Beer Street and Gin Lane,* many more. Full commentary. 256pp. 11 x 13¾. 22479-1 Pa. $7.95

DAUMIER: 120 GREAT LITHOGRAPHS, Honore Daumier. Wide-ranging collection of lithographs by the greatest caricaturist of the 19th century. Concentrates on eternally popular series on lawyers, on married life, on liberated women, etc. Selection, introduction, and notes on plates by Charles F. Ramus. Total of 158pp. 9⅜ x 12¼. 23512-2 Pa. $5.50

DRAWINGS OF MUCHA, Alphonse Maria Mucha. Work reveals draftsman of highest caliber: studies for famous posters and paintings, renderings for book illustrations and ads, etc. 70 works, 9 in color; including 6 items not drawings. Introduction. List of illustrations. 72pp. 9⅜ x 12¼. (Available in U.S. only) 23672-2 Pa. $4.00

GIOVANNI BATTISTA PIRANESI: DRAWINGS IN THE PIERPONT MORGAN LIBRARY, Giovanni Battista Piranesi. For first time ever all of Morgan Library's collection, world's largest. 167 illustrations of rare Piranesi drawings—archeological, architectural, decorative and visionary. Essay, detailed list of drawings, chronology, captions. Edited by Felice Stampfle. 144pp. 9⅜ x 12¼. 23714-1 Pa. $7.50

NEW YORK ETCHINGS (1905-1949), John Sloan. All of important American artist's N.Y. life etchings. 67 works include some of ·his best art; also lively historical record—Greenwich Village, tenement scenes. Edited by Sloan's widow. Introduction and captions. 79pp. 8⅜ x 11¼. 23651-X Pa. $4.00

CHINESE PAINTING AND CALLIGRAPHY: A PICTORIAL SURVEY, Wan-go Weng. 69 fine examples from John M. Crawford's matchless private collection: landscapes, birds, flowers, human figures, etc., plus calligraphy. Every basic form included: hanging scrolls, handscrolls, album leaves, fans, etc. 109 illustrations. Introduction. Captions. 192pp. 8⅞ x 11¾. 23707-9 Pa. $7.95

DRAWINGS OF REMBRANDT, edited by Seymour Slive. Updated Lippmann, Hofstede de Groot edition, with definitive scholarly apparatus. All portraits, biblical sketches, landscapes, nudes, Oriental figures, classical studies, together with selection of work by followers. 550 illustrations. Total of 630pp. 9⅛ x 12¼. 21485-0, 21486-9 Pa., Two-vol. set $14.00

THE DISASTERS OF WAR, Francisco Goya. 83 etchings record horrors of Napoleonic wars in Spain and war in general. Reprint of 1st edition, plus 3 additional plates. Introduction by Philip Hofer. 97pp. 9⅜ x 8¼. 21872-4 Pa. $3.75

HOLLYWOOD GLAMOUR PORTRAITS, edited by John Kobal. 145 photos capture the stars from 1926-49, the high point in portrait photography. Gable, Harlow, Bogart, Bacall, Hedy Lamarr, Marlene Dietrich, Robert Montgomery, Marlon Brando, Veronica Lake; 94 stars in all. Full background on photographers, technical aspects, much more. Total of 160pp. 8⅜ x 11¼. 23352-9 Pa. $5.00

THE NEW YORK STAGE: FAMOUS PRODUCTIONS IN PHOTO-GRAPHS, edited by Stanley Appelbaum. 148 photographs from Museum of City of New York show 142 plays, 1883-1939. *Peter Pan, The Front Page, Dead End, Our Town,* O'Neill, hundreds of actors and actresses, etc. Full indexes. 154pp. 9½ x 10. 23241-7 Pa. $4.50

MASTERS OF THE DRAMA, John Gassner. Most comprehensive history of the drama, every tradition from Greeks to modern Europe and America, including Orient. Covers 800 dramatists, 2000 plays; biography, plot summaries, criticism, theatre history, etc. 77 illustrations. 890pp. 5⅜ x 8½. 20100-7 Clothbd. $10.00

THE GREAT OPERA STARS IN HISTORIC PHOTOGRAPHS, edited by James Camner. 343 portraits from the 1850s to the 1940s: Tamburini, Mario, Caliapin, Jeritza, Melchior, Melba, Patti, Pinza, Schipa, Caruso, Farrar, Steber, Gobbi, and many more—270 performers in all. Index. 199pp. 8⅜ x 11¼. 23575-0 Pa. $6.50

J. S. BACH, Albert Schweitzer. Great full-length study of Bach, life, background to music, music, by foremost modern scholar. Ernest Newman translation. 650 musical examples. Total of 928pp. 5⅜ x 8½. (Available in U.S. only) 21631-4, 21632-2 Pa., Two-vol. set $9.00

COMPLETE PIANO SONATAS, Ludwig van Beethoven. All sonatas in the fine Schenker edition, with fingering, analytical material. One of best modern editions. Total of 615pp. 9 x 12. (Available in U.S. only) 23134-8, 23135-6 Pa., Two-vol. set $13.00

KEYBOARD MUSIC, J. S. Bach. Bach-Gesellschaft edition. For harpsichord, piano, other keyboard instruments. English Suites, French Suites, Six Partitas, Goldberg Variations, Two-Part Inventions, Three-Part Sinfonias. 312pp. 8⅛ x 11. (Available in U.S. only) 22360-4 Pa. $5.50

FOUR SYMPHONIES IN FULL SCORE, Franz Schubert. Schubert's four most popular symphonies: No. 4 in C Minor ("Tragic"); No. 5 in B-flat Major; No. 8 in B Minor ("Unfinished"); No. 9 in C Major ("Great"). Breitkopf & Hartel edition. Study score. 261pp. 9⅜ x 12¼. 23681-1 Pa. $6.50

THE AUTHENTIC GILBERT & SULLIVAN SONGBOOK, W. S. Gilbert, A. S. Sullivan. Largest selection available; 92 songs, uncut, original keys, in piano rendering approved by Sullivan. Favorites and lesser-known fine numbers. Edited with plot synopses by James Spero. 3 illustrations. 399pp. 9 x 12. 23482-7 Pa. $7.95

THE ANATOMY OF THE HORSE, George Stubbs. Often considered the great masterpiece of animal anatomy. Full reproduction of 1766 edition, plus prospectus; original text and modernized text. 36 plates. Introduction by Eleanor Garvey. 121pp. 11 x 14¾. 23402-9 Pa. $6.00

BRIDGMAN'S LIFE DRAWING, George B. Bridgman. More than 500 illustrative drawings and text teach you to abstract the body into its major masses, use light and shade, proportion; as well as specific areas of anatomy, of which Bridgman is master. 192pp. 6½ x 9¼. (Available in U.S. only)
22710-3 Pa. $2.50

ART NOUVEAU DESIGNS IN COLOR, Alphonse Mucha, Maurice Verneuil, Georges Auriol. Full-color reproduction of *Combinaisons ornementales* (c. 1900) by Art Nouveau masters. Floral, animal, geometric, interlacings, swashes—borders, frames, spots—all incredibly beautiful. 60 plates, hundreds of designs. 9⅜ x 8-1/16. 22885-1 Pa. $4.00

FULL-COLOR FLORAL DESIGNS IN THE ART NOUVEAU STYLE, E. A. Seguy. 166 motifs, on 40 plates, from *Les fleurs et leurs applications decoratives* (1902): borders, circular designs, repeats, allovers, "spots." All in authentic Art Nouveau colors. 48pp. 9⅜ x 12¼.
23439-8 Pa. $5.00

A DIDEROT PICTORIAL ENCYCLOPEDIA OF TRADES AND INDUSTRY, edited by Charles C. Gillispie. 485 most interesting plates from the great French Encyclopedia of the 18th century show hundreds of working figures, artifacts, process, land and cityscapes; glassmaking, papermaking, metal extraction, construction, weaving, making furniture, clothing, wigs, dozens of other activities. Plates fully explained. 920pp. 9 x 12.
22284-5, 22285-3 Clothbd., Two-vol. set $40.00

HANDBOOK OF EARLY ADVERTISING ART, Clarence P. Hornung. Largest collection of copyright-free early and antique advertising art ever compiled. Over 6,000 illustrations, from Franklin's time to the 1890's for special effects, novelty. Valuable source, almost inexhaustible.
Pictorial Volume. Agriculture, the zodiac, animals, autos, birds, Christmas, fire engines, flowers, trees, musical instruments, ships, games and sports, much more. Arranged by subject matter and use. 237 plates. 288pp. 9 x 12.
20122-8 Clothbd. $13.50

Typographical Volume. Roman and Gothic faces ranging from 10 point to 300 point, "Barnum," German and Old English faces, script, logotypes, scrolls and flourishes, 1115 ornamental initials, 67 complete alphabets, more. 310 plates. 320pp. 9 x 12. 20123-6 Clothbd. $13.50

CALLIGRAPHY (CALLIGRAPHIA LATINA), J. G. Schwandner. High point of 18th-century ornamental calligraphy. Very ornate initials, scrolls, borders, cherubs, birds, lettered examples. 172pp. 9 x 13.
20475-8 Pa. $6.00

CATALOGUE OF DOVER BOOKS

THE SENSE OF BEAUTY, George Santayana. Masterfully written discussion of nature of beauty, materials of beauty, form, expression; art, literature, social sciences all involved. 168pp. 5⅜ x 8½. 20238-0 Pa. $2.50

ON THE IMPROVEMENT OF THE UNDERSTANDING, Benedict Spinoza. Also contains *Ethics, Correspondence,* all in excellent R. Elwes translation. Basic works on entry to philosophy, pantheism, exchange of ideas with great contemporaries. 402pp. 5⅜ x 8½. 20250-X Pa. $3.75

THE TRAGIC SENSE OF LIFE, Miguel de Unamuno. Acknowledged masterpiece of existential literature, one of most important books of 20th century. Introduction by Madariaga. 367pp. 5⅜ x 8½.
20257-7 Pa. $3.50

THE GUIDE FOR THE PERPLEXED, Moses Maimonides. Great classic of medieval Judaism attempts to reconcile revealed religion (Pentateuch, commentaries) with Aristotelian philosophy. Important historically, still relevant in problems. Unabridged Friedlander translation. Total of 473pp. 5⅜ x 8½. 20351-4 Pa. $5.00

THE I CHING (THE BOOK OF CHANGES), translated by James Legge. Complete translation of basic text plus appendices by Confucius, and Chinese commentary of most penetrating divination manual ever prepared. Indispensable to study of early Oriental civilizations, to modern inquiring reader. 448pp. 5⅜ x 8½. 21062-6 Pa. $4.00

THE EGYPTIAN BOOK OF THE DEAD, E. A. Wallis Budge. Complete reproduction of Ani's papyrus, finest ever found. Full hieroglyphic text, interlinear transliteration, word for word translation, smooth translation. Basic work, for Egyptology, for modern study of psychic matters. Total of 533pp. 6½ x 9¼. (Available in U.S. only) 21866-X Pa. $4.95

THE GODS OF THE EGYPTIANS, E. A. Wallis Budge. Never excelled for richness, fullness: all gods, goddesses, demons, mythical figures of Ancient Egypt; their legends, rites, incarnations, variations, powers, etc. Many hieroglyphic texts cited. Over 225 illustrations, plus 6 color plates. Total of 988pp. 6⅛ x 9¼. (Available in U.S. only)
22055-9, 22056-7 Pa., Two-vol. set $12.00

THE ENGLISH AND SCOTTISH POPULAR BALLADS, Francis J. Child. Monumental, still unsuperseded; all known variants of Child ballads, commentary on origins, literary references, Continental parallels, other features. Added: papers by G. L. Kittredge, W. M. Hart. Total of 2761pp. 6½ x 9¼.
21409-5, 21410-9, 21411-7, 21412-5, 21413-3 Pa., Five-vol. set $37.50

CORAL GARDENS AND THEIR MAGIC, Bronsilaw Malinowski. Classic study of the methods of tilling the soil and of agricultural rites in the Trobriand Islands of Melanesia. Author is one of the most important figures in the field of modern social anthropology. 143 illustrations. Indexes. Total of 911pp. of text. 5⅝ x 8¼. (Available in U.S. only)
23597-1 Pa. $12.95

YUCATAN BEFORE AND AFTER THE CONQUEST, Diego de Landa. First English translation of basic book in Maya studies, the only significant account of Yucatan written in the early post-Conquest era. Translated by distinguished Maya scholar William Gates. Appendices, introduction, 4 maps and over 120 illustrations added by translator. 162pp. 5⅜ x 8½.
23622-6 Pa. $3.00

THE MALAY ARCHIPELAGO, Alfred R. Wallace. Spirited travel account by one of founders of modern biology. Touches on zoology, botany, ethnography, geography, and geology. 62 illustrations, maps. 515pp. 5⅜ x 8½.
20187-2 Pa. $6.95

THE DISCOVERY OF THE TOMB OF TUTANKHAMEN, Howard Carter, A. C. Mace. Accompany Carter in the thrill of discovery, as ruined passage suddenly reveals unique, untouched, fabulously rich tomb. Fascinating account, with 106 illustrations. New introduction by J. M. White. Total of 382pp. 5⅜ x 8½. (Available in U.S. only) 23500-9 Pa. $4.00

THE WORLD'S GREATEST SPEECHES, edited by Lewis Copeland and Lawrence W. Lamm. Vast collection of 278 speeches from Greeks up to present. Powerful and effective models; unique look at history. Revised to 1970. Indices. 842pp. 5⅜ x 8½. 20468-5 Pa. $6.95

THE 100 GREATEST ADVERTISEMENTS, Julian Watkins. The priceless ingredient; His master's voice; 99 44/100% pure; over 100 others. How they were written, their impact, etc. Remarkable record. 130 illustrations. 233pp. 7⅞ x 10 3/5. 20540-1 Pa. $5.00

CRUICKSHANK PRINTS FOR HAND COLORING, George Cruickshank. 18 illustrations, one side of a page, on fine-quality paper suitable for watercolors. Caricatures of people in society (c. 1820) full of trenchant wit. Very large format. 32pp. 11 x 16. 23684-6 Pa. $4.50

THIRTY-TWO COLOR POSTCARDS OF TWENTIETH-CENTURY AMERICAN ART, Whitney Museum of American Art. Reproduced in full color in postcard form are 31 art works and one shot of the museum. Calder, Hopper, Rauschenberg, others. Detachable. 16pp. 8¼ x 11.
23629-3 Pa. $2.50

MUSIC OF THE SPHERES: THE MATERIAL UNIVERSE FROM ATOM TO QUASAR SIMPLY EXPLAINED, Guy Murchie. Planets, stars, geology, atoms, radiation, relativity, quantum theory, light, antimatter, similar topics. 319 figures. 664pp. 5⅜ x 8½.
21809-0, 21810-4 Pa., Two-vol. set $10.00

EINSTEIN'S THEORY OF RELATIVITY, Max Born. Finest semi-technical account; covers Einstein, Lorentz, Minkowski, and others, with much detail, much explanation of ideas and math not readily available elsewhere on this level. For student, non-specialist. 376pp. 5⅜ x 8½.
60769-0 Pa. $4.00

THE DEPRESSION YEARS AS PHOTOGRAPHED BY ARTHUR ROTH-STEIN, Arthur Rothstein. First collection devoted entirely to the work of outstanding 1930s photographer: famous dust storm photo, ragged children, unemployed, etc. 120 photographs. Captions. 119pp. 9¼ x 10¾.
23590-4 Pa. $5.00

CAMERA WORK: A PICTORIAL GUIDE, Alfred Stieglitz. All 559 illustrations and plates from the most important periodical in the history of art photography, Camera Work (1903-17). Presented four to a page, reduced in size but still clear, in strict chronological order, with complete captions. Three indexes. Glossary. Bibliography. 176pp. 8⅜ x 11¼.
23591-2 Pa. $6.95

ALVIN LANGDON COBURN, PHOTOGRAPHER, Alvin L. Coburn. Revealing autobiography by one of greatest photographers of 20th century gives insider's version of Photo-Secession, plus comments on his own work. 77 photographs by Coburn. Edited by Helmut and Alison Gernsheim. 160pp. 8⅛ x 11.
23685-4 Pa. $6.00

NEW YORK IN THE FORTIES, Andreas Feininger. 162 brilliant photographs by the well-known photographer, formerly with Life magazine, show commuters, shoppers, Times Square at night, Harlem nightclub, Lower East Side, etc. Introduction and full captions by John von Hartz. 181pp. 9¼ x 10¾.
23585-8 Pa. $6.00

GREAT NEWS PHOTOS AND THE STORIES BEHIND THEM, John Faber. Dramatic volume of 140 great news photos, 1855 through 1976, and revealing stories behind them, with both historical and technical information. Hindenburg disaster, shooting of Oswald, nomination of Jimmy Carter, etc. 160pp. 8¼ x 11.
23667-6 Pa. $5.00

THE ART OF THE CINEMATOGRAPHER, Leonard Maltin. Survey of American cinematography history and anecdotal interviews with 5 masters—Arthur Miller, Hal Mohr, Hal Rosson, Lucien Ballard, and Conrad Hall. Very large selection of behind-the-scenes production photos. 105 photographs. Filmographies. Index. Originally Behind the Camera. 144pp. 8¼ x 11.
23686-2 Pa. $5.00

DESIGNS FOR THE THREE-CORNERED HAT (LE TRICORNE), Pablo Picasso. 32 fabulously rare drawings—including 31 color illustrations of costumes and accessories—for 1919 production of famous ballet. Edited by Parmenia Migel, who has written new introduction. 48pp. 9⅜ x 12¼. (Available in U.S. only)
23709-5 Pa. $5.00

NOTES OF A FILM DIRECTOR, Sergei Eisenstein. Greatest Russian filmmaker explains montage, making of Alexander Nevsky, aesthetics; comments on self, associates, great rivals (Chaplin), similar material. 78 illustrations. 240pp. 5⅜ x 8½.
22392-2 Pa. $4.50

CATALOGUE OF DOVER BOOKS

THE COMPLETE WOODCUTS OF ALBRECHT DURER, edited by Dr. W. Kurth. 346 in all: "Old Testament," "St. Jerome," "Passion," "Life of Virgin," Apocalypse," many others. Introduction by Campbell Dodgson. 285pp. 8½ x 12¼. 21097-9 Pa. $6.95

DRAWINGS OF ALBRECHT DURER, edited by Heinrich Wolfflin. 81 plates show development from youth to full style. Many favorites; many new. Introduction by Alfred Werner. 96pp. 8⅛ x 11. 22352-3 Pa. $4.00

THE HUMAN FIGURE, Albrecht Dürer. Experiments in various techniques—stereometric, progressive proportional, and others. Also life studies that rank among finest ever done. Complete reprinting of *Dresden Sketchbook*. 170 plates. 355pp. 8⅜ x 11¼. 21042-1 Pa. $6.95

OF THE JUST SHAPING OF LETTERS, Albrecht Dürer. Renaissance artist explains design of Roman majuscules by geometry, also Gothic lower and capitals. Grolier Club edition. 43pp. 7⅞ x 10¾ 21306-4 Pa. $2.50

TEN BOOKS ON ARCHITECTURE, Vitruvius. The most important book ever written on architecture. Early Roman aesthetics, technology, classical orders, site selection, all other aspects. Stands behind everything since. Morgan translation. 331pp. 5⅜ x 8½. 20645-9 Pa. $3.75

THE FOUR BOOKS OF ARCHITECTURE, Andrea Palladio. 16th-century classic responsible for Palladian movement and style. Covers classical architectural remains, Renaissance revivals, classical orders, etc. 1738 Ware English edition. Introduction by A. Placzek. 216 plates. 110pp. of text. 9½ x 12¾. 21308-0 Pa. $7.50

HORIZONS, Norman Bel Geddes. Great industrialist stage designer, "father of streamlining," on application of aesthetics to transportation, amusement, architecture, etc. 1932 prophetic account; function, theory, specific projects. 222 illustrations. 312pp. 7⅞ x 10¾. 23514-9 Pa. $6.95

FRANK LLOYD WRIGHT'S FALLINGWATER, Donald Hoffmann. Full, illustrated story of conception and building of Wright's masterwork at Bear Run, Pa. 100 photographs of site, construction, and details of completed structure. 112pp. 9¼ x 10. 23671-4 Pa. $5.00

THE ELEMENTS OF DRAWING, John Ruskin. Timeless classic by great Viltorian; starts with basic ideas, works through more difficult. Many practical exercises. 48 illustrations. Introduction by Lawrence Campbell. 228pp. 5⅜ x 8½. 22730-8 Pa. $2.75

GIST OF ART, John Sloan. Greatest modern American teacher, Art Students League, offers innumerable hints, instructions, guided comments to help you in painting. Not a formal course. 46 illustrations. Introduction by Helen Sloan. 200pp. 5⅜ x 8½. 23435-5 Pa. $3.50

AMERICAN BIRD ENGRAVINGS, Alexander Wilson et al. All 76 plates. from Wilson's *American Ornithology* (1808-14), most important ornithological work before Audubon, plus 27 plates from the supplement (1825-33) by Charles Bonaparte. Over 250 birds portrayed. 8 plates also reproduced in full color. 111pp. 9⅜ x 12½. 23195-X Pa. $6.00

CRUICKSHANK'S PHOTOGRAPHS OF BIRDS OF AMERICA, Allan D. Cruickshank. Great ornithologist, photographer presents 177 closeups, groupings, panoramas, flightings, etc., of about 150 different birds. Expanded *Wings in the Wilderness*. Introduction by Helen G. Cruickshank. 191pp. 8¼ x 11. 23497-5 Pa. $6.00

AMERICAN WILDLIFE AND PLANTS, A. C. Martin, et al. Describes food habits of more than 1000 species of mammals, birds, fish. Special treatment of important food plants. Over 300 illustrations. 500pp. 5⅜ x 8½. 20793-5 Pa. $4.95

THE PEOPLE CALLED SHAKERS, Edward D. Andrews. Lifetime of research, definitive study of Shakers: origins, beliefs, practices, dances, social organization, furniture and crafts, impact on 19th-century USA, present heritage. Indispensable to student of American history, collector. 33 illustrations. 351pp. 5⅜ x 8½. 21081-2 Pa. $4.00

OLD NEW YORK IN EARLY PHOTOGRAPHS, Mary Black. New York City as it was in 1853-1901, through 196 wonderful photographs from N.-Y. Historical Society. Great Blizzard, Lincoln's funeral procession, great buildings. 228pp. 9 x 12. 22907-6 Pa. $7.95

MR. LINCOLN'S CAMERA MAN: MATHEW BRADY, Roy Meredith. Over 300 Brady photos reproduced directly from original negatives, photos. Jackson, Webster, Grant, Lee, Carnegie, Barnum; Lincoln; Battle Smoke, Death of Rebel Sniper, Atlanta Just After Capture. Lively commentary. 368pp. 8⅜ x 11¼. 23021-X Pa. $6.95

TRAVELS OF WILLIAM BARTRAM, William Bartram. From 1773-8, Bartram explored Northern Florida, Georgia, Carolinas, and reported on wild life, plants, Indians, early settlers. Basic account for period, entertaining reading. Edited by Mark Van Doren. 13 illustrations. 141pp. 5⅜ x 8½. 20013-2 Pa. $4.50

THE GENTLEMAN AND CABINET MAKER'S DIRECTOR, Thomas Chippendale. Full reprint, 1762 style book, most influential of all time; chairs, tables, sofas, mirrors, cabinets, etc. 200 plates, plus 24 photographs of surviving pieces. 249pp. 9⅞ x 12¾. 21601-2 Pa. $6.50

AMERICAN CARRIAGES, SLEIGHS, SULKIES AND CARTS, edited by Don H. Berkebile. 168 Victorian illustrations from catalogues, trade journals, fully captioned. Useful for artists. Author is Assoc. Curator, Div. of Transportation of Smithsonian Institution. 168pp. 8½ x 9½. 23328-6 Pa. $5.00

CATALOGUE OF DOVER BOOKS

THE STANDARD BOOK OF QUILT MAKING AND COLLECTING, Marguerite Ickis. Full information, full-sized patterns for making 46 traditional quilts, also 150 other patterns. Quilted cloths, lame, satin quilts, etc. 483 illustrations. 273pp. 6⅞ x 9⅝. 20582-7 Pa. $3.95

ENCYCLOPEDIA OF VICTORIAN NEEDLEWORK, S. Caulfield, Blanche Saward. Simply inexhaustible gigantic alphabetical coverage of every traditional needlecraft—stitches, materials, methods, tools, types of work; definitions, many projects to be made. 1200 illustrations; double-columned text. 697pp. 8⅛ x 11. 22800-2, 22801-0 Pa., Two-vol. set $12.00

MECHANICK EXERCISES ON THE WHOLE ART OF PRINTING, Joseph Moxon. First complete book (1683-4) ever written about typography, a compendium of everything known about printing at the latter part of 17th century. Reprint of 2nd (1962) Oxford Univ. Press edition. 74 illustrations. Total of 550pp. 6⅛ x 9¼. 23617-X Pa. $7.95

PAPERMAKING, Dard Hunter. Definitive book on the subject by the foremost authority in the field. Chapters dealing with every aspect of history of craft in every part of the world. Over 320 illustrations. 2nd, revised and enlarged (1947) edition. 672pp. 5⅜ x 8½. 23619-6 Pa. $7.95

THE ART DECO STYLE, edited by Theodore Menten. Furniture, jewelry, metalwork, ceramics, fabrics, lighting fixtures, interior decors, exteriors, graphics from pure French sources. Best sampling around. Over 400 photographs. 183pp. 8⅜ x 11¼. 22824-X Pa. $5.00

Prices subject to change without notice.

Available at your book dealer or write for free catalogue to Dept. GI, Dover Publications, Inc., 180 Varick St., N.Y., N.Y. 10014. Dover publishes more than 175 books each year on science, elementary and advanced mathematics, biology, music, art, literary history, social sciences and other areas.